AAL - 6180

Toward Wholeness:

Rudolf Steiner Education in America

TOWARD WHOLENESS:

Rudolf Steiner Education in America

by
Mary Caroline Richards

Wesleyan University Press, *Middletown, Connecticut*

Library of Congress Cataloging in Publication Data

Richards, Mary Caroline.
 Toward wholeness: Rudolf Steiner Education in America.

 Bibliography: p.
 1. Steiner, Rudolf, 1861–1925. 2. Education —
Philosophy. 3. Education — United States. 4. Anthro-
posophy. I. Title.
LB775.S72R43 370′.1 80-14905
ISBN 0-8195-5059-3
ISBN 0-8195-6062-6 (pbk.)

DISTRIBUTED BY COLUMBIA UNIVERSITY PRESS
136 SOUTH BROADWAY, IRVINGTON, N.Y. 10533

MANUFACTURED IN THE UNITED STATES OF AMERICA
FIRST EDITION

Today we shall be considering not so much how to acquire the
actual subject matter of our work, but rather how to cherish and cultivate
within ourselves the *spirit of an education which bears the future within it.*

— Rudolf Steiner, *Discussions with Teachers*

Life as a whole is a unity, and we must not only consider the child,
but the whole of life; we must look at the whole human being.

— Rudolf Steiner, *The Kingdom of Childhood*

Contents

	Preface	*ix*
One	Introduction to Rudolf Steiner and the Author's Approach	*3*
Two	Introduction to Waldorf Schooling in America	*22*
Three	*The Education of the Child*: A Spiritual Anatomy and Basic Text	*42*
Four	To Feel the Whole in Every Part: Education As an Art	*63*
Five	Teacher Training and Handwork	*81*
Six	More on Curriculum/Methods/Teachers/Children	*102*
Seven	Camphill in America: Mental Handicap and a New Social Impulse	*121*
Eight	Education and Community: A School of Life and a Re-schooling of Society	*146*
Nine	Waldorf Education and New Age Religious Consciousness	*156*
Ten	The TEACHER	*170*
Eleven	Transformation	*179*
	Conclusion: Steps Toward a New Culture	*190*
Appendix 1	Directory of Waldorf Schools, Institutes, and Adult Education Centers	*195*
Appendix 2	A Brief Chronology of Rudolf Steiner's Life and Works	*199*
	Bibliography	*203*

Preface

Trying to write something about Rudolf Steiner and the educational impulse he generated is like trying to say something about life. Where do you begin? Where do you stop? What do you include? What do you leave out?

I am interested in Steiner's work and the schooling that has grown out of it because of the totality of the vision — and because everything is connected with everything else. This spirit reflects the direction in which modern consciousness is evolving. The grammar of interconnections is a new discipline of our age.

Rudolf Steiner came out of Central Europe, was born in 1861, and died in 1925, after an extraordinary life of prodigious research in many fields. The first school he founded was the Waldorf School in Germany in 1919. The educational movement he began, now international, is colorfully presented in Joan and Siegfried Rudel's *Education towards Freedom*. A more detailed account of his curriculum and methods from an English point of view is given in *Recovery of Man in Childhood* by A. C. Harwood, long-time chairman of the faculty and teacher of history at Michael Hall in Sussex. This present book is the first to look at Steiner and Waldorf education as it is expressed in America. It will not limit itself to schools, but will follow the art of lifelong learning as well.

Rudolf Steiner, in *The Tension between East and West*, said that there is some truth in every point of view (p. 101). If we stick to only one, we're bound to run into bias. He said it's like taking a photograph of a tree. You can't get it all from one angle. So he urged us to come to an awareness of the world from a variety of perspectives. Perhaps that is one good reason for calling this book *Toward Wholeness*.

He also urged us to see how important it is to become free in our thinking, uncoerced by past patterning. Perhaps that is a good reason for calling its conclusion "Steps toward a New Culture."

One living form unfolds out of the previous one, as we can plainly see if we look carefully at any grass plant. It is not cause and effect, it is metamorphosis. The space the new stem comes out of is hollow. It is empty. The next form comes straight from source. In this book I use an image of the sun raying out into all the vocabularies of our deeds, as the way source works from center. The next thing we do about schooling can come out of that sun. That source contains both our memory of what has happened so far, and the empty space of our freedom. Like the grass, the hollow is part of the plant.

I think this is a helpful and interesting way to look at education. We're connected to the past and grateful for all the earnest human effort, and we're open to the unfolding of the next form. We're not locked into anything. There is this free creative space in the spirit of life, which is rooted in our common soil. It bears new forms into existence as part of the continuum. They bring the nourishment we need now.

Rudolf Steiner believed that freedom and unpossessive love are two practices meant to be developed by human beings. They will affect everything we know and feel and can do. I enjoy thinking that as we invite these qualities into our hearts and imaginations and bodies, we are hosting a transformation of art, science, and religion. I enjoy the thought that in the renewal of education through the Waldorf methods and curriculum, a re-schooling of society is being aided.

Most books on education tend to emphasize how stimulating and efficient the schools are for the children. I wish in this book to emphasize how stimulating and nourishing Waldorf education is for teachers (and other adults) as well as children! Their growth is mutual.

I write from the point of view of an American person who has made a deep connection with Waldorf practice and philosophy for more than twenty years. I do not teach in the Steiner schools, though I have had some modest experience in them. My own work is in a variety of contexts. I write out of participation, observation, study, and a long and cordial inquiry.

My educational journey is one that many readers will be able to identify with: early years in public school, college, university graduate degrees, then college teaching, followed by a search into experimental education, alternative schools, free universities. Such has been the path of our age. Destiny brought me in due course to a meeting with Rudolf Steiner's contribution.

A first crisis beset me when the intellectual values to which I had been conditioned proved insufficient to sustain the wholeness of life. I turned then to Black Mountain College, where art and community and self-determination were added to cognitive disciplines. There another crisis mounted to challenge the trust I had

given to individual creativity. Some time later, I encountered Steiner education through a school and farm and cultural center in Spring Valley, New York, and I began to study Steiner's works in general. I was interested and often flabbergasted by what I read or experienced. I asked questions and tried in a variety of ways to inform myself about this little-known movement and the philosophy on which it is based. In this book I share the questions, the search, the ongoing growth.

At one time I had a strong wish to join one of the schools but decided I would continue to offer what I could to adults of college age or older. Rudolf Steiner said to teachers that the aim was not to make all schools on the planet into Waldorf schools, but to create a new impulse in education at large so that the Waldorf schools would no longer be necessary.

At this moment I believe the challenge of Steiner's work lies in its newness. It turns toward holistic methods and insights in specific educational practices. It discovers a common archetypal ground for art, science, and religion. The whole is found in every part. This of course lends to my descriptions of the work a circulatory style — repeating and spiraling in a cumulative rhythm. Part of my effort is to soften the division between documenting and contemplating — and to find a way of speaking which carries feeling into the mind and body. If the intention can be heard — the echoes and probes, the ponderings, the shifts from moist to dry — perhaps the inner forms themselves will be allowed to interpenetrate and overlap and flow into a space we cannot see, as well as proceed in ways satisfying to our wish for precision and clarity. It is dangerous to make clear in an intellectual way what is barely sensed, still vague and fragile, yet giving off an unmistakable scent. Also I believe it is desirable to reawaken a relationship to the undefinable. It is our imagination which has this ability.

This book combines a personal journey with the presentation of an educational movement. It is not a systematic exposition of Waldorf education, indexed for easy reference. It is rather an account of an American educator/artist's encounter with a point of view and practice which come from Central Europe and represent an impulse in life and learning not to be met with in American public or private education. The reader will find an interweaving of personal experience with information about Steiner's curriculum and philosophy. I have followed my own life-track in this book because it seems helpful to offer personal bridges between what has passed as the ordinary adaptation to the mythos of our culture and the potential for a new culture forming in our depths. Our "tree of life" is expanding at its root, reintegrating what has been divided during past centuries. This synthesis represents a shift in consciousness and requires some new coordinations in our inner experience. For example, one of the new coordinations which interests me the

most is how to imagine divinity so that it may work from the root into all the branches: into earth and society and medicine and food and learning. Our culture puts divinity into a church, while our intuitions, ancient and primal, find it springing from the very root of the tree of life, manifesting through all things.

Education is part of our real experience, involving all that we are, inside and out. Not all people need crisis to carry them forward in growth. The arts of transformation are basic to new age consciousness. I cannot honestly talk about the Steiner philosophy of education without saying how I have come to it. Otherwise it remains just one more abstract hypothesis. My view is that it represents a developmental stage in the evolution of educational practice and expresses in its forms a search for a renewal of a feeling for who we human beings really are, and for reconnection with the universe — inwardly as well as outwardly. My view is that the movement is only in its beginning and will grow as general consciousness evolves.

Other educational and cultural tendencies show bias toward intellectual aims or some other one-sided goal favoring social adaptation or money-and-power or sectarian belief. Other schooling, though often courageous, has proven fragile or unyielding. Rudolf Steiner stressed the importance of developing concepts which can contain growth and change rather than stifle them. Steiner philosophy provides room for a new culture to stir, rooted in our human wholeness and lifted by a universe of spirit.

One of the steps I personally have been slowest to take is toward the realization that I am not likely to grasp the new if I cling to the old. Often I have tried to match the descriptions of Waldorf pedagogy with what I already know and think about education and art. It doesn't work. One must begin at a new point and proceed to a new end. I am learning to part from old loyalties and to come to the new with a fresh openness. This is not to be unfaithful to history, but rather to affirm its pliability. New impulses in education and in society may represent a leap in our life-line like that from one evolutionary stage to the next.

I hope there will be something in this book for a variety of readers: friends and parents, students, teachers, philosophers, pilgrims, and question-askers. If some of the concepts seem difficult and unfamiliar, I hope the reader will receive them in an intuitively receptive way, and let them rest in a deep stratum of the mind, like seeds, which may awaken later.

Thanks to all the many dear persons who have helped and encouraged me in this undertaking, and to a friend at a publishing house whose idea it was in the first place.

M. C. R.

Toward Wholeness

Rudolf Steiner Education in America

Introduction to Rudolf Steiner and the Author's Approach

Rudolf Steiner states that life is to be experienced in the same way that art is experienced. Both are inner experiences expressed through the senses. It is from this union of inner experience and sensory life that we will begin to look at Waldorf education in America.

There is a creative way to write and to read, Rudolf Steiner said, which keeps the faith with living process, and which does not tend to congeal and rigidify ideas. He asks the readers of his books to follow them as an unfolding process, not to seize upon points here and there for momentary stimulation. We must try to keep a sense of the whole at all times. The movement of mind may be fluid, a continuum of experiences true to the currents and intersections of living. Making connections is essential, he said. And to ask for consistency from life is to misunderstand its form. Rudolf Steiner expresses here a common human intuition, for we know that in living forms certain elements lie nearer the surface, more visible, and some lie deeper, more invisible. If we want to come to an understanding of a living educational form, we must approach it from a variety of perspectives and at more than one level. Our imaginations may picture what is not visible.

In a Steiner school we may look into a kindergarten room and see a big toy ship in which the children ride, and the colored scarves in which they dress up. We may notice that the room is not the usual box shape, that organic forms have influenced the architecture. We ask why. What is the inner reason, or is there any? We look through the shapes and colors to the inner, motivating spirit. We do this also with each other as human beings. We see each other not merely as bodies, but also as persons, with feelings and thoughts and abilities not visible in external appearances. The ground we share in life is this inner sense. It creates the continuum through all external changes and impermanence.

Ordinarily when we describe the institutions of our culture, such as schools, we talk only on the one level. We describe the buildings, the organization, the curriculum, the methodology, the audio-visual aids, but we do not describe what philosophy stands within and behind these externals. I want to help to balance this one-sidedness, and to look as clearly as I can, and as objectively, at the values, the "beings," who form the expressions of Waldorf schooling, in contrast to the patterns of our popular culture.

James Hillman, whose current research in archetypal psychology time and again corroborates Rudolf Steiner's findings, says, "Ideas we don't know we have, have us." Do we know what "idea of the human being" underlies the schools to which our children are sent? For you may be sure there is such an idea, however unconscious. We owe it to ourselves to ask Parsifal's question "What's going on here?" It is a step toward consciousness.

There came a time in my life when I began to ask that question. I had studied and taught English in a variety of colleges and universities, including the experimental Black Mountain College. Even it fell apart. Why? Why, if we are all so smart and creative and highly educated, are our schools so often characterized by confusion, ill will, violence, sterility? I came across the Steiner schools at a time when the bottom had dropped out of the other methods of education I had experienced or observed. What are the Steiner schools? Why are they growing? I pressed my questions, and I discovered that within the Steiner/Waldorf educational movement there lives a conception of the human being, of nature, and of universe that inspires the work. It is an inner picture that strikes and cheers the imagination for educational effort. The teachers work valiantly for very modest pay. Parents tend to get involved. When so many social institutions are falling apart, it is heartening to notice places of new growth that are bearing fruit.

I shall consider it appropriate in this book to weave together the external facts about curriculum and methods with the interior ground, until the fabric of experience is such that we cannot be sure whether we are in a vision or a reality. We will be in both. Our reality is our vision. We may be unconscious of the lens through which we look at life. To awaken the inner eye is part of the task of education. To see with the inner eye into the inner form is part of perception. How do we look into one another's hearts? How do we perceive the individual nature of a child or a tree or stone or cloud?

Rudolf Steiner called this path toward "seeing into" the new science for our modern age. He called it spiritual science because it recognizes the resources of our thinking and our feeling and our willing as well as the membranes through which

they may shine. He was a pioneer in the twentieth-century mapping of this science, which integrates the inner and outer worlds. Though he stands in a long tradition of gnostics, Rosicrucians, alchemists, theosophists, Steiner comes into the material originally and anew, through an inner training which he then makes available to others. He has renewed the science of interiority, calling it Anthroposophy, the knowledge of man.

Anthroposphy, he said, is the inner language of anthropology. It probes deeply the question, "What is the human being?" It is a way, he said, of reconnecting the inwardness of man and the inwardness of universe, or of seeing how man and universe are parts of a common physical-spiritual linkage. In order to see how things are in their cosmic wholeness, he suggests that we turn the glove of perception inside out. It will look the same, all five fingers, palm. Yet we are seeing it from the inside, reversed. And precisely what we see inside, namely the landscape and personages of that inner world, was the territory of Steiner's research. The values of the spirit seem ever and again "the reverse" of materialistic greed and reductionist, alienated tendencies.

Remember the story of the Chinese potter who said, "It is not the pot I am forming, but what lies within. I am interested only in what remains when the pot is broken." What remains when the pot is broken? The quality of the inner activity which has taken place, the spirit of the form. In order to see this quality which the potter values even when the pot is gone, we have to look with his kind of eye. And this eye will have the quality of this person. In other words, the eye is also the "I." Because it is we — not our physical organs by themselves — who see, we will not see more than we are. This is why inner development must accompany physical sensory development in order for us to perceive with wholeness. Inner development is the education of soul qualities, spiritual qualities, ego strength, differentiation, will, thinking, feeling, and breathing. The body itself opens from the inside.

We have observed then that when people ask what things are, they don't want to know just the physical characteristics, the content and definition; they want to know something more. They sense a quality. So when we ask what is going on in certain schools, we cannot be satisfied by a description of procedures alone. Externals can be duplicated. They can be put on like a mask for a few hours a day. This is okay. Masks are probably a good influence. But we are interested here not in the mask alone, but in what stands behind.

It is like a work of art. We are interested not only in the clay and the glazes, but in the image, the form, the intention. We see not only the pigment and the contours on the painter's canvas, but an inner world through the window of the artist's soul.

5

It is a world of color and tone and ambience, undefinable. It is a world that contains us all. Its light shines in the walls of clay, the twists of fibre, the rings of wood, the grain of stone, the skin of water, draft of fire.

When I was a child, this light shone in all the daily facts of life (it still does). I was incredulous with wonder and amusement at the way words sound: *pink,* for example, or *mush* or *wet.* Brothers and sisters, mother and father, aunt and uncle, neighbors, were mysteries. Houses, rooftops, gardens, horizons, roads and cars, clothes, tools, books — stockings and garters seemed to me especially fabulous. A pencil box? A drawer? I was awestruck by both life and death.

In the schoolroom and in the family, for the most part, merriment and wonder were not encouraged. They seemed exaggerated, implausible, undignified. The facts of life were defined in a way that turned them into information rather than living mysteries. Education and religion tried to convince me that what was inside a person, a soul for instance, might be important, but that what was inside me had no connection with what was inside *pink* or brother or road or tree or ant. There were human beings, and there were things, and there were animals and plants and there was God, and there seemed to be a gap between one thing and another. A person stood outside somehow. There didn't seem to be much sense of connection, except in the mind. We could think about relationships of kinship, space, time, species. There were knowledge and prayer. But in experience things were separated. And any significant experience of inwardness seemed confined to the human being. It felt to me like being in a box and looking out through eyeholes and getting messages over earphones. Of course there was God, who was said to love us even though we didn't deserve it, we being so small and sinful. I felt some embarrassment for God about this. He seemed self-righteous and belittling. My soul didn't grow strong by being told how unworthy I was. The impression given was that life was a disaster, that it would be better not to be born, and that the only thing to hope for was a better shake in the "beyond." Art turned to absurdity for its inspiration. Where else?

This seemed to me an ungenerous and stifling view to take of oneself and the world. I was confused by the sneers and jeers at the human condition. Intuitions of nobility, courage, humor, sympathy, diligence, creativity all seemed to have to be justified in an atmosphere of basic negativity. It was hard going. It still is. To stay true to primal wonder in such a cynical age is a challenge.

So what was life then? Life was going to school and working for money and falling in love and spending time. Life was reading and writing and making things and being athletic and having a garden and joining a community. And when every-

thing went wrong, which usually meant that a personal relationship had terminated, the ego consciousness which had been "trying so hard to make things come out well" (i.e., to control everything) fell into ruin. And then there was psychotherapy, and the discovery of the rest of the self who was throwing monkey wrenches into the ego's totalitarian plans. The rest of the self had a lot of that child in it, who felt rejected, and discredited, and unloved, and unloving. Actually it felt a lot of hatred and resentment and anger at having been betrayed by the authoritarian viewpoint of home, school, and church. I don't mean the authority of persons; I mean the authority of a point of view about humankind which did not honor mystery, awe, merriment, and wonder. That point of view was closed off from the interiority, even of things it did believe in, like greed, appetite, and anxiety. It is quite an eyeful when we begin to take in the whole inner landscape of our humanity. T. S. Eliot said, "Humankind cannot stand very much reality." Is that true?

When I worked with a therapist-teacher, who was a Jungian, I discovered the objective existence of the human psyche: not just my own personal psyche, but the underlying one I share with everyone else: what Jung calls the collective unconscious. It was wonderful to re-enter that experience of feeling alive to myself through and through, not just topside in consciousness. It was wonderful to feel that my daily conscious life was part of a larger, ongoing conscious life at other levels which mostly we aren't aware of. It was a life-saving, life-giving re-entry.

From Jung I learned the reality of the objective psyche, empirically — not as belief. Rudolf Steiner's research widened the horizons of consciousness to include all things and beings, not only humans. From Steiner I learned the spiritual being of the natural world and of the universe as well as that of human persons. One world. A self-consistent universe, and one, incidentally, that is similarly described by the most radical hypotheses of subatomic physics, a subject treated by Fritjof Capra in his book *The Tao of Physics*.

Steiner points to the elemental beings of earth, air, water, fire: the gnomes, sylphs, undines, and salamanders. He re-visions the angels, archangels, and archai. Spiritual beings abound. They permeate. Readers of modern depth psychology will recognize the pantheon of archetypes which characterize the unconscious. The psyche is not monotheistic. Steiner says, in "Individual Spiritual Beings and Uniform Ground of the World":

It is not so that all which surrounds us comes or stems from a unified ground of the world, but it comes from totally different, from individually different spiritual beings.

7

Spiritual individualities work together in order to bring about and to create the world that surrounds us and which we experience.

This is old knowledge renewed. The difference between primitive animism and the new "seeing into" the heart of things is to be found in history. We are not primitives. We are modern people who have developed a natural science which we respect. Consciousness has continued to evolve. And now is a time when consciousness moves into spiritual perception without sacrificing its disciplined objectivity. Or, as William Irwin Thompson, American historian and founder of the Lindisfarne Community, said recently in an article in *Parabola:*

> We are at an evolutionary quantum leap, in which consciousness is going into a radical mode of thought. Now, it may be that it is very similar to what went on in ancient times, as Rudolf Steiner says; but even Steiner says that we're not going back to some Atlantean sensibility but that we're going to carry into the recovery of astral sensitivities the whole journey of ratio and logos and consciousness and man as the measure of all things.

This idea is exciting: to feel a recovery of the sacred, of spiritual interiority, in our daily life, in daily things; to feel the renewal of powers of perception; to feel an integration of science and religion and art. Inwardness and outwardness are moving toward each other across the interface, and a new quality of wholeness is occurring in human consciousness. Natural science is developing into spiritual science without any loss of discipline and with a widening of consciousness. When we are ready to see, the organs of perception develop. Or as Goethe said, "Light creates the eye."

Steiner's work is very much connected with the work of his early twentieth-century contemporaries in psychology and anthropology. He was trained as scientist, mathematician, and philosopher. He was endowed from birth with unusual powers of perception of the meta-sensory world. The pioneering effort of his life was to unite the streams of science and seership in a way that would be authentic and available to everyone. Anthroposophy was not his invention any more than relativity was Einstein's or psychoanalysis Freud's. These were movements within human consciousness received by, or perceived by, human beings at the frontier. Steiner often said that we cannot force spiritual perception; it comes when its time is ripe. And part of the ripening is our own.

Life is an educational process from birth to death. We receive stimulation and information, we assimilate it, we change and grow. We learn. Steiner contributed to

education at its widest circumference by sharing publicly the results of his personal, inner work. In every human being, he wrote, there slumber capacities for growth and development, and specifically for the development of the kind of "senses" we will need in order to perceive the interiority of the world, in order to "see through." This kind of education is a path each of us may choose to travel consciously. It is an inner path for the teachers in the Steiner schools. Unconsciously, human development is moving in this direction in any case. The initiate, as such a man as Steiner is called, accelerates the process and makes it available to general human consciousness. He is a teacher.

Before we take a step in "seeing," Steiner warns, we should be sure to take three steps in "being." That is to say, the quality of our seeing depends upon the quality of our being — upon the development of our character. Again I find this a very helpful step toward integrating knowledge and character. Morality and virtue are difficult concepts to handle, by themselves. They tend to become dissociated from other human gifts, and even antagonistic to human understanding. Virtuous behavior in itself does not equip us for seeing clearly. It may in fact deform our perception further by being entangled with egotism and fearfulness. But reverence for life enables cognition to ripen to a quality of accurate understanding. Objective seeing, truthful seeing, is the functioning of our inwardness. And so objective and subjective merge into a marriage. No longer divided, we kiss the world through the windowpane which is no longer there. No more glass divides us from our environment and from others. We see face to face.

Steiner placed a great deal of emphasis on the prerequisites for proper seeing. In *Knowledge of the Higher Worlds and Its Attainment*, he says:

> It is not easy, at first, to believe that feelings like reverence and respect have anything to do with cognition. This is due to the fact that we are inclined to set cognition aside as a faculty by itself — one that stands in no relation to what otherwise occurs in the soul. In so thinking we do not bear in mind that it is the soul which exercises the faculty of cognition; and feelings are for the soul what food is for the body. . . . Veneration, homage, devotion are like nutriment making it healthy and strong, especially strong for the activity of cognition. Disrespect, antipathy, underestimation of what deserves recognition, all exert a paralyzing and withering effect on this faculty of cognition. . . . Reverence awakens in the soul a sympathetic power through which we attract qualities in the beings around us, which would otherwise remain concealed. (pp. 12–14)

The power obtained through devotion can be rendered still more effective when the life of feeling is enriched by yet another quality, Steiner continues. This consists of developing a vivid inner life, which will serve as a key to unlock the beau-

ties of the outer world. Otherwise much that we pass through will remain veiled to us. "The outer world with all its phenomena is filled with divine splendor, but we must have experienced the divine within ourselves before we can hope to discover it in our environment," Steiner explains. A path to the divine within ourselves may open through our keeping in touch with our own feelings and ideas.

It is desirable to set aside moments in our daily life when we can withdraw into ourselves quietly and alone. There, Steiner advises, we are to occupy ourselves not with ego-desires, but with experiences of the outer world which we allow to re-echo within our own completely silent self. "At such moments, every flower, every animal, every action will unveil secrets undreamt of," Steiner assures us. But enjoyment is not the end; it is the means of awakening us to the world, which we can then better serve. To students of higher knowledge, Steiner says, enjoyment is like a scout informing them about the world; but once instructed by enjoyment, they pass on to work. They learn, not in order to accumulate learning as their own treasure, but in order that they may devote their learning to the service of the world.

> In all spiritual science there is a fundamental principle which cannot be transgressed without sacrificing success, and it should be impressed on the student in every form of esoteric training. It runs as follows: *All knowledge pursued merely for the enrichment of personal learning and the accumulation of personal treasure leads you away from the path; but all knowledge pursued for growth to ripeness within the process of human ennoblement and cosmic development brings you a step forward.* This law must be strictly observed, and no student is genuine until he has adopted it as a guide for his whole life. This truth can be expressed in the following short sentence: *Every idea which does not become your ideal slays a force in your soul; every idea which becomes your ideal creates within you life-forces.* (p. 17)

The process of seeing must take us from a new ground toward another threshold. The Waldorf educational impulse is based upon a way of perceiving, which senses that all things share in consciousness and meaningful form. The sounds of our speech are heard not only by human ears but by angels. Brothers and sisters not only are siblings in the physical sense, but represent relationships of personal destiny at deeper levels. House and road are the geometry of body and spirit. The things we make are the language of our souls. Imagery is the soul's art: dishpans and automobiles, sculpture and drama — vessels of the psyche are everywhere. Seasons are created by movement in the cosmic spheres, and the festivals of solstice and equinox are presided over by archangelic beings: Raphael in spring, Uriel in summer, Michael in autumn, and Gabriel in winter. The geography of our planet

is inspirited place, for special elementals animate each locale. Gertrude Stein, a twentieth-century American writer, said that if we want to understand human beings, we must know their climate and geography!

The world is alive throughout. Even the processes of death are connected in the ongoing movement of human being and universe. Steiner's sense of the world does not disparage our intuitions, does not tell us that what we see is Nothing. His educational effort is based upon a perception of the human being and the universe in a detailed connection, one which opens many fruitful paths of work. Once authority is given to the inner connection between person and nature, person and person, person and universe, this step in consciousness is reflected in new deeds. We shall have new work to do in agriculture, the arts, medicine, economics, social planning, architecture, education, science, religion, business, and industry.

There is a growing readiness for education which expresses a living connection between nature, person, and society. Waldorf Schools have developed a specific (though flexible) curriculum and methodology, and a way of training teachers. They are not only asking questions, they are growing to answers. The problem, which is to be expected, is to keep a balance between the answers Steiner indicated and an ongoing spirit of research and free growth. Anthroposophy, he said over and over again, is just at its beginning. It will grow and change, and it will depend upon the emergence of creative personalities to carry the work forward. He was also aware of how the consciousness that was developed in the German language would need to be translated (not just the words, but indeed the quality of consciousness) for Americans and other English-speaking peoples. The English language, he said, is to be a carrier of consciousness into the coming epoch.

I first heard of Rudolf Steiner in 1949, when I was in London looking for a school for a nine-year-old girl to whom I was stepmother. At the Ministry of Education I picked up a variety of brochures, and among them was one that spoke of an approach to growth and learning and teaching which had been set in motion by Rudolf Steiner in Germany many years earlier. There were a number of such schools in England. Steiner had given lecture courses there in 1922, 1923, and 1924, which have been translated and published under the titles *Spiritual Ground of Education, A Modern Art of Education,* and *The Kingdom of Childhood.*

I was struck by the tone of the brochure, so different from the others. The brochure indicated that the schools had a grounding, a point of view, a Form, and that this Form proceeded from the essence of the developing human being in the context of nature and universe. It described the life cycle of the human being, connect-

ing the physical changes of the growing person to ways of being and learning, and consequently to curriculum and methods. The school turned out not to be suitable for our little girl, who wanted something short-term and focused in the performing arts. But I never forgot that introduction to a name I had never heard before. When, a few years later, life brought me again into touch with the ideas of Rudolf Steiner, I wasn't surprised.

The brochure referred to the seven-year rhythms of growth in child and adolescent, and at once I connected this with what I had read years earlier in my own college study in Plato, namely, that the body renews itself every seven years. This formative idea had awakened early in my own life-track, in my own learning. Our natural style, it would seem, is to grow by metamorphosis and rebirth. No wonder the genesis of the butterfly — from egg stage, to larva, to cocoon, to winged creature — stirs our souls and bears images into our poems, fables, and symbolism. Psyche, who is the Greek name of soul, is also butterfly. Our soul-butterfly is the beloved of Eros, who lives in the body's desire to unite with its soul. The adventure of being a human person on earth is in large part a process of getting together our body, our soul and our spirit. This is what we long to do. In *Study of Man* Steiner says, "The task of education conceived in the spiritual sense is to bring the Soul-Spirit into harmony with the Life-Body" (pp. 19–20).

In Rudolf Steiner schools, this process is undertaken by teachers along with the pupils. The life-learning flows throughout. When a group of teachers experiences the processes of learning in mutuality with others called students, a kind of energy is activated. Instead of being drained through "giving," teachers are nourished and replenished through learning, of which giving is only one part.

When we say "life-body," we are already speaking the more precise language of the forms which Rudolf Steiner perceived as characteristic of the human being and of the universe in which we live. These terms are part of a widespread esoteric language, common to both East and West. Steiner reintroduces them to ordinary usage, as he reintroduces the perceptions themselves. They are for most of us like new colors on our palette, providing a more differentiated spectrum. We are invited to look in ways and places we have not looked before and to be unprejudiced. We are asked to test the language and the perceptions against our own experience, as we do with any other hypothesis.

Life-body is the living aspect of the forces which animate the body in its growth and self-healing, as distinguished from its sheerly mineral components. It implies the distinction between a living body and a corpse, which may look alike but are very different. Karl Ege, a teacher in the New York City Rudolf Steiner School,

explained to me that when you cut yourself, it is the life-body (or ether body or etheric body, as it is also called) which heals the cut. The physical-mineral body cannot do that. German conveniently has two words for these two aspects of body: *Körper* (corpse) and *Leib* (living- or life-body).

You can see immediately that we are in the middle of a big conception of the human being, of nature, of universe, and of forms. It seems, for example, that we have more than one kind of body! And this big conception is the context for Steiner education in the Waldorf schools. It is not taught as a subject, but stands behind what is taught, as a presence.

The child is beheld as a being who comes into earthly life from a previous life; the child in each of us has a supersensible origin and nature, and our development is seen as following an unfolding relationship between physical growth and inner growth. The human person is comprehended holistically, as a being of body, soul, and spirit. Inner forces mould the outer forms, and the outer forms sow seeds for inner shaping. The human being is seen as a field of interweaving forces, some of them more visible than others. But it is the body and its processes with which we always start. It bears the script of meaning. The human being is like a word, bearing both a visible script and an inner meaning. We learn to read its language.

The growth of Steiner's own learning, the course of his life, is a fascinating study in itself. I will mention here two particular, formative ideas: one, from Goethe and his theory of knowledge, particularly has to do with the archetypal form of the plant and with metamorphosis as a principle of plant and animal growth. The other is from Theosophy, a path of esoteric knowledge from which Steiner diverged as the direction of his own seership became clearer. Another strong element in the evolution of Steiner's path was a very special experience of what he called the "Mystery of Golgotha." This was an experience of the cosmic Christ, whose union with earth marked the turning point of time. These ideas are deep and subtle and live in an esoteric tradition going back to ancient Greece and earlier. Steiner discusses these matters in *Christianity as Mystical Fact*. He would probably have said that they go back much further than that, indeed to the primal origins of earthly consciousness.

Anthroposophy is not taught to the children and adolescents in Waldorf schools. It lives in the consciousness of the teachers and creates a particular kind of atmosphere. This "particular kind of atmosphere" is hard to describe, but it has kept me involved ever since I read that first brochure.

I have asked a lot of questions about it, and have tried to answer them over twenty years of acquaintance. I have read books by Steiner (he gave over 6,000 lec-

tures, most of which have been published, and wrote several books besides) and others, I have talked with teachers and students, observed in classrooms, attended courses and conferences, and shared experience in schools. I took a teacher-training course under the guidance of Francis Edmunds at the New York City Steiner School because I wanted to experience what I had read about. Some of the notions and procedures were so different from anything I had come across in conventional public education or experimental education that I had to work hard to grasp them fully. I substituted in the Green Meadow School in Spring Valley, New York, for two months, teaching fourth and fifth grades. I attended Emerson College in England for a short period to study with Oliver Whicher in projective geometry and plant growth. And I have been associated with the Camphill Schools and Villages for the mentally handicapped since they began in this country in 1962. These are also based on Steiner's pioneering work in curative education, though the Camphill Movement was initiated and inspired by another extraordinary doctor and artist, Karl König. These schools and villages incorporate and build upon Steiner's research and contributions in biodynamic agriculture, homeopathic medicine, community-forming, architecture, and the other arts, as well as the schooling of normal adults in new social forms and in a way of life which may become a path of meditation.

Learning, schooling, and education are experiences of the whole person. They share a single idea which is reflected in a variety of particular forms: kindergarten, elementary school, high school, adult education centers, teacher training institutes, summer conferences and programs at the college level, communities for the elderly, and villages for the handicapped. And indeed life itself is indistinguishable from learning, if learning has a meaning and scope beyond instruction in certain skills or the mastering of certain subject matters. Surely meditation, for example, is a kind of inner schooling. Perhaps what we are asking now is not what life and learning *should be*, but what they *are!*

It is no surprise these days, as ecological consciousness is awakening apace, that there are connections between things. Then it is not difficult to say that behind every image stands a meaning, an activity, a spirit, a soul-force. That color is as important on a wall as it is on a painter's canvas. That shape is as important in the design of a room or a building as it is in sculpture or organic life. That forms are interrelated, as, for example, the forms of animals and the forms of the human being. The forms of plants, stones, crystals, and the forms of water and air. The forms of speech made in the larynx are the forms of air are the forms of sound are the forms of movement are the forms of meaning. This is taking our theme too fast,

but I want to try to give a feeling from the inside of an aliveness and interconnectedness, multi-leveled, by the nature of things.

The word "nature" is also deepened and made resonant as it is filled with consciousness. Since I was schooled in the romantic poets of England and felt a special love for Wordsworth, I recognized in the Anthroposophy of Rudolf Steiner the same intuitions Wordsworth presented, though Steiner spells them out in a language of "spiritual science" rather than poetry. I recognized them as well in Zen Buddhism and in American Indian songs, poems, and prayers, as well as in their healing rituals and dances. Nature, all these sources say, is the "face of a Great Being."

How can we understand this concept? How do our own faces relate to the fullness of our own being? Mysteries and riddles abound. How are we able to perceive and receive this Great Being? By opening our imagination, by letting the images of nature speak to us, and by trusting our intuition, we may begin. We may allow our thinking to quicken with life, to be bold in stepping inside phenomena. There is a thinking in us which is asleep and ready to wake, to rise and participate — a thinking which sees through the images of life, the faces, to the beings who form them. This is not a literal, visual seeing, but an insight.

In a way, all the things we hear as information are like a stage in our soul-butterfly growth. They are like the cocoon. We need to go to sleep in them and let them metamorphose into multi-colored awareness. What we will have given up is the security of the cocoon, which housed us during a certain period. And we will have given up a kind of heaviness, a kind of squareness, a monochrome intelligence, which was right for its time. Colors, Rudolf Steiner reminds us, come from the same realm as feeling and sensation, desire and will. To think with sensation, feeling, and will, is to develop a participatory consciousness, one that moves within life, experiencing it in thought. Again, it is thought which has outgrown its abstractly intellectual stage and moved into modes of understanding which Steiner calls "higher knowledge."

I have difficulty with words like "higher" and "lower" because of their ambiguity. They tend to apply not to a spatial image but to a ladder of values. I do not think that one form of knowledge is more valuable than another; likewise I do not think a flower is more valuable than a seed. Everything is needed and has its part to play. I have resolved the problem of "higher" and "lower" by translating them into their root images. What do these words really mean? It turns out that their meaning is related to the concept of gravity. The "low" is horizontal like the horizon; it lies flat and is heavy. The "high" is not gravity bound. It follows the princi-

ple of levity, which is the property of gases which rise from the earth. Higher knowledge would be a consciousness which is, like the butterfly, winged and filled with colored imagery: that is, it would be imagination. A still higher stage, more like hearing than seeing, would be what Steiner calls inspiration. And yet a higher stage would be more participatory: it would be intuition.

In addition to the stages of knowledge, there is the "someone" who is knowing. It is you or I. Our ego carries its knowing like the butterfly carries the colors of its wings. The ego is both present in its knowing and separate from it. It is this relationship between our ego and our experience which makes learning and change so possible and so exciting. The ego is the "I am" who speaks in our voice. It gives rise to the mythic image of the charioteer, riding with the reins in her hands, guiding the horses of libido, without whom she would be still. In us lives our "I am," who thinks and feels and wills and knows, and who can distance itself from these activities. The "I" can undertake practices or exercises or meditations which develop capacity for higher knowledge and for participatory consciousness. The "I" can wrestle with problems of balance and can wait to take a step in knowledge until it has taken three steps in the ripening of character.

To enter into Rudolf Steiner education is to enter into a world where these are the concerns taken up by the imaginations of the teachers, each in his or her own way. What is unique in these schools is the inner path of the teacher. The teacher's personal path is to enter into a consciousness of the human being and universe and to enter into teaching as a practice of this consciousness. A community is thus created among the teachers by the fact that they are students together and are connected through a meditative life. In almost every school, you will find some teachers who do not enter so fully into this consciousness, and they are met with flexibility. But the teachers who do commit themselves make up the "college of teachers," who, by and large, govern the school's affairs.

Teaching is ideally a path of development for the teacher as well as for the student. Professional work and personal meaning come together as one, accounting for the energy and enthusiasm and wholeheartedness which tends to characterize the atmosphere of Waldorf schools. It was part of Steiner's approach to question the concept of "working for wages." Surely one needs money, but that is not what one works for. Since the salaries are so modest, the motivation to teach in a Waldorf school tends to be personal and sincere and to reflect idealism. The teachers are free to be individually creative in their classrooms and at the same time they feel grounded in a common impulse and vision. Frequent faculty meetings keep in lively motion the interweaving of personal initiative and common purpose.

A concern for the teacher's spiritual welfare, soul life, and physical health seems to be an ongoing theme, carried mutually by the entire group — not always successfully. Teachers study together, govern together, and make policy together. Theoretically, there is no principal, though schools differ widely in the powers given to the chairman of the faculty. Each school is autonomous. Of course, there are frictions and schisms as elsewhere in life, and schools are constantly going through crises of growth, finding the best way within a life situation to evolve a practical life together. Administrative forms seem to vary from school to school and from stage to stage within a single school. Though each school is independent, there is a Waldorf School Association. Differences between the schools are the subject of controversy.

Rudolf Steiner education is a cultural import. Many of the teachers are German or British. American teachers often study abroad, in Switzerland, England, or Germany. There is a flavor to Anthroposophy and its arts which seems odd to many Americans. As the movement grows, and more Americans become involved, this will change. Americans tend to be impressed by imports and are sometimes slow in maturing their own sense of authority. In its movement westward, Waldorf education finds a growing number of Americans who greet it like an old friend and who take on responsibility for new schools and new ideas.

Bringing Anthroposophy to these shores is like kissing Sleeping Beauty; for either Anthroposophy sleeps in the unconscious of every person or it is less than the renewed human science of body/soul/spirit which it claims to be.

In this respect I had a surprising and informing experience at the dedication of Fountain Hall, a community center at Camphill Village in Copake, New York. I had been asked, along with others, to make a short talk to celebrate the opening. As I stood in front of the audience of vintage Anthroposophists, many of whom were European, I felt as if I had been there a long time awaiting them, and now they had appeared out of spirit worlds like angels in spectacles, embroidered blouses, and tailored wool suits. A mist of iridescence spread over their faces, and I greeted them through it.

Later in the day I had a vision of an Indian chief in full tribal costume, white fringed buckskins and feather headdress, standing in the center of the hall near where I had stood, speaking to the building and to the beings around him. I heard him called Chief Crazy Horse, a name with a ring, though I knew nothing of him historically. When I got home, I looked him up in the dictionary. And so a poem came into being, "Chief Crazy Horse at Fountain Hall." The power of this Native American welcome evokes a sense of the strong bond of destiny that links Rudolf

Steiner to America. In America Steiner saw an energy and a vision that will carry forward the transformation of schooling and of society, which we must conduct if humanity is to continue its evolution in the right way.

CHIEF CRAZY HORSE AT FOUNTAIN HALL

I like it here: big teepee,
 big directions: sun rise set
 north star south
 big axis
 world cross
 four winds
 big colors in small pieces
 my horse crazy with mana light
 me big chief, crazy fountain.

I like
 crosses: two dark on dawn-down-under leaves' light,
 window spirits,
 in kiva crypt.
 Stepping stones of sun jewels
 for souls at their rain source,
 in planetary round dance.

 Corn sun king god
 comes pale yellow and green
 in middle window
 sweet eyes lightening from afar.

I like
 these green horizons.
 Light
 in the cup
 and the center a lamb,
 a spilling fountain,
 blood in the earth red a
 crazy mystery,
 big chief mystery.
 Crosses black like empty night:
 eclipse:
 dark spirit doors:
 a whale, a scorpion.

 This
 cup

running over
crazy with truthful giving
 and
the highest window of red sounds
 and blue horses of light.
My horse runs in your spilling windows,
 o crazy fountaineer.

I like it here: your hall,
 big teepee,
 big heaven door cross on ceiling for spirit eyes
 on floor earth cross for spirit calling dance.
These signs: good medicine.

 I Chief Crazy Horse of Indianos
breathe in my breath
 the speech of your temple.
 Good medicine
will sing now its way
 welcome in our land.

In the breath of the Indian there already lived and was comprehended the speech of Anthropos Sophia, of Human Wisdom. He was the host and was receiving that band of European pilgrims into his home which mirrored theirs. *You think you are in a strange land, O Pioneers? We are already here! We await you and recognize you! We are your brothers and your sisters. We too have been working and keeping faith with the gods, the spirits, the Great Being. We too have been teaching our children reverence for life, for nature. Welcome!*

While the origin of Rudolf Steiner education is European, my particular interest is Steiner education in America, and I bring to the subject an American perspective. Born in Idaho, I grew up in Portland, Oregon, and I attended public elementary and high schools, an Episcopal junior college for girls, and Reed College, from which I graduated with a degree in Literature and Languages. I took a doctorate in English at the University of California in Berkeley. All very conventional. The only unusual element was that I originally went to Berkeley to be an Oriental Studies student, majoring in classical Chinese!

After I joined the faculty of the College of the University of Chicago, I began to question the "intellectual virtues" on which it rested. I then left those assumptions for a more holistic approach to person and society. At Black Mountain College, the arts were central to curriculum, no matter what one's major field. Community

was central as well. The emphasis was threefold: intellectual, artistic, and social. We did our own administration and the physical work of maintenance. We operated a farm. We had no president or trustees, and we governed ourselves in common. There were no grades or tenure. Salaries were token: twenty-five dollars a month, plus medical insurance, board, and room. A "needs policy" covered other contingencies. The curriculum was created by teachers and students together. There I began to work with clay as a potter and to sow seeds of an interdisciplinary cast.

Black Mountain folded (more precisely, "adjourned") because of fatigue, poverty, and legal challenge. But before it ever folded, I did, discovering that even the perfections of Black Mountain's freedom and creativity did not equip us with human insight or loving wills. Time and again faculty broke in schism, ill will, or warfare. Personal relationships suffered deeply. Was there no help from education for the crises of life? Was there no way to keep the faith, working together through thick and thin, embracing the differences? Did art leave one as silly as ever? How could I understand or answer these challenging questions?

For five years I forswore academia and lived in an atmosphere of avant-garde artists, musicians, dancers, and craftspeople in New York. Pottery opened up for me as an art of transformation. Challenged to my depths by the events of life, I was drawn to the images of alchemy and transmutation. It was at this time that I came in touch with Rudolf Steiner's work again. Its language of soul and of living forms spoke, as the Quakers say, to my condition. I translated Antonin Artaud's *The Theater and Its Double,* moved by his vision of "The Alchemical Theater," which would transform society. With friends I was reading aloud James Joyce's *Finnegans Wake*, that alchemy of speech. And I was turning gingerly through the pages of C. G. Jung's *Psychology and Alchemy.* Meeting Steiner again at this time seemed like joining a companion on the path.

David Tudor, avant-garde musician and student of Anthroposophy, gave me Steiner's books on education to read. I heard Francis Edmunds, distinguished Steiner teacher from England, speak about Waldorf education at the Threefold Farm in Spring Valley not far from where I lived, and I became his student (in my own mind) for the next ten years, attending his lectures whenever he came to this country. Edmunds founded Emerson College in England, an adult education center based on Steiner's principles.

It is not surprising that, having served my time in both alternative and conventional public education, and having experienced the shadow side of each so consciously, I found myself responding to the imagination of the Steiner schools, and particularly of the Camphill Schools and Villages. Their members too lived in the

forms that shaped Black Mountain: noncompetitive learning, community, voluntary poverty, the arts, self-government, nontoxic agriculture, making one's own decisions, one's own culture. They had taken another step. And this step was the idea of persons coming together to form something which was more than themselves. Rudolf Steiner puts the image this way: when people come together in community, they may, if they so will, create a vessel which will receive a spiritual being. Into their circle, a being descends and incarnates. When we grow faithless to one another, we may still be faithful to the being of our school, our community, as to a friend.

Coming to this experience from another perspective, a scientist like Buckminster Fuller might rather use the term "synergy": the whole that is more than the sum of its parts. Steiner personifies, and emboldens our souls to savor the presence of *living being*, not just metaphysical forces. What it means to the soul to personify has been recently proposed as well by psychologist James Hillman in his *Re-Visioning Psychology*.

Personification is an animism appropriate to the anima, to Psyche, the soul. It is her way, to personify in images. That is why imagination is her life, and why the arts make soul, stirring us in our depths. Perhaps it is the way of body to speak of physical forces. And perhaps it is the way of spirit to speak of pure light and of emptiness. Could it be so, then, that we have been concentrating on the language of body during these five hundred years of learning natural science? And from time to time of spirit and its disciplines? But the language of soul has languished, save for the romantic poets. In our time, romanticism is coming of age. So says Owen Barfield in his books *Romanticism Comes of Age* and *What Coleridge Thought*.

So my path, my life-track, has found its way, learning from all my teachers along the journey. We are teachers to one another when we share our experiences. When, in 1962–64, I was writing my book *Centering*, I said that Rudolf Steiner pedagogy was the closest thing to a centering impulse in education I had run across. Perhaps this equips me in part for mediating between this still little-known educational movement and the American public of parents, teachers, friends, and philosophers of education.

The main challenge in undertaking this book has been to enter into the living experience, living forms, living ideas, living substance, living imagination, living persons, and to write from the inside. To create a mood which indicates a field of endeavor and yet allows each reader to find his or her own way in it. To create a mood which is artistic in the largest sense, one which affirms imagination as a way of experiencing and of knowing.

Introduction to Waldorf Schooling in America

*Our college of teachers needs to become more and more of a
united organic whole. Everyone of us must take his share in
the whole education throughout the school, — directly or indirectly.*

— Rudolf Steiner, *Supplementary Course*

Each Waldorf school is unique and has its own local color and personal history. The sequence of the curriculum, the methods of presentation, and the overall philosophy of education are drawn from the same source, but each group of teachers, parents, and children who make the school, creates a unique organism. The fabric of relationships is at once noticeable, for a Waldorf school comes into being through the needs of specific children and parents and the readiness of certain persons to be teachers.

Rudolf Steiner undertook to create the first Waldorf school in response to a specific personal invitation by Emil Molt, in Stuttgart, Germany. Molt wanted a school for the children of the workers in his Waldorf Astoria cigarette factory. The school started with these children and their particular needs, and grew to include many many other children in the vicinity.

Most of the people Rudolf Steiner asked to be teachers had never taught before. Their qualifications were an openness to life, experience and knowledge often drawn from some professional vocation, love for children, and an interest in the new universal human science and philosophy and art of which Steiner was a pioneer. Steiner's was a synthesis sought by twentieth-century individuals preparing for the future.

The future of humankind that the movement presented would seek a holistic approach to knowledge. Science would cease to be estranged from art and religion

and human values. Institutional religion would cease to monopolize the human being's intuitions of meaning and of belonging in the world. Art would grow toward revelation of nature's secrets. People together would create schools, which would take on a character given by many different kinds of personalities working together. They would be free of state control. And these characteristics continue to mark Waldorf education.

Now that there are more Waldorf Teacher Training Institutes, more teachers come into the schools after at least two years of study and practice teaching. Nonetheless, many teachers still come to a school through an apprenticeship, which grows slowly from interest and familiarity with a particular school. Sometimes public school teachers or college faculty will join a Waldorf school out of a desire to integrate their own lives and to participate in a more affectionate and independent activity with children and peers. Sometimes parents become interested and decide to work in the school, first as teachers' aids and gradually as committed teachers.

A Waldorf school starts with a kindergarten. It may in due course add a first grade. Then a second, and a third, and so on. Ideally, a grade is added each year as the children who started the school require it. But this does not always happen, at least not right away. A suitable first grade teacher must be found, and this, again ideally, implies an interest in staying with the group of children as their Main Lesson teacher and friend and companion for the next eight years. Some schools grow slowly, others faster. But the way they grow is organic to the needs and resources of the human situation in each. Suitable space must be found, and eventually persons to teach not only the Main Lesson but foreign languages, music, painting, eurythmy, and handwork as the children grow and are ready to take in more and more.

In the kindergarten the children enjoy an environment which is meant to provide them with rich opportunity for exercising their fantasy, rather than one programming them in prescribed routines. In some other approaches to early childhood education, toys are chosen in order to develop skills. Not so in a Waldorf preschool. Most of the toys are soft and handmade, such as stuffed creatures and elves and gnomes. They are very simple, so as not to dominate the child's imagination, but to attract its play. Square, sharply angled blocks are usually replaced by less manufactured forms: pieces of wood, strips of cloth, unspun wool fleece, and an outdoor space with trees, branches, earth, stones, and sand to play with. Other learning takes place through the child's joy in imitating grown-ups in real-life situations of cooking and cleaning and taking care of a baby or small animals and planting

seeds. These activities are performed not as projects but as part of everyday life.

Each day the children have a story, a verse; they sing many songs and make up plays from the stories they are told. They paint with watercolors, have a snack, and rest. Often there are corners of the room arranged for special activities: a boat, a kitchen, a toolroom, or a little greenhouse. The children are accepted as children and are not hurried into being little adults before their time. The mood is warm. There are tangible learning opportunities in human relations and in taking care of toys and materials — what Rudolf Steiner called the social arts. The natural softness of a child is encouraged and protected. Wonder is kept alive. Reverence for life is taught by example. There seems to be a balance between natural spontaneity and learning through play and through example.

In the elementary grades, childhood play is gradually transformed into a feeling for work. Play, Steiner pointed out, comes from the inside; work from the outside. Both are inwardly experienced. From first grade on, work becomes gradually conscious.

In first grade, as in all grades, school begins with the children and their teachers saying together a verse by Rudolf Steiner. They learn to stand tall and to speak out. There seems to be a minimum of mumbling and shuffling. Some exercises may follow, combining movement with word sounds.

Then there is the Main Lesson, a period of one and one-half to two hours. Its purpose is to present a subject in wide scope and depth every day for a number of weeks, to give the children a real experience of knowledge. This lesson often begins with lively singing and speech chorus of poems currently being learned, which get the children off to a vigorous start and use the energy they are often already bursting with. After the teacher's concentrated presentation follow some recitation and dialogue, then working on the children's Main Lesson books. This "block" method is in contrast to the usual public school timetable, by which pupils are required to shift their attention from one subject to another every forty-five minutes all day long.

Steiner advised against a uniformly "intellectual" day with recreational periods only for relief. There should be recreational aspects in all the Main Lessons. If the presentations are made with a proper sense of rhythm, the children do not become tired. But even these lessons should not go on all day. In the afternoons, the children should be carried by their physical vitality into gardening, art and crafts, eurythmy, and gymnastics, and in the higher grades, practical work.

In Waldorf education there is a rhythm to the day which reflects the three-fold nature of the person and the needs of a particular age group. There is also a rhythm

to the school year, through the sequence of subject and the festivals, with the repetition of themes and practices. In addition, there is the overall rhythm of the curriculum as a whole, kindergarten through twelfth grade, as it unfolds and spirals over itself. The rhythms of breathing and heartbeat, of seasons, of day and night, waking and sleeping, weave in all these forms of schooling.

In first grade there are blocks in writing and storytelling and eventually in reading and arithmetic. In second grade, there are fables and legends. In third grade, Old Testament stories, and the beginning study of farming and housing. In fourth grade, geography begins, along with the study of man and animal, and Norse myths. In the fifth grade, botany and Greek myths. In sixth grade, mineralogy and acoustics. In seventh grade, nutrition, physiology, and the history of the Renaissance. In eighth grade, modern history (after the seventeenth century), literature, and physics. These are just random samplings, which will be filled out in succeeding chapters. For an exhaustive account of the curriculum according to grade, refer to A. C. Harwood's *Recovery of Man in Childhood* or E. A. K. Stockmeyer's *Rudolf Steiner's Curriculum for Waldorf Schools*.

The teachers are free to do what they think is best for their particular class. The curriculum is rich with suggestions but undogmatic in intent. Whatever subject is being studied, the material is presented by the teacher, rather than by textbook. There is usually a picture drawn in colored chalk on the blackboard. The students have bound notebooks with unlined paper in which they write and draw with colored pencils, documenting what they are learning. Each Main Lesson will call upon the child's powers of listening, of body movement, of thinking, and of feeling. Artistic activity is particularly related to the will: it is an experience of doing, of making. Artwork also invites the child's feeling for expressiveness and encourages a kind of intuitive thinking about how to get things done. In the early grades, some teachers allow the children to copy what has been drawn on the board so that they may learn to draw in ways they would not otherwise know. Other times the children draw freely. Variety exists, according to teacher and grade.

Art is not separated from learning. The children work on their lesson books earnestly, and in the higher grades, these books are often impressive: carefully executed, colorfully adorned, imaginative, and substantial — they reflect a personal growth experience and record.

Most of the drawing in these books is done with wax crayon or colored pencil. There are also lessons in watercolor. In the lower grades, painting is done with flowing color on wet paper and usually follows the telling of a story. Initially, there is no attempt to make representational shapes. It is the experience of the flowing

color that is stressed. Gradually skill is gained in controlling the flowing colors and in bringing imagery out of the color.

Because of the point of view toward painting in these lower grades, the children's work has a similarity. Primary colors are preferred. The little children learn to mix the primary colors, for example, using yellow and blue to make green. The emergence of the new "mixed" color is usually dramatized in a story told before the lesson. Black and white tend to be avoided until the higher grades, because they are considered to be more abstract and not as living for a small child. The children are also encouraged to *paint* with their colors and not to draw outlines and fill them in. Likewise in drawing, the children are asked to fill in an area with strokes of the crayon from the upper right-hand corner to the lower left. This helps them to realize that space is not empty and colorless, nor is it opaque.

Art is taught in the Steiner schools independent of contemporary trends and tastes — though not so much now that a feeling for "the color field" is presently in vogue. Art is taught, not to make the children into artists, but to expose them to the healing influence of color, to exercise their creative wills, and to counteract the tendency of our time to set the imagination apart from other learning activities. The children are asked to make their colors transparent, so that they can show through each other, and to let the shapes come from the colors and not from hard-edged boundary lines. In their classes they are given qualities of experience which they would not otherwise be likely to get from their culture.

In the later grades the children are introduced to black-and-white charcoal drawing and scratchboard. In high school they may have oil painting, print making, and other graphics. Painting, modeling, design, and string constructions are part of math lessons. Sculpture is part of the history lesson because it is a part of history, as are the other arts.

In the early grades, all the children learn to knit and to crochet. In the first grade, they knit a scarf. In the second, they crochet a recorder bag. In the third, they begin cross-stitch and running stitch. Soon boys and girls alike are knitting argyle socks, ski caps, and mittens. They make a shirt. Woodworking is another craft: carving a spoon, a boat, or a picture frame. Handwork will be gone into in more detail in a later chapter.

These are all appealing activities, but they are more than that. They are an essential part of the child's growth and development during the grade-school years from age seven to fourteen. In these years, the child learns through imagination and feeling. All the pedagogy in Steiner schools is geared to this fact. The child learns through story and drama, through color and rhythms, through movement and in-

terplay. For the kindergarten child, the life of imitative action is basic. It is enough to tell the infant a simple story. For the elementary school children, there must be drama and feeling to hold their interest. Thus the artistic approach is made to the Main Lesson and throughout. What a creative opportunity for the teacher!

During the rest of the day, there are special lessons in foreign languages, music, handwork, eurythmy, or remedial work in reading or writing or arithmetic. The small children begin to learn French and German, or Spanish, or Russian, through songs and poems and conversation. Grammar comes much later.

The mood of the classroom varies according to what is going on. At the beginning of the day, there is a vibrant seriousness which seems characteristic of children in one of their aspects. They are encouraged to take themselves seriously as soul beings. The content of their morning verse tends to affirm the day that is beginning and to connect the children with a sense of themselves as persons of courage and reverence. There are usually songs of various moods — some funny, some dramatic — to help the children to wake up and to enjoy the rhythm of tune and verse.

Then there is usually a conversation with the teacher about the things the children want to share. They are encouraged to speak up, though each must learn to take his/her turn and to give space to the others. There is continual opportunity for speaking in the Waldorf schools, so that the children seem remarkably unselfconscious and strong-voiced. They are used to telling stories in front of the class and to reciting poems in unison. The natural energy of the children under the guidance of the teacher is the life-line of the class.

The class develops as a kind of small community. Since ideally the same class teacher accompanies the children through their eight grades, they are like a family growing up together. Everyone, including the teacher, functions in his/her own way, with the respect of the group. It is pleasing to see an unstandardized conception of individuality and a minimum of social pressure to conform. In rare schools there is a dress code, but in most cases, the children give their own special colors to the portrait of the class.

One basis for this respect of individuality seems to be the recognition given to a study of the temperaments: sanguine, phlegmatic, melancholic, and choleric. Every person is a mixture and yet has a certain dominant tendency. This tendency is not only expressed in the physical body, but in moods, behavior, and preferences. All the temperaments are a part of being human, so every class must expect to contain a mixture of children: some will be lighthearted, some will be serious, some will be indifferent, and some will be aggressive. The teacher tries to understand the tem-

perament of any given child and to work with it and through it, not against it. At the same time, s/he tries to help the child balance one-sidedness by awakening latent faculties and tempering those which might otherwise engulf the child. The teacher is often compared to a musical conductor who leads a group of children into harmonious and lively expression.

In the training of teachers, much is made of artistic work, the temperaments, and the presentation of the Main Lesson. The teachers paint and draw, sing and play recorder, recite and tell stories, and cook and play with the children. Because they stay with their group year after year, they can allow each student to move along at his/her own pace. If something doesn't get done by the end of a given year, it can be done at the beginning of the next! The path through the eight grades of elementary school is meant to be as personally enriching to the teachers as it is to the children. The teachers offer to the children an experience of world history and the evolution of consciousness, a consciousness which they must also have if they are to share it with students in a real and living way. Steiner was continually urging the teachers to teach out of personal enthusiasm, rather than grim duty — to be sure to include humor and surprises, to appeal always to the feelings, and to use the charm of the unknown in order to whet the children's appetite for what might be coming next. Make the experience *interesting,* he stressed — that above all!

Though there are certain guidelines in the sequence of material covered in the course of the years, the order is not rigid, and the teacher's freedom and creativity are emphasized. Teachers' meetings give opportunity for the exchange of ideas and mutual help. The progress or difficulty of children is continually discussed by the teachers.

Ideally, grades are not given nor are final examinations. But actually there are many compromises owing to parental and cultural pressures. Elementary schools are mostly free of marking until grades seven and eight. Even then, grades are for the school, not for the children. Waldorf schools were once called "education without anxiety." Maybe the reason lies partly in the emphasis away from testing and grading. During high school, grades are given for students preparing to go on to college. And at the end of high school, students are coached for College Boards and Scholastic Aptitude Tests. On the whole, they do well.

The attitude toward homework is typical of the atmosphere of the school: namely, that the children should be helped with their work rather than tested and punished. Teacher and student cooperate to promote successful learning. In his *Lectures to Teachers* Steiner says:

In the Waldorf School the development of the powers of memory is included in the class teaching. The children are given as little homework as possible, in spite of the parents' complaints that their children have not enough to do. To set homework is to give pupils something they may neglect. And it is the worst possible thing when something the teacher wishes to be carried out is not done. This risk should not be taken. (p. 59)

It is risky to say anything factual about specific schools, since they are free to change when needs and possibilities arise, and all of the schools are growing. What may be true this year may not be so the next. It is also risky to talk in generalities and abstract models, since the schools are very alive (and hence undefinable), and each is a unique variation upon a theme. But still I would like to give a basic picture of what is going on today in Waldorf Schools in America.

The Rudolf Steiner School in New York City was founded fifty years ago, in 1928. It lives in a building that looks like a historic New York house, five stories high with basement, a block from Central Park, on Seventy-ninth Street. The children come from many different cultural backgrounds — in all colors and sizes. At recess, the little ones walk to the park holding on to loops on a long rope, like hikers on a wilderness trail. One teacher holds the rope in front, another at the back, and across Fifth Avenue they go, intrepid through the traffic, on to their playing fields.

On either side of the classic portico entrance to the school building is a window where student work is displayed for passers-by to notice and enjoy: a painting, a geometric string construction, pages from a workbook on optics or zoology, a first grader's knitting or writing, all in bright colors.

The Rudolf Steiner High School is on Seventy-eighth Street, a block away. Here again, the interior of the school winds in a spiral up a staircase with classrooms, library, eurythmy room, and cafeteria miraculously opening on either side like leaves up a stem.

By contrast, the Green Meadow School across the Hudson River in Spring Valley, New York, enjoys buildings designed specifically and generously for its needs. Rudolf Steiner gave many hints for a new approach to architecture, including the shapes of rooms, the colors of walls, and the questions to be taken into consideration when one is planning an environment for specific human activities. The buildings of the lower school and high school cluster around a central court. They are set in a wooded area, with meadows and playgrounds nearby. The school has grown gradually over the last twenty years and now serves over three hundred

children from kindergarten through twelfth grade from a wide community in Rockland County. At the present time, new teachers seem to join the school by a kind of osmosis. Individuals — sometimes parents — become interested, begin to help in the school, and gradually take on a commitment.

The Kimberton Farms School near Phoenixville, Pennsylvania, is likewise an entire school, K through 12. It is situated in rolling, rural countryside and serves hundreds of children from surrounding areas. There is some participation in a farm, as well as a strong sports program and a college preparatory emphasis. It is one of the few schools still, at this writing, with a dress code.

The New Morning School in Baltimore started a few years ago as a kindergarten, and now it has four grades. It is small and struggling and lives in a modest house on a property which serves another and unrelated educational effort. It is looking for its own place and space. Meanwhile, it is a lively frontier effort, courageously and resolutely undertaken by a group of young teachers, children, and parents. Some of the teachers have come from the Waldorf Institute at Adelphi University on Long Island. The school is under the protective caring of several experienced Waldorf teachers and artists, who visit regularly to help with suggestions and workshops. In this school I experienced vividly the reality that is present in all the schools: namely, the recognition that it is the individual persons who make the school. There is no institutional organization separate from the persons. The schools are a form of educational community-building, where individuals take on certain aspects of the creative work and where the overall guiding vision is shared in common. One is continually struck by "the power of the small" — the importance of each individual in bringing something special to the form of what is being made. The dialogue between individual initiative and community goals is a source of energy and renewal. Persons must develop a living trust in their creative intuition as it manifests in a social context, and at the same time they must develop an ear for the purposes of others in which they imaginatively participate and with which they make a practical connection. One must be prepared to trust the inspiration which may come to one, and develop confidence in the dialogue between what one might call "pioneering" impulses and "maintaining" or "conserving" impulses. One needs to be refreshed and at the same time deepened, able both to receive and to contain. The making of a Waldorf school is an example of a creative human activity which is both innovative and rooted. Is this not perhaps a useful image for the flowering of a social art which is an art of education, that it shall be both deeply rooted and at the same time be new and colorful and bearing fruit which will have its own fresh quality.

Steiner pointed to a spirit of trust in the human being that is the source of an art capable of creating the right forms for education and for the social order. In "The Free School and the Threefold Social Order" (as quoted in *Education towards Freedom*, edited by Joan and Siegfried Rudel), he said, "One should not ask: 'What does a person need to know and to be able to do for the existing social order?' but rather: 'What gifts does a person possess and how may these be developed in him?' Then it will be possible to bring to the social order ever new forces from each succeeding generation. Then this social order will always be alive with that which each fully developed individual brings with him into life, rather than that each succeeding generation is made to conform to the existing social organization" (p. 203).

I asked to visit the New Morning School because it was in the process of becoming a Waldorf school. I wanted to get a feel of the process, the struggle, the questions, the resources, the relation between faculty and parents, the physical work — carpentry, painting, landscaping — as well as all the other activities: preparing the noon meal, teaching, holding faculty meetings, greeting visitors, preparing school assemblies, and looking ahead to the festivals of Advent and Christmas. It was Halloween, and the teachers were putting on a play for the children: "Snow White and the Seven Dwarfs." In Steiner schools, teachers perform for the children, as well as the children for teachers and parents. It was a charming play, beautifully sung and acted, in a simple room crowded with children in Halloween costumes. The front of the room was the stage; the back was for the audience. A piano and one floodlight operated by a parent with a piece of cardboard for a dimmer were on one side. It was a terrific success and was followed by a Halloween party for the children prepared likewise by teachers and friends — with plenty of spook rooms and appropriate deviltry.

I felt the strength of New Morning School's beginning, by people who were not waiting for a beautiful building and a generous budget before they could offer something creative and substantial to the world. Gradually it may grow into the fullness of a school with kindergarten through twelfth grade, with a gym and auditorium, and money for lighting gelatins. But meanwhile, the spirit is finding its way into living activity.

In New Hampshire, the Pine Hill school now has kindergarten and six grades. Its sister school nearby, High Mowing, has for many years been a boarding high school, grades seven through twelve. The faculties of the two schools are joining in a vision of a middle school, grades seven through nine, which they will develop in common. The years of early puberty are crucial and an attempt will be made to

give this period a special attention and identity, which will nourish the children.

The Pine Hill School is pioneering a movement in this country among faculty to continue together their personal and interpersonal development with an approach developed by a European group called the Netherlands Pedagogical Institute. Members hold workshops which focus on trust, openness, and sharing. Though these goals resemble those of the "human potential movement" already strong in America, it is striking that the teachers are taking them on as part of faculty concern. Their sense of individual spiritual being and destiny tends to keep them free of a generalized model. It is not meant as a psychological technique, but as a spiritual practice which organically expands and strengthens individual warmth and imagination. Warmth of feeling can become moral will. Imagination can become mutual trust.

There is also a cluster of schools around Harlemville, New York, and Great Barrington, Massachusetts, in the western Berkshires. The Great Barrington Rudolf Steiner School (formerly Pumpkin Hollow School), the Hawthorne Valley School, and the Rudolf Steiner Farm School all have been gradually built through the combined efforts of parents, friends, teachers, and students, and each is at a different stage of growth toward K through 12. Each place has a special physical charm, and each consists of a growing community of loyal supporters.

The Farm School is a biodynamic farm and residential facility, which pioneers a new concept, integrating agriculture with the more usual curricular and artistic offerings. It is used by various Waldorf schools during the year. Students from New York City and elsewhere make periodic trips to the farm to experience the rhythms of life there. A resident farmer and assistants have developed a cheese-making industry, which sells large rounds of Swiss-style cheese to customers near and far. In the summer, children's camps are held, and the Farm School is used for conferences and festivals. It is available to any interested school (not just to Waldorf schools) for student projects in farming and nature study, and to other conference groups. There is also a land and community development center, Shelter Associates, which focuses on planned land use, housing, and real estate.

There are two Waldorf Schools in Chicago, one for normal children and another (the Esperanza School) for severely retarded children; and schools as well in Denver, Colorado; Washington D.C.; and Belmont, Massachusetts. Waldorf nurseries and kindergartens are appearing now in many places: Cincinnati, Ohio; Boca Raton, Florida; Eugene, Oregon; and Paonia, Colorado. A basic characteristic is evident even in these seedling schools, namely, that the relationship between adult and child is a real human connection.

In Detroit the Waldorf School is in a spacious building that looks like a vintage, brick country house. Inside are three floors of light and airy rooms, an auditorium with a stage, and a cafeteria, which surround a garden court and playground. Near Detroit is the Waldorf Institute of Mercy College, which is a center for teacher education and internship in special fields of early childhood education, curative (special) education, and Waldorf elementary and high school education; in addition it offers an orientation year and a major in Anthroposophical studies which is recognized for the bachelor's degree. Teacher preparation may lead to state certification. And the curative education course, offered in association with the Camphill and Esperanza schools, may meet the special education requirements of Pennsylvania, in affiliation with Westchester State College.

Two very developed Steiner schools exist in California: one in Sacramento (Fair Oaks) and one in Los Angeles (North Hollywood). There are several other smaller schools in Marin County, Sebastopol, Potter's Valley, Nevada City, and Santa Cruz. The Sacramento Waldorf School is housed in one-story buildings which were moved to its beautiful natural site and made over into California Spanish style with covered walkways. They are on a stretch of land along the American River, with generous surrounding fields, trails, swimming holes, and sites of historic Indian digs. A kindergarten building was built cooperatively and is a charmingly original organic form with shingled roofing in wavelike contours. This building is now the library, and a new kindergarten-nursery has been added to the campus. There is a biodynamic garden, and the gardener is a faculty member. Classroom space is adequate and forms a good base from which to plan expansion to include an auditorium, eurythmy room, and so forth. An art center has been recently developed in a large house which had been created on the property. It is called Meristem, and in it pottery, woodworking, graphics, spinning and weaving, and bookbinding will take place, with space for exhibits and talk sessions. Parents and teachers have worked on the building, and its stone walls and rotunda give it a unique flavor. Both the art center and the other school buildings were moved to the site when the property was bought, and they were worked on by school members over the summer. It is this quality of common purpose and cooperative activity that is especially striking in Waldorf schools. It engenders a noticeable spirit of cohesion and flexibility. Nothing is pre-established except the needs of the children, and the will of the parents and teachers. The rest they figure out together.

Highland Hall in Los Angeles is one of the oldest Waldorf schools and teacher training centers in America. Hermann von Baravalle, mathematics teacher in Steiner's original Stuttgart School, taught for many years at Highland Hall, and put

together useful pamphlets and teaching aids in math and physics. Werner Glas, founder of the Detroit Waldorf Institute, also taught for many years at Highland Hall. The school is in a residential, suburban area of North Hollywood, where there are still open fields. Its one-story buildings surround a central court. On one side is a garden on a sunny slope, where the children in the various grades plant and harvest during the growing season. The school has no hall of its own, and its assemblies are held in a modern church a block away. Highland Hall has a strong musical life, with exceptional development in recorder playing and orchestra.

A rich musical culture exists in the Waldorf School at Adelphi College in Garden City, Long Island. As in the Los Angeles school, this has developed through the presence of gifted teachers, as well as through an educational philosophy which stresses the importance of music, both in itself and as a companion to intellectual and scientific studies. Music is basic to human life, Rudolf Steiner emphasized. Life in its rhythms is intrinsically musical. Rhythm, interval, tone, polyphony — all affect our thinking capacities and our responses to many other subjects and experiences. In the Waldorf curriculum, music may be interwoven with other studies such as botany, geometry, and astronomy. "History through Music" is a course taught in eleventh grade. Singing as well as listening to music is stressed. The choral work at the Garden City school has been outstanding.

In this respect, Steiner urged that the college of teachers (the core group that governs the school) cooperate with the entire school community on behalf of the whole being of the child. No subject is more important or less important than any other, and all support one another. History, for example, is only successfully taught and understood by the children if they are having music as well, and are helped to develop a sense of *time*. Subjects which appeal almost exclusively to mental activity will risk leading to sleepiness if they are not accompanied by activities which involve the waking life of the body: handwork, writing, eurythmy, singing, playing music, or gymnastics.

Teachers not only work together, he said in his *Supplementary Course*, but actually work *for* one another.

It is good if we can in this way see the work of the School as a connected whole; for then, if anything shows itself to be out of order in a child, we shall make a point of seeing how we can cooperate with other teachers to put it right.

On such a basis, it will really become possible for us to give each other good advice. The history teacher, for instance, will discuss with the teacher for singing what measure could be taken to help some particular child. If we were to go about this with the intention of working out programs and elaborate schemes, no good would come of it. We

must first be able to see clearly how things are with the child in question, and then this insight will of itself give the right impulse for the discussion with our colleagues. Only so will the cooperation lead to a fruitful result.

And as you gradually acquire this wider outlook, you may be quite sure that when, for instance, a physics teacher notices something lacking in his pupils, it will in some circumstances occur to him to discuss with the singing teacher how things might be improved by special attention to the point in question in the singing lesson. The singing teacher himself will know best just what is necessary; at the same time he in turn will be thankful that his attention has been drawn to the lack in the child. In this way we shall arrive at a living cooperation throughout the College of Teachers. Working thus, we shall be taking the whole human being into consideration, and we shall find that one thing leads on to another. (Lecture 1, p. 9)

The concept of a school as a united, organic, interacting whole is an artistic one. And it arouses the same feeling for minute-by-minute involvement as life does: feeling the whole in every part. Being a part of a Waldorf school resembles a kind of choreography. Respect for the individual destinies of those whose lives are at stake in the school — parent, teacher, child — is the ground color of this human art.

The teacher's day begins and ends with an inner picturing of the children in his/her care. S/he takes them into daily meditation, for review and for preparation. It is through getting to know the language of the body and the physical world that the teacher speaks to the child's spirit.

Steiner's *Supplementary Course* continues:

We have to help the child bring together in thought the soul-and-spirit and the bodily functions; he has to learn to think of them *together*. We reject utterly that most pernicious modern way of thinking, where the things of soul-and-spirit are perpetually explained without any reference to the body, and then on the other hand — as a perfectly natural corollary — all that has to do with the body is spoken of in grossly material terms. In reality, neither the one nor the other exists as such; what we have in life is the confluence of the two. (Lecture 1, p. 9)

Steiner goes on in this lecture to speak about how unabstract life is. Teachers must honor a practical and objective knowledge of people, of how people are "built up and organized." They must make a habit of observing the children in physical detail. They must be pioneers in seeing the physical person imaginatively. This they can do also, he suggests, when they connect the different subjects: history with anatomy, for example; or geography with art. Certain subjects risk being taught sheerly as concepts, others as grossly material. Weaving things together will bring out the underlying life quality which they share.

He speaks specifically of studying the liver and the later history of Egypt at the same time. I might have found this somewhat outlandish if I had not been forever impressed by my visit to the British Museum ten years ago, where the most amazing thing I saw was a clay liver! Made in Egypt three thousand years ago! Covered in part with sacred writing which had to do with healing practices! At the time, I saw in this a most remarkable, interdisciplinary event, uniting clay sculpture, anatomy, medicine, and religion. This image has remained with me vividly as an inspiration of how radical our perceptions must be prepared to be, how open we must be to what we have yet to learn.

When we begin to see the inner connections of life throughout history, we can experience its outer forms as an imaginative script. A sense of the interiority of outer forms is developing today through new age science. Teachers in Steiner schools study continuously to see with this double eye. It is the seer's eye. The artist's eye. The psychologist's eye. The holistic scientist's eye. It is an evolving human sight — an evolving human consciousness — as we enter the early stages of a new epoch. Steiner called it the Fifth Post-Atlantean Epoch, the age of the Consciousness Soul. Many in America, similarly led by the spirit of the age, call it "new age consciousness," or "holistic breakthrough." Once the connections begin to rise into consciousness, the new, hard work begins, starting from a different point and proceeding to a different end. We, like Waldorf teachers, begin to see the physical world as a script and to sense a "living word." We begin to create a new map, find our way in a new landscape, and build a new world with a deepened sense of connections. This sense of need for a new work in a new time is strong in many people in America now among young students and onward-growing adults.

I see the Steiner schools as seedbeds in which a group of devoted gardeners have been sowing, nurturing, and cultivating a young, living form. This form, tender still, is taking root and growing slowly and steadily, strengthening in stalk and leaf. It can be set out now in human gardens here and there, prudently, carefully, being cared for and protected as it grows strong to bear fruit, as more gardeners come forward ready to tend it. Gardening is hard practical work, full of risks from weather and pests. But gardeners we must be, for we live by what comes from the earth. Food in our time has turned toxic. It is artifically preserved and colored, to last and look good, but it makes us sick. A cycle seems to be ending. New food is being grown on a very modest scale. It can never be mass produced and machine produced. Each human being will need to take part in the sowing, cultivating, and harvesting. There is no substitute for the real thing.

It may well be that the impuises for education which Steiner pioneered are part

of a larger world picture. It may well be that streams from the same source will gradually come in touch and help one another. Rudolf Steiner saw universalism as the direction human beings will take in the future if they decide to live. He saw how necessary it is to come to truth from a variety of perspectives. Pierre Teilhard de Chardin saw it too. Sri Aurobindo saw it. The American Indians saw it. The African Bushmen saw it. Rudolf Steiner was personally called to a perspective that lives in the tradition of concern for the physical world as the fabric of soul and spirit. He was one of the first in our century to experience consciously the human being as an integral member of earth and universe. And, more specifically, he saw how the human spirit-being is part of a larger spiritual world. Part of the teacher's work is to receive in the right way what flows from that world. It flows through the physical processes in child, adult, and nature.

This means starting anew from perception rather than from outgrown dogmas of contemporary culture. This moment of new life comes after a moment of dying. The new is not easily won. Perhaps this is part of what Steiner experienced in the mystery of Jesus Christ's death and resurrection on Golgotha — a mystery he was willing to take seriously in the history of human evolution — seeing into it as the wellspring of human freedom to come. If we only die, there is no freedom. If we only live, there is no freedom. If we enter the paradox, and die into a new quality of life, live into a new quality of death — well, there may be some imagination in that! Such an artistic and creative approach has an element of the unknown in it, the seed-force of creativity; it isn't already packaged. It has its source in our hands and feet and diaphragm and liver and larynx, which have their source in water and earth and air and fire, which have their source in moon and sun and saturn, which have their source in — movement and music perhaps? The point is that we may now choose to live in artistic risk, in an ongoing genesis, coworkers in an effort which brings people together because they want to build something together that feels real. They want to feel alive and original in their wills and connected in purpose, warm in human relations, and clear in their way of "seeing into." If we learn how to learn, learn how to see, we can perhaps accommodate the changing information that comes toward us.

This way of "seeing into" is the parascience of our time, bearing the future within it. Because it is a science, it requires both data and theory. Americans working at the frontiers of brain research, biofeedback, and humanistic psychology are beginning to sense the emergence of a new world-view: "the search for what it means to be human." Marilyn Ferguson, editor of *Brain/Mind Bulletin, Frontiers of Research, Theory and Practice*, wrote in the July 3, 1978 issue:

Scientific discoveries in avant-garde brain research, consciousness research, physics, parapsychology and molecular biology are converging toward a radical new world-view. At the same time, the most innovative American researchers warn that the politics of science is frustrating the most exciting adventure of this century or any other: the search for what it means to be human. Large theories are desperately in order. . . .

For all our political freedom, we are inhibiting intellectual freedom and creativity among scientists. Only a few have the courage to think broadly . . . and fewer yet get adequate funding for critical research.

We will have no one to blame but ourselves if we fail to use the most potent psychic 'weapon' around —

Imagination. (p. 2)

This growing awareness of the need for a "radical new world-view" and for a holistic approach makes a look at Rudolf Steiner/Waldorf education in America especially timely. The wholeness of the child and of the teacher is its concern. A world-view stands behind the methods and curriculum and lives in the consciousness of the teachers. It is a view which engenders the holistic approach to the human being and an interdisciplinary approach to education. The entire elementary school experience is specifically grounded in imagination.

The physical age and development of the child is the key to where s/he stands. In first grade, the normal child is in a state of mythic consciousness, ready to live in the pictures of fairy stories; and to come to the skills of writing and reading through an imaginative picturing of the letters — as indeed the human being did historically. The evolution of consciousness is followed through the eight grades, until, at graduation, the student is crossing the threshold of puberty into a new independence in thinking and into a modern consciousness. More is said about this sequence in the chapters that follow.

In high school, the experiences which have been introduced in the lower grades through imaginative pictures, drama, and feeling, are reintroduced at another depth and with a different attention to detail in order to awaken powers of objectivity and judgment. As I have said, all the way through the schooling, the emphasis is upon the physical world of living experience that surrounds us. Therefore it is science that is the foundation. And it is science unestranged from imagination. The Steiner schools are sometimes thought to be art schools since there is so much emphasis upon "education as an art" and upon the artistic element of all knowledge. But the fact is that the education is a balance of thinking, feeling, and willing. In the high schools, chemistry, physics, botany, biology, zoology, mathematics, and geometry are taught and the workbooks of the children continue to show

an exceptional integration of information and personal learning. They draw and paint the steam engine, the gas engine, the action of sulphur, the metamorphosis of the plant, maps of the sea and land, animal studies, and the inner organs of the human being. Mathematics and geometry lead not only to capacities for thinking, but to surveyor's maps and projections of planetary orbits and artistic modeling. Connections between projective geometry and plant growth are rendered in drawings and in watercolor plates.

Subjects are taught by specialist teachers. Each of the four years a different period of history and of literature is studied. Foreign languages, handcrafts, eurythmy, music, and painting continue to be developed. In the ninth grade the students study history through art; in the tenth, history through poetry; in the eleventh, history through music; in the twelfth, history through architecture. Again through the making of their own books, these rich experiences are internalized and represented with increasing skill: in painting, in writing, in musical notation, and in architectural sketching and rendering. In the eleventh grade the study of medieval history is accompanied by the study of the Arthurian legends and the Grail legend, the story of Parsifal. It is the purpose of the curriculum to surround the students with what they need for a particular age and stage of growth. The story of Parsifal is a journey toward individual consciousness and an inner sense of selfhood. The seventeen-year-olds, who tend to carry their new sense of themselves like a secret, appreciate sharing their own awakening with Parsifal's.

The high school class, many of whom have come through the school together from first grade, remains intact under a faculty sponsor, who accompanies them through the four years.

The mighty questions of adolescence and the education proper to it will not be answered in this book. Suffice it to say that attention is given continually by the teachers to the stages of the young people's development, and their changing needs, both spoken and unspoken. The schooling is meant to speak to their questions and to their ideals. More about the curriculum of this high school period is presented in the beautifully illustrated book *Education Towards Freedom*, edited by Joan and Siegfried Rudel, and thoughtfully outlined by A. C. Harwood in *Recovery of Man in Childhood*.

What is striking to observe is the trust that can exist between students and teachers: mutual respect: mutual growth. The children who begin in school by learning chiefly by imitation and then by trusting their teacher, graduate from high school as young adults prepared to think for themselves and judge for themselves,

39

with broad interests and cultural background. The young people relate to their teachers now not as guides or authorities but as friends. These steps are consciously fostered by the teachers in response to the students' development.

High school students (especially the twelfth grade) share responsibility for the welfare of the school; they tend to be proud of it and concerned for it, and take initiative with regard to it. They raise money for field trips, by putting on dinners, bazaars, and plays. The culminating cultural event is a senior play, which is chosen with care for its connection to what they have been studying and what they are interested in. The production makes use of their talents and skills — which are considerable by this time — in painting sets, singing, acting, playing instruments, doing eurythmy, and bringing into their characterizations a depth of human understanding.

And what happens to them after high school? Some go on to college, some don't. Their destinies may not be that much different from other young people, though the way they experience their lives may be very different. And their view of the options open to them may be wider. Their imagination for inventiveness may be stronger. I quote from the 1978 annual report of High Mowing School, located in New Hampshire:

> Every American Waldorf school that has grown up and developed a high school has certainly been properly concerned, probably somewhat anxious, possibly even over-anxious, about college preparation. It has been generally assumed that all, or nearly all, graduates would apply to college and go. As the first Waldorf high school in America, this was true of High Mowing. But no longer. Parental and student expectations have changed for many in recent years. We do find that most eventually go on to higher education, but even some very capable students want to wait until they know more clearly their purpose. It is usually the parents who are more likely to be stuck in convention. Why should we as Waldorf teachers join them there? Our students pursue very individual paths.

Of the fourteen seniors, one was going to advanced riding school and then to college, one to a weaving school in Nepal, one to the Rhode Island School of Design, one to Smith College (with $6,000 in financial aid), two to work in their fathers' businesses, one to Johnson and Wales College, one to a weaving apprenticeship, one to a masonry apprenticeship, one to Carleton State College, one to work in construction, one to the Rochester Institute of Technology, one to the University of South Florida, and one to the University of Vermont.

Waldorf methods and curriculum may be used by teachers in any school, public or private. It was never Steiner's intention to reproduce in quantity the original

model of Waldorf schools, but rather to develop a pilot approach to education which could nourish and fertilize ongoing efforts anywhere and everywhere. But while there is a Waldorf method and curriculum, broadly speaking, which can be widely and flexibly applied, there is also an inner commitment by Waldorf teachers to the philosophy out of which the curriculum arises. This is not a philosophy of dogmas, but a path of learning which tries to see the human being and the earth and the universe as interconnected inside and out. It asks for openmindedness and some new capacities in perception. What stands behind the methods and curriculum and how it animates the schooling will be the focus of succeeding chapters. We are in a school of life all the time. New forms are developing not only for normal children and teachers K through 12, but for the handicapped and the aging. Out of those forms come new approaches for our human work in agriculture, industry, medicine, art, and economics. The schooling of the child is a part of the reschooling of society.

The Education of the Child:
A Spiritual Anatomy and Basic Text

The education of the child follows seven-year rhythms, which are based on Steiner's observations of childhood development. He explains this foundation of education in his book *The Education of the Child in the Light of Anthroposophy*. It was prepared for publication in 1909 after he had given the material in various lectures. A paperback translation by George and Mary Adams was published in 1975 (all citations refer to this edition). It is a good place to start to examine what stands behind the Waldorf schools.

Before I attempt to steer a course through the content of the book, we need to pause to take a look at the kind of vocabulary Steiner uses and the point of view from which he is speaking. Work in the schools is based upon a way of seeing the world: not only *what* is seen, but *how* it is seen.

He roots education, as he does all of life, in a "spiritual scientific" approach. When I first read this book, the language sounded abstract, theoretical, and dogmatic. I am no enemy to abstraction, theory, or dogma; and I am familiar with the tone of German language and thought; and there was enough surprising content to challenge me even at the beginning — so I pressed on, letting first impressions settle, and coming back for more when I was ready. All Steiner asks is an open mind, common sense, and testing through experience.

Since Steiner claims to know things differently and more deeply and truly than other educators, we must look briefly at his theory of knowledge, how knowing takes place. What do we know about the child, and how do we know it? How do we look at the child, how do we see him/her? What we see will depend upon how we look. If we want to see the whole child, then we must be able to understand him/her inside and out. How can we see something inside and out? Only by a way of looking that combines insideness and outsideness, an eye for inner form and

outer form, for the spirit in physical matter. This is Anthroposophy. I think the reader has to understand this and accept it with an open mind if s/he wants to grasp the basis of the education. Steiner claims this is not just one more personal philosophy; he claims it is the new science proper for the new consciousness of our age, and as such, offers to all people a common knowledge. He speaks of a transformation in knowledge which heralds a new epoch in history. To understand him, we must follow the images, as we do in poetry, art, and science. Let the images speak, and see them develop out of one another, often in unpredictable ways. He says that we will not be able to see clearly unless we cultivate certain moral qualities. Cognition and reverence for life are interdependent.

"Spiritual science" is the translation of the German word "Geisteswissenschaft." We don't have words like that in English, words that are formed by putting two different ideas together in a way that makes a new, third idea. In this instance "knowledge" (Wissenschaft) is moved into union with "spirit" (Geist). "Spirit" is different from "intellect." It is the very being of man, and of universe. It is not a tool. This is not intellectual science, but spiritual science, whole and living. Spirit uses intellect and goes beyond it. Spiritual science requires the union of inner perception (spiritual) and objectivity (science).

It should be noted that "Geisteswissenschaft" is the name given to the humanities in German universities. These are the studies related to the human spirit, as it is expressed in literature, philosophy, and so forth. The special meaning given to this term by Steiner claims for that aspect of knowledge having to do with the spirit an objectivity potentially as disciplined as that of natural science.

Inner perception means a perception into the underlying forces, forms, movements, and substances which are invisible to the naked eye, but which constitute the reality of what we think of as the human being and nature. Insight and intuition are ways of knowing; so too are imagination and inspiration. We practice introspection to observe patterns of feeling in ourselves. Feelings and states of mind and motivations are difficult to observe and measure physically. They require a certain kind of eye and understanding, a certain spirit in the observer. This spirit depends on the development of spiritual organs, a process Steiner called initiation.

In the new research in physics, there is a recognition that the observer is part of the observation. Measurement will always require a measurer, and the point of view of the measurer will be an element in the results. This insight has helped to develop a new consciousness which is ready to grow beyond the former division between object and subject, objective and subjective, and to see that one world extends through both. Spirit, insight, and intuition are objective facts, distributed

through the body of the world. The visible objective world is a form of spiritual activity. It comes about as a result of invisible movements and forces, which, because they are invisible and not detectable by our ordinary senses, are called supersensible or meta-sensory. Spiritual science is the means of fathoming the perceptions of this new consciousness. It is not mediumistic or trancelike. It is disciplined consciousness in what Steiner calls "higher" forms, which anyone who wants to put in the effort may develop. Some people have an easier time of it than others, which happens in every kind of learning. Steiner had a gift for supersensible perception, which he was aware of early in his childhood. He had the task then of integrating this perception into the disciplines of mathematics, natural science, and philosophy, in which he majored at the University of Rostock, receiving his doctorate in 1891.

One of his problems was to find people who would take seriously and share with him the wish to unite meta-sensory perception with scientific objectivity. He found friends among artists and writers, and he edited a Berlin literary review. More importantly, he was asked to edit the scientific writings of Goethe for the Weimar edition, and in Goethe, the poet-scientist-statesman, he found his guide. Goethe's theory of perception, his discovery of the archetypal plant, and the metamorphosis of the plant were touchstones for young Steiner. He wrote two books about Goethe, focusing on his world conception and his theory of knowledge. Here he found confirmation of a path of scientific knowledge which was also connected with the powers of intuition and envisioning of a poet-artist. Early on, then, Steiner was free of a model which divides artist, scientist, and seer.

The German title of his own first book is, in English, *Philosophy of Freedom*, but it is sometimes translated (with Steiner's approval) into English as *Philosophy of Spiritual Activity*. It is an interesting equation: freedom = spiritual activity. And this is the argument of the book. Our given nature is not free. It can become free through inner work. By inner activity one can go beyond the ordinary limitations of consciousness and thinking. The move from limited sense perception and conditioned thinking to the "freedom" of supersensible perception and "body-free" thinking was called "initiation" or "crossing the threshold." The crossing is fraught with egotistic temptations, unless moral character is achieved as well.

Steiner's activity was meant to help to free Western epistemology (the theory of knowledge) from a dualism of science and faith. Immanual Kant, for example, who was a powerful source for modern philosophy, had spoken in great detail of a conditioning of human thinking by certain categories: space, time, causality. According to Kant, the only path beyond these categories was by way of faith, for knowl-

edge was unable to pass beyond sensory patterns or thinking based upon them. So there was the dilemma: man, discontented with his prison of bounded thinking, could only gain a sense of freedom and dignity through religious faith. And this way of crossing the threshold was unacceptable to people who, like Steiner, could not live in two different worlds: one of science and one of faith. The split was especially unconvincing to a person like Steiner. Knowledge came to him free of boundary. He tested and researched the territory of knowledge for twenty years before he began to talk about it publicly.

It is not surprising that Steiner was recognized and esteemed for his determination to reunify science, art, and religion without sacrificing the gains made by modern science. The Theosophical Society, which had been founded by Madame Blavatsky to foster spiritual developments, gave him an opportunity to speak and work, and in 1902 he became head of the German section in Berlin. However, he took exception to the trend of the Theosophical Society that one-sidedly emphasized Eastern religious thought. And when the Theosophists decided to recognize a young Indian boy, Krishnamurti, as the second coming of Christ, Steiner resigned. His integrity as an occult scientist, i.e., a scientist who was determined to open his perception to the worlds beyond ordinary sense perception, led him to the founding of Anthroposophy. In Anthroposophy, the histories of East and West show exciting interconnections in the evolution of consciousness.

The path to higher knowledge is also a moral path; it is a path of the whole person. Steiner continually cautions about the wrong and right uses of esoteric knowledge. Egotistical motivation disfigures and frustrates the movement of spirit. He also discovered that the inner path of meditation which he followed brought him to an encounter with daimonic aspects of himself. His meeting with the Guardian of the Threshold is like C. G. Jung's meeting (as described in *Memories, Dreams, Reflections*) with the shadow in his own long exploration of the unconscious. The moment comes when personal evil must be faced and embraced. Until that embrace, until the "loving of the enemy" is suffered through, one cannot meet what Steiner calls the Second Guardian. The Second Guardian is the Christ Being. For Jung, as he states in *Aion*, it is the Self, for which Christ is the archetype in our culture.

We will become educated to the extent that we combine our personal inner discipline and development with our practical knowledge. If we are greedy for knowledge and techniques without undertaking at the same time a personal growth and purification, results will be shallow.

In *The Education of the Child*, Steiner begins:

Life in its entirety is like a plant. The plant contains not only what it offers to external life; it also holds a future state within its hidden depths. One who has before him a plant only just in leaf, knows very well that after some time there will be flowers and fruit also on the leaf-bearing stem. In its hidden depths the plant already contains the flowers and fruit in embryo; yet by mere investigation of what the plant now offers to external vision, how should one ever tell what these new organs will look like? This can only be told by one who has learnt to know the very nature and being of the plant.

So, too, the whole of human life contains within it the germs of its own future; but if we are to tell anything about this future, we must first penetrate into the hidden nature of the human being. And this our age is little inclined to do. It concerns itself with the things that appear on the surface, and thinks it is treading on unsafe ground if called upon to penetrate to what escapes external observation.

In the case of the plant the matter is certainly more simple. We know that others like it have again and again borne fruit before. Human life is present only once; the flowers it will bear in the future have never yet been there. Yet they are present within man in the embryo, even as the flowers are present in a plant that is still only in leaf. And there is a possibility of saying something about man's future, if once we penetrate beneath the surface of human nature to its real essence and being. It is only when fertilized by this deep penetration into human life, that the various ideas of reform current in the present age can become fruitful and practical. (pp. 6–7)

He goes on to say that if one has a true knowledge of life, it is out of life itself that one's ideas for doing and making will come. There will be no arbitrary programs drawn up, but only those which come from present fundamental laws of life.

The spiritual investigator will therefore of necessity respect existing things. However great the need for improvement he may find in them, he will not fail to see, in existing things themselves, the embryo of the future. At the same time, he knows that in all things "becoming" there must be growth and evolution. Hence he will perceive in the present the seeds of transformation and of growth. He invents no programmes; he reads them out of what is there. What he thus reads becomes in a certain sense itself a programme, for it bears in it the essence of development. For this very reason an anthroposophical insight into the being of a man must provide the most fruitful and the most practical means for the solution of the urgent questions of modern life.

In the following pages we shall endeavour to prove this for one particular question — the question of Education. We shall not set up demands nor programmes, but simply describe the child-nature. From the nature of the growing and evolving human being, the proper point of view for Education will, as it were, spontaneously result. (p. 8)

I quote at this length from Steiner in order to indicate the form and flow of his thinking. He starts at the beginning. He tells us his basic observations and premises. He proceeds by letting one idea (or Form) grow out of the preceeding; the picture builds up organically. When I first began to read Steiner on education, I

was at a time in my life when I had had enough of high hopes and enthusiasm as a basis for education, and enough of reaction *against* something. In 1964 I wrote in *Centering*:

I want to know why a child is sent to school at all. Why at one age rather than another. Why s/he is taught one subject now and another later on. And I don't want to be told that it is to keep up with an enemy or that it is legally required or that it's what an expert recommends. I want to know how it gets that way, in the enemy's or the law's or expert's mind. I am not satisfied with opportunism or experiment as a rationale of curriculum. I want to know what needs (whose needs) are being served by doing things one way rather than another, and what makes anybody think so. I want to know what happens to the artist who lives naturally in a child's responsiveness to rhythm and tone and color and story, what happens to the child in man. I want to know why so many grownups who are smart in school blow their brains out in middle age, or rely on anxiety depressants. I want the whole story from beginning to end. There are answers to these questions. (p. 100)

We don't know all the answers, not even Steiner knew all the answers, but he looked for them in ways that diverge from the materialism of our colleges of education or from the piety of parochial schools. His approach is worth looking into. A good way to estimate the value of a point of view is to look to see what fruit it bears. A directory of Steiner schools in America may be found in the back of this book.

It is not enough to claim a generous concern for the harmonious development of all the powers and talents in the child. Steiner's *Education of the Child* says these phrases are not false, they just aren't worth much when you are trying to plan what to do. They are as useless, he says, as it would be to say of a machine that all its parts must be in harmonious working order. You still have to know how to get the thing to go!

To work a machine, you must approach it, not with phrases and truisms, but with real and detailed knowledge. So for the art of education it is a knowledge of the members of man's being and of their several developments which is important. We must know on what part of the human being we have especially to work at a certain age, and how we can work upon it in the proper way. There is of course no doubt that a truly realistic art of education, such as is here indicated, will only slowly make its way. This lies indeed in the whole mentality of our age, which will long continue to regard the facts of the spiritual world as the vapourings of imagination run wild, while it takes vague and altogether unreal phrases for the result of a realistic way of thinking. Here, however, we shall unreservedly describe what will in time to come be a matter of common knowledge, though many today may still regard it as a figment of the mind. (p. 23)

47

Certainly today there is more willingness to consider education in these terms. The number of Steiner schools is growing, and the teacher training centers have tripled in capacity. It's a tough, long road of insight and transformation, but there are entrances all along the way, and one can find one's own place and one's own level in the ongoing stream. The goal is to do the work of the world, not to bliss out. The inner form of man evolves toward ethical individualism, freedom, responsibility for one's own decisions, and conscience for the welfare of the earth and the people on it. Renewal of art, science, and religion is part of the impulse. And a personal sense of participating in a community of the "quick and the dead" slowly grows.

Steiner observes in the human being four different "organizations" or "bodies." It is upon these that the educator works in specific ways at specific times. The unfolding, or birth, of these bodies is the basis of the seven-year rhythm, which I read about in that first fascinating brochure. It is the nature of the unfolding human being which stands behind the curriculum and methodology.

The first of the four bodies to be born is the "physical body." When we are born as babies, we make our physical entrance. Other aspects of ourselves are still protected as our physical bodies had been in our mother's womb. We have our physical bodies in common with the whole of the mineral kingdom. *Education of the Child* states, "The 'Physical Body' . . . brings the substances into mixture, combination, form, and dissolution by the same laws as are at work in the same substances in the mineral world as well" (p. 9).

Over and above the physical body, there is a second essential principle in man. It is the organization of his life forces, called "life-body" or "etheric body." Steiner says it is similar to what was called the "vital force" in earlier times. It cannot be observed by ordinary senses, but can be seen by those who have developed the proper organs of perception. He says that "there are many worlds around man, and man can perceive them if only he develops the necessary organs." To deny these worlds is to be like "a blind man who rejects the statements of seeing people as lying outside the possibility of human knowledge" (p. 10).

The human being has this etheric or life-body in common with plants and animals. "The etheric body is a force-form; it consists of active forces, and not of matter" (pp. 13–14). This life-body works in a formative way on the substances and forces of the physical body, and brings about the phenomena of growth, reproduction, and inner movement of saps and fluids. It is the builder and moulder of the physical body, "its inhabitant and architect." In the course of development, it may become the carrier of habit, memory, character, temperament, and thought. The

birth of the life-body occurs with the change of teeth, usually about the seventh year. Second dentition indicates the completion of certain tasks and the release of etheric forces for imaginative activity.

The third member of the human being is what is called the "sentient" or "astral body." "It is the vehicle of pain and pleasure, of impulse, craving, passion, and the like — all of which are absent in a creature consisting only of physical and etheric bodies" (p. 12). It is the body of sensation. Steiner says that an organism can be said to have sensation only if it *experiences* the impression in its inner life, that is to say, if there is a kind of inward reflection of the outer stimulus. Plants do not have this kind of sensation, he says, though they may show symptoms of reaction to stimulus. "The astral body is a figure of inwardly moving, coloured, luminous pictures" (p. 14).

The fourth member of the human being is the vehicle of the human ego, the human "I." "In designating himself as 'I,' man has to name himself within himself. A being who can say 'I' to himself is a world in himself. Those religions which are founded on spiritual knowledge have always had a feeling for this truth. Hence they have said: With the 'I,' the 'God' — who in the lower creatures reveals himself only from without, in the phenomena of the surrounding world — begins to speak from within" (p. 14). The "body of the ego" is the bearer of this faculty of saying "I."

The body of the ego is like a Creator within each person. Its special task is to work creatively on the other members of our nature. For example, as the ego works upon the etheric or life-body, the life-body becomes transformed. Originally it is simply the vehicle of the forces of growth and reproduction. It becomes, through the work of the ego upon it, the vehicle of our habits, character, temperament, and memory. Likewise with the astral body: its impulses, desires, passions are originally only those stimulated by external nature. As the ego works upon this body, wishes and desires change; sensations of pleasure and pain change. The contemplation of great works of art influences the etheric body. Religion is also a powerful means for the development of the etheric body. Conscience is born.

Education of the Child stresses an important element:

> It is on these four members of the human being that the educator works. Hence, if we desire to work in the right way, we must investigate the nature of these parts of man. It must not be imagined that they develop uniformly in the human being, so that at any given point in his life — the moment of birth, for example — they are all equally well developed. This is not the case; their development takes place differently in the different ages of man's life. The right foundation for education, and for teaching also, consists in a knowledge of these laws of development of human nature. (p. 19)

49

Steiner speaks of the "three births of the human being." The first one is the birth of the physical body, which we think of as the birth of the infant. The second one is the birth of the etheric body at the second growth of teeth. The third is the birth of the astral body at puberty. During approximately the first seven years of the child's life, the physical body is forming its organs. It is the physical environment which is of crucial importance at this period. Not only the environment of shapes and colors and so forth, but the environment of behavior. The child drinks everything in. Its inner being imitates its surroundings. The power of example teaches.

The best kind of toys and games allow for fantasy and imagination. "The work of the imagination moulds and builds the forms of the brain. The brain unfolds as the muscles of the hand unfold when they do the work for which they are fitted. Give the child the so-called pretty doll, and the brain has nothing more to do. Instead of unfolding, it becomes stunted and dried up." Better, Steiner says, to "make a doll for a child by folding up an old napkin, making two corners into legs, the other two corners into arms, a knot for the head, and painting eyes, nose and mouth with blots of ink" (p. 26). He recommends toys and picture books with movable figures.

The colors which surround the small child should be selected with the awareness that the complementary color is created within the child, and it is the one by which the child will be influenced. An excitable child should be dressed in red; s/he will inwardly create the opposite, green; and this activity of creating green has a calming effect.

Pleasure and delight, Steiner says in *Education of the Child,* are the forces which most rightly quicken and call forth the physical forms of the organs. At the same time, he speaks of bringing the child "into a right relationship, physically" with things like food. Teachers who have a happy look and manner, an honest unaffected love, will fill the physical environment with warmth. Warmth "may literally be said to 'hatch out' the forms of the physical organs" (p. 28).

The value of children's songs is stressed. Their rhythm and beauty of sound are more important than their meaning. Also the wish of the child to paint and to scribble written signs and letters long before s/he understands them should be understood as a deep will to imitate. Dancing movements in musical rhythm have a powerful influence in building up the physical organs.

And so when the young child comes to kindergarten, s/he tends to imitate what is alive in the atmosphere. It becomes a question then of awareness on the part of the teachers of what they will offer and how, and of acute self-awareness of how their inner feelings are influencing the children unconsciously. Although I have not come across Steiner's views, my own opinion is that feelings should be openly

shared with children, so that they will know from the beginning that their feelings are respected and do not need to be hidden or blocked.

In the schools I have observed, I have noticed that there is a marked sense of form in beginning the day and ending it. Kids don't just straggle in or storm out. There is always a beginning ritual of some sort. With the tiny children, it is often sitting in a circle, lighting a candle, holding hands, saying a verse, singing songs, or acting out a story. After the circle, there is play time and watercolor painting. Then snacks. Then outdoor play. Maybe a walk or work in the garden. Or a puppet show on a rainy day. Then lunch, and a nap. And a final circle after playtime.

In a third grade class which I visited recently, the young man teacher stood at the door at the end of the day and shook each child's hand, said goodbye to the child by name, and the child, clasping the hand, said the farewell. Goodbye Neil, goodbye Mr. Levin. Goodbye Amy, goodbye Mr. Levin. Goodbye Matthew, goodbye Mr. Levin. A moment's pause at the doorway. A contact, a greeting, an affirmation of identity and affectionate respect; an acknowledgment of meaningful time spent together. I was touched by it. And it seemed to be felt and meant by the children as well as by Paul Levin. Not staged nor artificial, though oddly courteous in our culture. It bespoke that special kind of dignity that children have, even with all their pettiness and disorder.

Education of the elementary school years is based not on intellect but on imagination and inner picturing. Steiner stressed in *Education of the Child* that "it is not abstract ideas that have an influence on the developing etheric body, but living pictures that are seen and comprehended inwardly" (p. 32). The child's memory, which is connected with the etheric body, is of course present, but not yet ready for external stimulation. It is simply to be nourished but not overdeveloped by external measures during this period. It will then unfold freely and of its own accord. Likewise the powers of thought and judgment which will waken consciously at puberty, must be allowed to unfold without pressure during these earlier years.

With the change of teeth, when the etheric body lays aside its outer etheric envelope, there begins the time when the etheric body can be worked upon by education from without. We must be quite clear what it is that can work upon the etheric body from without. The formation and growth of the etheric body means the moulding and developing of the inclinations and habits, of the conscience, the character, the memory and temperament. The etheric body is worked upon through pictures and examples — i.e. by carefully guiding the imagination of the child. As before the age of seven we have to give the child the actual physical pattern for him to copy, so between the time of the change of teeth and puberty, we must bring into his environment things with the right inner meaning and value. For it is from the inner meaning and value of things that the

51

growing child will now take guidance. Whatever is fraught with a deep meaning that works through pictures and allegories, is the right thing for these years. The etheric body will unfold its forces if the well-ordered imagination is allowed to take guidance from the inner meaning it discovers for itself in pictures and allegories — whether seen in real life or communicated to the mind. It is not abstract conceptions that work in the right way on the growing etheric body, but rather what is seen and perceived — not indeed with the outward senses, but with the eye of the mind. This seeing and perceiving is the right means of education for these years. (pp. 29–30)

Here we can recognize what we naturally observe to be the child's power of fantasy. It is upon this ground of imagination, that the later powers of intellect and judgment and critical thinking will be based. They will be rooted in feeling and imagination. It is important to realize that in fact the intelligence is being educated all the time! In early childhood, intelligence lives in the will. It metamorphoses then into intelligence of feeling, and again metamorphoses and awakes as capacity for rational judgment.

Another characteristic of children of these years, which Steiner spells out in this book and stresses as essential, is the wish of the children to love and respect their teachers. "Veneration and reverence are forces whereby the etheric body grows in the right way. . . . Where reverence is lacking, the living forces of the etheric body are stunted in their growth" (p. 31). This relationship between teacher and child is expressed in Steiner schools by having the same teacher accompany the child through the eight years of elementary schooling. The teacher is friend and companion to growth. This long-lasting daily rapport nourishes the soul of both teacher and pupil. It doesn't mean an eight-year-long honeymoon. It does mean, from one point of view, faithful commitment and working through of the relationship. From another point of view, it may feel like a trap. On the whole, it seems to work well. Otherwise, no doubt, it would have been reconsidered as a method. Of course the children have several other teachers in addition to their Main Lesson teacher who accompanies them through the years. The special subject teachers — of foreign languages, handwork, gymnastics, music, and eurythmy — bring a flow of variety to the child's contacts.

"Authority" is the word Steiner uses to describe the role of the teacher for the student during these years. "What the child sees directly in his educators, with inner perception, must become for him authority — not authority compelled by force, but one that he accepts naturally without question. By it he will build up his conscience, habits and inclinations; by it he will bring his temperament into an ordered path. He will look out upon the things of the world as it were through its eyes. Those beautiful words of the poet, 'Every man must choose his hero, in

whose footsteps he will tread as he carves out his path to the heights of Olympus,' have especial meaning for this time of life" (pp. 30–31).

The word "authority" is not easy to get a clear understanding of. It tends to sound pompous and schoolteacherish. It suggests another adult expectation forced on children: "Do it because I say so; I'm in charge here." As Steiner says, tremendous tact must be used in the way all things are done with children, or just the opposite effect will ensue rather than the one hoped for. I have wrestled with Steiner's idea of authority, and I believe he means it in a fairly simple way. Indeed it reflects the children's natural desire to love and believe in their adult friends, and one friend in particular to whom they entrust their young lives. They naturally wish to believe that the teacher knows more than they do, has life wisdom from experience, has exciting stories to tell and skills to share, and will not deceive them. They want to make a connection between what is good and what is true. And they want to feel that a human being is capable of being both good and true.

The development of this feeling in childhood, directed to a significant adult, seems to help us to develop that feeling later on about ourselves, to develop a sense of inner authority, to know what it is to be a good friend to ourselves and to others, and to be a truthful observer.

I see it as significant that teachers should be asked to regard themselves as trustworthy, sensitive, and loyal. This seems to me to restore the teachers' sense of inner dignity and moral worth, and to make it absolutely clear from the beginning that they are neither information machines nor policemen. They give themselves as human beings to the children. The children are affected by the inner being of their teachers. This makes the process of education a mutual adventure all the way through. The teachers are assured that their own inner growth serves others. Waldorf teachers, as I have met them, seem to be always working on their humanity. Of course humanity comes in all shapes, flavors, and sizes, so we certainly cannot generalize about personality formation in Waldorf education. But I see a continuing concern on the part of the teachers for their own development. This is one way that teachers integrate personal life and professional life. Who they are is what they will teach. That is a courageous confession.

And in a way it disarms the teacher of the authority that comes from role, the wrong kind of authority. If we know that the child sees us and depends on us *as we are*, we will see the uselessness of hiding behind rank and status. It seems healthy to redeem the word "authority" from its abuse, and to renew it as the name of our adult integrity. The name of who we really are in spirit. Authority based on position gives way to a sense of personal identity, of selfhood. What the word "author-

ity" really means is the ability to create something that other people can follow without danger to themselves. Its original meaning is "to create, to increase." So our authority is our creativity, that special quality of uniqueness which we offer. Others may grow in its presence. We are not creatures encased in skin sacks. Our boundaries are permeable. We take in and give off, like cells and membranes. Part of coming to terms with authority seems to me to be a recognition that the concept is organic, not arbitrary.

When we develop a sense of inner authority, a quality in ourselves matures: something we can depend on, look to for faithful, ongoing, living concern. This process can be strengthened by having an outside model in childhood for a relationship to ourselves which will ripen later on. Awareness of this process could be an antidote to the self-belittling and the compensatory conceit which so widely afflicts adults. To have a sense of inner authority, to grow with one's own help, to be inspired by an inner friend and guide — perhaps this is what "teachers" mean when they talk about "the higher self," "the daimon," "the inner guru," "the inner master," and "the Christ within." Certainly we learn from introspection that there is an ongoing dialogue between the members of our inner family. Perhaps we Americans could do well to be open-minded to the appearance of "the teacher" in our unconscious pantheon. It is perhaps the archetype of the teacher which Steiner means to awaken in the soul of the child, so that s/he may take on his or her own inner teacher and friend in due course, and thus grow in independence and moral creativity.

In this respect, Steiner's *Education of the Child* quotes a most interesting passage from a book on education by Jean Paul (*Levana*). Prior to the passage Steiner emphasizes the need to develop memory in elementary school years. He answers the argument against memorizing things we don't as children quite understand, saying that "other forces of the soul are at least as necessary as the intellect, if we are to gain a comprehension of things. It is no mere figure of speech to say that man can understand with his feeling, his sentiment, his inner disposition, as well as with his intellect" (p. 37). He says intellectual understanding comes after puberty. Childhood is the time to store the memory with cultural riches, which later can be conceptualized and subjected to independent judgment and criticism. Jean Paul as quoted by Steiner supports this view:

> Have no fear of going beyond the childish understanding even in whole sentences. Your expression and the tone of your voice, aided by the child's intuitive eagerness to understand, will light up half the meaning, and with it in course of time the other half. It is with children as with the Chinese and people of refinement; the tone is half the lan-

guage. . . . We are far too prone to credit the teachers with everything the children learn. We should remember that the child we have to educate bears half his world within him all there and ready taught, namely the spiritual half, including, for example, the moral and metaphysical ideas. For this very reason language, equipped as it is with material images alone, cannot give the spiritual archetypes; all it can do is to illumine them.

Jean Paul goes on to praise the gifts children have for inventing words!

Besides living authorities, who embody for the children intellectual and moral strength, Steiner says there should be those they can only apprehend with the mind and spirit. He is referring to the study of history and the stories of the lives of great men and women. The curriculum develops out of these correlations between the physical development of the child and his inner development. History begins with fairy tale, legend, Bible story and myth, then goes on to biography, followed by written history. The historic consciousness of the child parallels in its development the evolution of human consciousness. The seventh graders are learning about revolutions just when they are beginning to feel in themselves a creative change toward the independence of adulthood — feeling, as their bodies begin to change, the transformation of dreaming child into waking youth. Steiner's text states:

> In another connection too, the presentation of living pictures, or as we might say of symbols, to the mind, is important for the period between the change of teeth and puberty. It is essential that the secrets of Nature, the laws of life, be taught to the boy or girl, not in dry intellectual concepts, but as far as possible in symbols. Parables of the spiritual connexions of things should be brought before the soul of the child in such a manner that behind the parables he divines and feels, rather than grasps intellectually, the underlying law in all existence. 'All that is passing is but a parable,' must be the maxim guiding all our education in this period. It is of vast importance for the child that he should receive the secrets of Nature in parables, before they are brought before his soul in the form of 'natural laws' and the like. An example may serve to make this clear. Let us imagine that we want to tell a child of the immortality of the soul, of the coming forth of the soul from the body. The way to do this is to use a comparison, such for example as the comparison of the butterfly coming forth from the chrysalis. As the butterfly soars up from the chrysalis, so after death the soul of man from the house of the body. No man will rightly grasp the fact in intellectual concepts, who has not first received it in such a picture. By such a parable, we speak not merely to the intellect but to the feeling of the child, to his soul. A child who has experienced this, will approach the subject with an altogether different mood of soul, when later it is taught him in the form of intellectual concepts. It is indeed a very serious matter for any man, if he was not first enabled to approach the problems of existence with his feeling. Thus it is essential that the educator have at his disposal parables for all the laws of Nature and secrets of the world. (p. 33)

In the training programs for Waldorf teachers, the art of creating such parables is emphasized. It is an art that must be practiced with total sincerity and without condescension. "For when one speaks in parable and picture it is not only what is spoken and shown that works upon the hearer, but a fine spiritual stream passes from the one to the other, from him who gives to him who receives. If he who tells has not himself the warm feeling of belief in his parable, he will make no impression on the other. For real effectiveness, it is essential to believe in one's parables as in absolute realities. And this can only be when one's thought is alive with spiritual knowledge. Life flows freely, unhindered, back and forth from teacher to pupil" (p. 34).

Steiner says the teachers needn't torture themselves trying to think up parables. They are the reality they see when their eyes are opened through Anthroposophy. The pictures are "laid by the forces of the world within the things themselves in the very act of their creation. . . . That such a thing as a seed has more within it than can be perceived by the senses, this the child must grasp in a living way with his feeling and imagination. He must, in feeling, divine the secrets of existence" (pp. 35, 40). The sensory world is the doorway of the spirit.

In all these ways and more, knowledge is made an inner experience. The children feel the connections between themselves and the seasons and the animals, plants, rocks, the starry skies, mountains and rivers, bridges and skyscrapers. The materialist way of thought, Steiner says, will never give rise to a really practical art of education. Narrowing reality to only one of its elements, materialism creates a basic mistrust, illness, and, I would add, criminality. Evil, there is reason to believe, comes about when human beings are estranged from the depths of their own natures. These depths can be spoken to through parable, allegory, story, and myth. They connect the human soul and life of feeling with external events. Our lives are such stories, moving like music, on more than one level at once.

We said that the first seven years of the child are the years of learning by imitation, of the development of the physical organs, and that the basic expression in this time is *will*. Steiner makes a connection between willing, feeling, and thinking (the three main functions of the threefold human being, body-soul-spirit) and sleeping, dreaming, and waking. He says the preschool infant lives primarily in the sleeping will. Our will is the least conscious member of our being. We do not know how we raise an arm, or type, or begin to speak. The *will* in our digestive system, brain activity, and so forth, is unconscious. We are asleep to it, fortunately. Through the years from seven to fourteen, after the change of teeth, the child is dreaming, and lives in his or her feeling. After puberty, the youth wakes, and in-

dependent thinking begins to work in consciousness. These stages are to be respected, he cautioned. Do not wake the child too soon from its sleeping or from its dreaming. Do not overstimulate, or overconceptualize. Do not ask for a lot of mental activity. (The Waldorf schools do not stress homework in the elementary grades.) Bring intellectual brightness into balance with feeling and will. Humanize. Do not hurry the children into reading skills. Let them first write. Then read. Teach them the letters through stories of the pictures they suggest. Writing is drawing. Use colored pencils and crayons no matter what you are writing. Do not separate feeling from writing. Do not separate color and form from writing. Do not intellectualize it. Let a feeling for writing as an imaginative manual activity develop. Give the children themselves a chance to write and to tell stories aloud, before they begin to read what other people have said and written. Give them an experience of authorship first. Let the children observe; teach them to read nature before books. Be careful about creating dependency upon the written word. Be careful of mechanizing the processes of reading and writing. Have a care for the inner word that lives in all forms. Let it live. Be careful of packaging the mind between covers that don't breathe. *Education of the Child* explains:

> *Thought* in its proper form, as an inner life lived in abstract concepts, must remain still in the background during this period of childhood. It must develop as it were of itself, uninfluenced from without, while life and the secrets of nature are being unfolded in parable and picture. Thus between the seventh year and puberty, thought must be growing, the faculty of judgment ripening, in among the other experiences of the soul; so that after puberty is reached, the youth may become able to form quite independently his own opinions on the things of life and knowledge. The less the direct influence on the development of judgment in earlier years, and the more a good indirect influence is brought to bear through the development of the other faculties of soul, the better it is for the whole of later life. (pp. 43–44)

So *feeling* is developed through the parables and pictures referred to, and through pictures of great men and women taken from history, a correspondingly deep study of the beauties and secrets of nature, and the cultivation of the sense of beauty and the awakening of the artistic feeling. The musical element, Steiner says, "must bring to the etheric body that rhythm which will then enable it to sense in all things the rhythm otherwise concealed. A child who is denied the blessing of having his musical sense cultivated during these years, will be the poorer for it the whole of his later life. If this sense were entirely lacking in him, whole aspects of the world's existence would of necessity remain hidden from him" (p. 42). Nor are the other arts to be neglected: awakening a feeling for architectural forms, modeling and sculpture, drawing and designing, color — all should be included.

As Steiner says, much can be done with the simplest means, if only the teachers themselves have the right artistic feeling. Artistic activity is a central aspect of Waldorf teacher training. It should be clear by now that the Main Lesson teachers present their material artistically to appeal to the children's feeling. All of the teachers learn to feel at home with artistic activity, both in the narrow sense of painting and music and modeling, and in the wider sense of creativity in all their class preparations. The opportunities for the teacher to use imagination and at the same time to feel on firm ground in relation to the development of the wholeness of the child are elements that attract people to become Waldorf teachers. Teachers as well as children learn to be expressive, original, and deeply connected in common forms. Each finds his or her own way and level. To teach artistically is to teach in a certain spirit — there is no blueprint. For most Americans who study to be Waldorf teachers, this is a new approach to childhood education: for teachers to regard themselves as artists. It is not in the conventional sense, i.e., making works of high aesthetic value, but of seeing how form and color and rhythm are part of the wholeness of experience, and how feeling is basic to learning. Often there is a kind of aesthetic innocence in what the teachers do. Or, like the children, they copy what others do until they are ready to do things their own way.

Children's games and gymnastic exercises are also part of the foundation of this education. Their purpose, Steiner says, like that of the other activities, is to help the growing etheric body experience an inner feeling of ever increasing strength and flexibility. This is accomplished without strain, and with a "healthy sense of inner happiness and ease. To think out gymnastic exercises from this point of view requires more than an intellectual knowledge of human anatomy and physiology. It requires an intimate intuitive knowledge of the connexion of the sense of happiness and ease with the positions and movements of the human body — a knowledge that is not merely intellectual, but permeated with feeling. Whoever arranges such exercises must be able to experience in himself how one movement and position of the limbs produces an easy feeling of strength, and another, an inner loss of strength" (p. 44). To teach with these things in view, Steiner admits, requires a certain habit of mind, a way of seeing. This seeing will be proven, not theoretically, but by the fruits it bears, he says. A special gymnastic called Bothmer has come to be widely practiced, as it was developed out of Steiner's indications by Count Bothmer.

The strongest of all the impulses that can work on the etheric body, as Steiner noted,

come from the feelings and thoughts by which man divines and experiences in consciousness his relation to the Everlasting Powers. That is to say, they are those that come from religious experience. Never will a man's will, nor in consequence his character, develop healthily, if he is not able in this period of childhood to receive religious impulses deep into his soul. How a man feels his place and part in the universal Whole, — this will find expression in the unity of his life of will. If he does not feel himself linked by strong bonds to a Divine-spiritual, his will and character must needs remain uncertain, divided and unsound. (p. 42)

It is not clear from a passage of this kind how consciously the religious instinct must be satisfied. Surely Steiner does not consider it a matter of "religious beliefs" in the ordinary sense. He says elsewhere that the greatest souls of our time may be found among persons who profess no religion. This question of religious feeling in the human being is complex and subtle, and it is indeed a sensitive issue. Steiner comes at it from a number of perspectives and says different things at different times. I believe the tone of his meaning is this: in every individual there is an instinctive sense of connection between oneself and the universe. There is a built-in sense of meaning and of identity. There is an inner world of spiritual being and of spiritual beings in which mankind, nature, and universe participate. A sense of connection with this inner spirit is what is ordinarily called religion. It is as natural to people as a sense of self and a feeling for nature. It is a crossing point between inside and outside. A materialistic viewpoint denies this experience, saying there is no inside to nature, no spiritual being or beings. The primal archaic human person in us knows the world of spirit intuitively. The renewal of religion is inseparable from a renewal of science and art. They are each renewed as humans reconnect the material world with the inner world, and re-vision the inner world as objective fact, as knowable.

This has been the terrain of modern depth psychology as well. Carl Gustav Jung, its founder, discovered that neurosis is not based upon frustration of the sexual instinct, but upon frustration of the religious instinct. This frustration can be healed through contact with the unconscious, the objective world of the psyche. This is the world of soul, of the archetypal figures who appear in myth and dream, and who stand behind all the imagery of reality. The nourishment of soul should be a central task of education. Art, storytelling, and dream touch the realm of those "Everlasting Powers" which Steiner speaks of.

It is important to honor the intuition of "presence" which the human child has. The intuition of meaning and the love of beauty are as natural to the child as are disobedience and destructiveness. It is important, Steiner says, to keep the paths to

meaning and beauty open, as well as to give play to mischief and boisterousness, and to feed the conscience. This accounts for the feeling for ritual in the schools. Candles are lit, hushed tones are used, the children grow quiet. The religious references tend to be Christian, though nondenominational. Hanukkah is often celebrated along with Christmas.

Steiner experienced the entrance of Christ into earthly life as a turning point in the evolution of man. His Christology is unorthodox, nonsectarian. He distinguishes between religion and church. There is no church affiliation in the Waldorf schools. But in the conception of humankind upon which the education is based, the figures of Christ and the archangels loom large. They are considered not as figures of belief, but as spiritual beings who weave through the ground of time, forming the world. The earth, like the human person, has an etheric envelope. The Christ Being, since his advent on earth, lives in the etheric and shapes the spirit of the planet. Many people now, as Steiner predicted, are having an experience of the etheric Christ. The impulses toward freedom and relationship among individuals and nations signify the etheric Second Coming, as do the growing insistence upon justice for all and compassion for the needy. Buddha, Zarathustra, and other initiates play their parts in this vast scenario as Steiner perceived it.

The Christianity of the schools is expressed in their celebrations of the festivals of the year: Christmas, Easter, St. John's Day and Michaelmas — the cosmic festivals of solstice and equinox. St. John's Day comes on 24 June, and Michaelmas, 29 September. At Christmas time, the teachers often put on for the children a medieval folk drama of the Nativity. The beginning of Advent is often celebrated by what is called an Advent Garden. A spiral path is laid out, marked with mosses and logs from the woods, and crystals. At its center is a special place on which a large lighted candle stands. Each child is given an apple with an unlit candle inserted through its core. S/he walks the spiral path to the center, lights his or her little light from the big one, and walks back, placing the lighted apple on the path. By the end, in the darkened hall, the path has turned into a garden of lights. Christmas carols are sung to the accompaniment of lyres.

The course of the year is experienced in detail in its seasonal aspects, and these follow the inbreathing and outbreathing rhythm of the earth, about which Steiner has written in *The Cycle of the Year* and *The Four Seasons and the Archangels*. Plays, festive walks, pageants are often given to celebrate nature's rhythms.

The ego also has its corresponding seasons. For example, Michaelmas, which comes at harvest time, is an enormously important festival for the human ego. The ego sees itself in this festival as an *opus contra naturam*, as the alchemists called

the labors of the human spirit. Nature in the autumn, the time of Michaelmas, dies. We human beings do not die. On the contrary we feel an independence from nature's patterns, feel the uprightness of human individuality as stalks fall and leaves drop. It is a festival of what I called earlier the "inner authority," or "higher ego." It is ruled by Michael, an archangel who acts as a kind of "countenance" for Christ. Michael's reign began at the end of the nineteenth century, in 1879, and introduces a cultural epoch of increasing social concern, individuation, human relationship, and mutual service. He might be thought of as an artist in separating and connecting! At the same time Michael exerts no pressure, no influence. He waits with a steady serious gaze, as Steiner describes him in *Michaelmas.* When something happens that pleases Michael, the gaze deepens. His spirit is that of freedom itself. No new and good thing can come into being for modern man that does not come freely, as an act of initiative out of personal spiritual activity. The time of receiving from the gods is over. God in that sense — God the big giver — is dead. So long as people were treated by God as children and servants, they had no freedom. The first Adam was born into the Garden of Eden. The second Adam will be born into initiation consciousness.

With the age of puberty another step is taken in the ripening of the child's powers. *Education of the Child* continues:

With the age of puberty the astral body is first born. Henceforth the astral body in its development is open to the outside world. Only now, therefore, can we approach the child from without with all that opens up the world of abstract ideas, the faculty of judgment and independent thought. It has already been pointed out, how up to this time these faculties of soul should be developing — free from outer influence — within the environment provided by the education proper to the earlier years, even as the eyes and ears develop, free from other influence, within the organism of the mother. With puberty the time has arrived when the human being is ripe for the formation of his own judgments about the things he has already learned. Nothing more harmful can be done to a child than to awaken too early his independent judgment. Man is not in a position to judge until he has collected in his inner life material for judgment and comparison. If he forms his own conclusions before doing so, his conclusions will lack foundation.

The thought must take living hold in the child's mind, that he has first to learn and then to judge. What the intellect has to say concerning any matter, should only be said when all the other faculties of the soul have spoken. Before that time the intellect has only an intermediary part to play: its business is to grasp what takes place and is experienced in feeling, to receive it exactly as it is, not letting the unripe judgment come in at once and take possession. For this reason, up to the age of puberty the child should be spared all theories about things; the main consideration is that he should simply meet the experiences of life, receiving them into his soul. Certainly he can be told what different men have thought about this and that, but one must avoid his associating himself through a too early exercise of judgment with the one view or the other. Thus the

opinions of men he should also receive with the feeling power of the soul. He should be able, without jumping to a decision, or taking sides with this or that person, to listen to all, saying to himself; 'This man said this, and that man that.' (pp. 45–47)

The cultivation of such a mind, with the power to listen and not to judge, with the power to know the difference between passion and judgment, is devoutly to be wished. Or, as a friend of mine recently wrote, "To be able to tell the difference between what feels good and what is true!" It is interesting that Steiner equates "feeling" with "receiving into one's soul," and sees these as ways of learning. Martin Heidegger, the modern German philosopher, says this is what thinking is: to let be, to receive experience into the soul. "Feeling," Jung says, is a way of knowing; it is the experience of valuing. These human insights are all notes in the harmonious music of the mind.

So we see, through this basic text of Steiner, that what lies behind the Waldorf schools is an effort to see into the heart of life and to let the curriculum and methodology grow out of that heart. This is not meant in a sentimental way. It is meant to indicate how earnestly Steiner pledged himself and encouraged others to follow the evolution of consciousness into its new forms, and to base education upon the truths perceived in the forms of being.

He said that we are at the beginning of a new epoch, the Fifth Post-Atlantean Period, which began five hundred years ago with the Renaissance and the advent of modern consciousness. The first step was the discovery of the physical world and the loss of the medieval synthesis and the secularization of science. This had to happen, Steiner is sure, if human beings are to become free from spiritual interventionism. Before we can be free, we have to be able to be alone, unsupported by inherited religious solutions. The abyss of materialism and atheism is the brittle chrysalis out of which the new age consciousness will wing. History does not move by causality but by metamorphosis. We are in a new time, Steiner says, and as in any new time we will be provided with the new kinds of consciousness we will need. This provision rests in us like the flower in the root of the plant, which is the image with which Steiner began his lecture on "The Education of the Child." The Steiner schools are trying to help it to grow.

To Feel the Whole in Every Part: Education As an Art

Waldorf School education must be listened to with other ears than those with which one hears about other kinds of education or educational reform. For the Waldorf School gives no answer to the questions people want to have answered today and which are ostensibly answered by other systems of education. What is the aim of such questions? Their usual aim is intelligence, much intelligence — and of intelligence the present time has an incalculable amount. Intelligence, intellect, cleverness — these are widespread commodities at the present time. One can give terribly intelligent answers to questions like: What should we make out of the child? How should we inculcate this or that into him? The ultimate result is that people answer for themselves the question: What pleases me in the child, and how can I get the child to be what *I* like? But such questions have no significance in the deeper evolutionary course of humanity. And to such questions Waldorf pedagogy gives no reply at all. To give a picture of what Waldorf Education is, we must say that it speaks quite differently from the way in which people speak elsewhere in the sphere of education: Waldorf School Education is not a pedagogical system but an Art — the Art of awakening what is actually there within the human being. Fundamentally, the Waldorf School does not want to educate, but to awaken. For an awakening is needed today. First of all, the teachers must be awakened, and then the teachers must awaken the children and the young people.

— Rudolf Steiner, *The Younger Generation*

When the teacher makes a garden with the students, or makes lunch with a class, or shows them how to make a shirt or knit socks, or make a book, or tell a story, or set up a lab experiment, these are part of something real. The garden is part of the earth and related to sun and moon, to weather and seasons, to nourishment of body and soul, to insects and birds and cows and worms, to the mystery and cycle of sprouting and harvesting and seed sowing, spring and winter. It is also related to

fertility gods and goddesses, to death and resurrection, to myth and poem and play and worship, to history, to science, and to the present community. Receptivity to the gifts from one's subjects and activities in school, from the earth, from the threads and fibres of animals and plants, from paper and color, and from the stories one tells and hears — this is the art of *sophia*, the art of wisdom, the feminine aspect of knowledge. Wisdom exists already in nature. Nature knows already how to engender, yield fruit, and die in new life. The thoughts lie within the forms. As we think them, we receive the thoughts like seed sown by a goddess's hand, by Demeter, the Goddess Natura. In *Spiritual Ground of Education,* Steiner says:

> If one desires to be a Waldorf teacher, which means to work from a true philosophy of life, this mysterious relationship between man and the world must have become second nature: (literal translation: it must become an unconscious wisdom of the feelings.) Certainly people take alarm today if one says: the Waldorf teachers start from Anthroposophy: this gives them their vision. For how if this Anthroposophy should be very imperfect. That may be. Produce other philosophies then, which you think are better. But a philosophy is a necessity to one who has to deal with human beings as an artist. And this is what teaching involves. (p. 132)

From the ground of this philosophy, and from the study of humans and nature, as well as from self-knowledge, the teachers in Steiner schools are continually nourished by insight and by a sense of living context. Take, for example, human speech, or the so-called language arts. The learning of writing, of reading, of speaking a foreign language — these are deeply connected with the experience of oneself as ego, as individual spiritual being. Steiner's *Practical Advice to Teachers* explains that speech "is the expression of the feeling links we form with the objects around us. . . . Vowels express soul stirrings that live in the sympathy we have toward things. . . . Just as vowels are related to our own sounding, so consonants are related to things; the things sound with them" (pp. 29–31). The vowels are the musical element; the consonants are the sculptural element. "In speech we have a true synthesis, a true uniting in the human being of the musical with the sculptural element" (p. 32). Teachers must be permeated with feeling for language and speech, and in turn must permeate it with consciousness, for its effective use in teaching. In their first lessons in writing, the children experience how the sounds that come from their breath can be seen in pictures which carry a certain story and feeling content. First they draw and paint, then they draw the pictures which become letters, and then they learn to read from handwriting. In this way writing is closer to them; it lives more immediately in their limbs. Everything the children

learn should be connected with a feeling for the human being. Steiner's advice continues:

> You see how the important thing for us in our endeavour to achieve teaching that is living rather than dead is always to start from the whole. Just as in arithmetic we start not from the addenda but from the sum which we divide into parts, so here too we proceed from the whole to the parts. The great advantage gained from this in teaching and education is that we are thus able to place the child in the world in a living way; for the world is a totality and the child maintains permanent links with the living whole if we proceed in the way I have indicated. (p. 75)

Language is close to the heart of the mystery of creation and creating. It makes communication possible; it makes poetry, drama, and literature possible. Its grammar is connected with the forms of our soul life: with the what, the how, the when, and with the acting and the actor and the acted upon. It is connected with social relationships and observation. If one experiences language in the right way, one feels that one belongs to the world. One is not a stranger. The world speaks through nature and oneself, and one offers onself as a "word." Steiner tells teachers: "In this way speech is rooted in human feeling. In feelings you are linked to the whole world and you give the whole world sounds that in some way express these links of feeling" (p. 29).

To experience words as living forms and living meaning is to experience them imaginatively as living art. By receiving aliveness into one's learning, one feels the wholeness of life in every part. The parts of speech — noun, adjective, adverb, verb, preposition, and conjunction — are organs of a body of meaning, parts of an artistic form. And so they should be taught: like theater, like architecture, like the colors in a painting. First we experience language intuitively through speech and listening, then we become conscious of it. Steiner continually stressed that teachers must imbue themselves with artistic feeling. From their earliest years it is customary for children in a Waldorf school to do speech exercises, speech chorus, and individual speaking before the class. It is seen as a central part of the development of their feeling and their will, as well as of personality. Well aware of the horror many people still feel when they recall their lessons in grammar and syntax, Steiner's *Practical Advice to Teachers* approaches the question of grammar in another way.

> What is it we do when we raise unconscious speech to the grammatical realm, to the knowledge of grammar? We make the transition with our pupils of lifting speech from the unconscious into the conscious realm; our purpose is not to teach them grammar in

a pedantic way but to raise something to consciousness that otherwise takes place unconsciously. Unconsciously or semiconsciously man does indeed use the world as a trellis up which to climb in a manner that corresponds to what we learn in grammar. Grammar tells us, for instance, that there are nouns. Nouns are names for objects, for objects that in a sense are self-contained in space. That we meet such objects in life is not without significance for this life of ours. All things that can be expressed by nouns awaken our consciousness to our independence as human beings. By learning to name things with nouns we distinguish ourselves from the world around us. By calling a thing a table or a chair, we separate ourselves from the table or chair; we are here, the table or chair is there. It is quite another matter to describe things with adjectives. When I say: the chair is blue — I am expressing something that unites me with the chair. The characteristic I perceive unites me with the chair. By naming something with a noun I dissociate myself from it; when I describe it with an adjective I become one with it again. Thus the development of our consciousness takes place in our relationship to things when we address them; we must certainly become conscious of the way we address them. If I say the verb: the man writes — I not only unite myself with the being about whom I have spoken the verb, I also do with him what he is doing in his physical body. I do what he does, my ego does what he does. When I speak a verb my ego joins in with what the physical body of the other person is doing. I unite my ego with the physical body of the other when I speak a verb. Our listening, especially with verbs, is in reality always a participation. What is so far the most spiritual part of man participates, only it suppresses the activity. Only in eurythmy is this activity placed in the external world. In addition to everything else, eurythmy also gives the activity of listening. When one person tells something, the other listens; he performs in his ego what lives physically in the sounds, but he suppresses it. The ego always does eurythmy in participation, and what eurythmy puts before us through the physical body is nothing other than a making visible of listening. So you always do eurythmy when you listen, and when you actually do eurythmy you are just making visible what you leave invisible when you listen. The manifestation of the activity of the listening human being is in fact eurythmy. It is not something arbitrary but rather in reality the revelation of what the listening human being does. (pp. 63–65)

In eurythmy the children are given not only a hygiene of the body, as in gymnastics, but a hygiene of the soul. Steiner continues:

It is essential to educate our children in a way that will enable them to notice once again the world around them and their fellow men. This is of course the foundation of all social life. Everyone talks today of social impulses, yet none but anti-social urges are to be found among men. Society ought to have its roots in the new esteem men should gain for one another. But there can only be mutual esteem when people really listen to each other. If we are to become teachers and educators it will be vastly important that we turn our sensitivity to these things once more.

Now that you know that when you speak a noun you dissociate yourself from your environment, that when you speak an adjective you unite yourself with your surroundings, and that when you speak a verb you blossom out into your environment, you move with it, now that you know all this you will speak with quite a different emphasis about

the noun, the adjective and the verb than would be the case if you did not have this consciousness. (p. 66)

Rudolf Steiner sets the teaching of the language arts in an overall sense of the structure of language and the wisdom of language. Indeed, he says "It is of the utmost importance to learn to feel something concrete of the working and weaving of the spirits of language" (p. 67). He goes on to mention the power of speech in religious ritual and in passages of great writing.

Feeling the whole in every part, children discover how they are knitted right into the fabric of the physical world and its mysteries, right into the world of objects and feelings and doings — the world of minerals and plants and animals, of geography, of numbers, of stories and science, of family and friendships, of society and institutions, of visions and creativeness, of all the arts.

"The teacher of the present day," said Rudolf Steiner in the course he gave to the first group of teachers in the original Waldorf School, just before it opened in 1919, and published in his *Study of Man*, "should have a comprehensive view of the laws of the universe as a background to all he undertakes in his school work" (p. 41). The teacher makes his/her relation with the children through what s/he *is*, which depends upon his/her thoughts about the world. Steiner asks for a recognition of "the importance of the relation between the thoughts that fill us and the effects of our teachings on the children, body and soul." *Study of Man* continues:

And we must above all become conscious of this first of educational tasks: that we must first make something of ourselves, so that a relationship in thought, an inner spiritual relationship, may hold sway between the teacher and children. So that we enter the classroom with the conscious thought: this spiritual relationship is present — not only the words, not only all that I say to the children in the way of instruction and admonition, not only skilfulness in teaching. These are externals which we must certainly cultivate, but we shall only cultivate them rightly if we establish the importance of the relation between the thoughts that fill us and the effects of our teaching on the children, body and soul. (p. 24).

The education of the teacher must be an education in a philosophy of life. Given an orientation to this philosophy, the teaching arises organically and spontaneously. All teacher training courses in Waldorf Institutes begin with what is called a "foundation year": i.e., a year of introduction to the basic philosophy. This philosophy, is not taught to the children. It stands within the consciousness of the teacher. The children grow to feel, through the presence of their teacher, how they are part of a holistic picture. Since the spirit of the philosophy is universal,

teachers and children alike develop their individuality in freedom. *Study of Man* states:

> But a teacher above all, if he is to do anything with the human being, must be in a position to grasp the fundamentals of civilisation. These are essential to him if he is to educate rightly out of the depths of his own nature through his unconscious and subconscious relations with the child. For then he will have due regard for the structure of man; above all he will perceive in it relationships to the macrocosm. How different is the outlook which sees the human form merely as the development of some little animal or other, a more highly developed animal body. Nowadays, for the most part, though some teachers may not admit it, the teacher meets the child with the distinct idea that he is a little animal and that he has to develop this little animal just a little further than Nature has done hitherto. He will feel differently if he says to himself: here is a man, and he has connections with the whole universe; and what I do with every growing child, the way I work with him, has significance for the whole universe. We are together in the class room: in each child is situated a centre for the whole world, for the macrocosm. Think what it means when this is felt in a living way. How the idea of the universe and its connections with the child passes into a feeling which hallows all the varied aspects of our educational work. Without such feeling about man and the universe we shall not learn to teach earnestly and truly. The moment we have such feelings they pass over to the children by underground ways.
>
> In another connection I said how it must always fill us with wonder when we see how wires go into the earth to copper plates and how the earth carries the electricity further without wires. This imagery came into an earlier discussion about Morse Code and telegraphy. If you go into the school with egotistic feelings you need all kinds of wires — words — in order to make yourself understood by the children. If you have great feelings for the universe which arise from such ideas as we have discussed today, then an underground current will pass between you and the child. Then you will be one with the children. Herein lies something of the mysterious relation between you and the children as a whole. Pedagogy must not be a science, it must be an art. And where is the art which can be learned without dwelling constantly in the feelings? But the feelings in which we must live in order to practise that great art of life, the art of education, are only kindled by contemplation of the great universe and its relationships with man. (pp. 147–48)

Rudolf Steiner never tired of calling education an art, for art is characterized perhaps most of all by its particular relationship between the part and the whole, or the articulations of the medium and the vision they radiate. This is why, in trying to characterize the educational impulse which has arisen out of Steiner's pioneering, we must hold between our fingers the two faces of the coin: the vision and the means. The philosophy and the methods are like the image and the pigments of a painting. Any part of the schooling, like any part of the canvas, can only be properly understood and experienced as the whole "picture" shines through it. Perhaps this is why, in a Waldorf school, there seems to be an earnestness shining through

even the simplest activities: a sense of dignity and meaning in the way the children learn to take care of their paintbrushes and recorders, the way they greet their teachers, and the way they assemble for a school festival. Natural youthful boisterousness seems to be accompanied by another level of awareness as well. The presence of the whole gives dimension to all the daily parts. It is difficult to describe. But it is not difficult to experience. There doesn't seem to be any way of falling out of the sphere of meaning.

When Rudolf Steiner says that education is an art, he means in part that education, like art, involves an experience of forming, both for the teacher and for the student. The process is creative for both. It is a practice which has a certain intentionality; it requires an openness to becoming and is guided by understanding. It involves a certain way of seeing the child, a feeling for life, an intuition of the connections between the inner processes of forming and their outer expression. It invokes as well a love of knowledge — a knowledge one can love — a *philo sophia*. A sense of awe rises in the presence of the child, as in the presence of a poem one hears forming in one's inner ear. There is a sense of the child's mystery, his/her identity, a sense of the child's long history already served, and the future into which one is accompanying him/her.

Education is an art because it relies upon that combination of know-how and inspiration, of enthusiasm and dedication, of ability and restraint, which the artist has, and which is awakened in the artist-teacher. The teacher, like the artist, is in touch with inner sources, with creative imagination, and with the unconscious world of the archetypes. S/he trusts inspiration and intuition and accepts the fact that work is not finished until it has taken physical form. Artists know that sensitivity alone is not enough; diligence alone is not enough. Inner sensing and daily practice combine in order for the inner being to take an outer form — to become sense-perceptible.

It is this mystery of the inner and outer which the teachers celebrate in their own lives and in relationships to colleagues and pupils. Education, as a form of living and learning, is a social art. It is a social form which needs renewal as society itself asks for renewal. The bases on which earlier education was founded have changed. We do not now educate for kingship, nor for statecraft, nor for industrial and professional skills. Surely these are needed, and each of us must grow into our self-rule, into our practical judgment, and into skills which are needed for the welfare of our neighbors. But we have learned that these abilities and skills are the expressions of an inner being; they do not replace that being. We know now that statecraft and professional practice and manual labor take on their quality from the

being who practices them. And it is the human being who is now our concern in education — the human being in his/her wholeness.

When we are creating something artistically, we have a certain kind of experience: we sense, as we are painting or modeling with clay, that something is coming. It is hovering about us. It comes, gradually, gradually, incarnating, taking on its sensuous form in this moment. We pinch the clay bit by bit; each pinch feels real and each pinch makes its bit of being, in dialogue with that form which is unfolding. It is an experience which is common to artistic activity and distinguishes it from mechanical activity. We both know what we are doing and don't know what we are doing. We are in the presence of a mystery unfolding, which speaks deeply to us below (or above) the threshold of ordinary consciousness; and at the same time we put on a color here, a color there, we introduce this thread, we turn the rim of the bowl this way or that. We are both helping to make something, and aware that something autonomous is coming into being. The artist listens. S/he is participating in the experience of form.

The world of forming, as experienced from the inside, as process coming into being, is not the world of most of the public schools. There the forms are given ahead of time, are applied from external considerations, and are often therefore rigid and inappropriate to the needs of teachers and students. In the way that subjects are set up to be taught, by syllabus and workbook and text, the perceptions are already formed. Knowledge is packaged in plastic covers or stored in electronic circuits. To many children it seems dehumanized and abstract. Students tend to be overwhelmed by the apparatus and the complexity before they have really experienced themselves as source.

The experiencing of oneself as source, human being as source, the history of humankind as source, evolution of consciousness as source, future unfolding as source — this is a formative factor in Waldorf schooling. And it accounts, for example, for such principles as the teaching of writing before reading, and the fact that the curriculum follows the history of human consciousness. It starts with fairy story and myth, and unfolds, with the child, gradually to modern consciousness. The child repeats the stages of human consciousness as s/he grows up. Certain kinds of experiences are suitable to certain ages. Children are therefore grouped according to chronological age and stay together in a class like a family. They are not dropped back nor skipped ahead. As we have said, their Main Lesson teacher, ideally, stays with them from first to eighth grade. This permits the rhythms of life to be observed more naturally and faithfully. "And life has a rhythm in the most comprehensive sense," Steiner says in *Practical Advice to Teachers* (p. 93). Repeti-

tion of educational motifs is at the heart of the schooling, allowing the understanding to ripen gradually and naturally. The Waldorf teacher plays with the rhythm of life, sowing seeds in certain subjects one year and allowing them time to take root and grow, and taking them up again the next year, at another level. In other words, questions of understanding and remembering are answered rhythmically.

The form of the class is an expression of social and moral attitudes. Faithfulness, flexibility, and diversity of abilities are affirmed. If there is trouble in the relationship between teacher and pupils, it will have to be worked out as in a family. Students and teachers learn to get along, to give and take, to accept, to forgive, to change, to adapt, and to develop humor and warmth that don't quit.

It is a lot of fun and hard work to take a class through the elementary grades. Most of us have not been educated in Steiner schools and therefore have not had the unique experiences available in these schools. Many parents who send their children to a Waldorf school say they would like to enroll! To become a Waldorf teacher is a rewarding way of life. The work is life itself.

As mentioned earlier, the class teacher gives the Main Lesson every day. A subject is focused on for three or four weeks and is reviewed at the end of the year. During each Main Lesson there is an attempt to involve, in a rhythmic way, the child's thinking, feeling, and willing, all in relation to the subject of the lesson. The lesson is presented personally and imaginatively by the teacher. It is not assigned as reading homework. It is transformed by the child's own hands into a book. No matter what the subject, the book will contain the lesson of the day, with drawing and coloring. Artistic enjoyment of color, rhythm, shape, and sound is part of learning and knowledge. In arithmetic the children learn through games and movement how to count and multiply, divide and subtract. In geometry, they make colored drawings and string constructions. In physiology they model the bones and the inner organs out of clay.

After the Main Lesson, other subjects are taught by other teachers: foreign languages, music, handwork. In the afternoon, eurythmy, gardening, physical education. The children usually bring their lunches, and eat together informally with their teacher. It is a nice time for conversation. In some schools there is a cafeteria, and teachers and students eat together. The Main Lesson teacher is also some kind of specialist and helps with other classes in the late morning or afternoon, teaching handwork, cooking, music, or taking a class for an outing. In the higher grades of elementary school, there is a specific effort made to link all subjects to practical human life and to employ them in a comprehensive sense toward a social educa-

tion of the pupils. Field trips to factories, mines, and craft studios are taken, and professional people are invited to speak to the class.

This experience of education as an art, as an experience which comes out of an inner forming, which has therefore a kind of "practice," is one of the most remarkable features of Waldorf schools. It accounts for the special combination of coherence and spontaneity, of order and imagination which can be felt in the schools. One feels ground under one's feet, and yet everything is growing, forming, transforming. There seems to be a continual interweaving of what is unique and what is common: a sense of form of the human being and our stages of growth, the form of our inwardness, the form of our freedom, the form of the day and of the night, of waking and dreaming and sleeping, the form of the cycle of the year; a sense of the inwardly living form out of which physical appearances develop is vital and energizing.

Form is the process of unfolding being. Three observations support the artistic process of life: that the child is a being, that this being of the child unfolds from within, and that the child's being follows certain laws and relationships to its physical body and to its environment. And though there is this sense of law, it is imaginative. It is a forming and at the same time not static, nor rigid, nor is it indeterminate. The root image of the word "law" is "to lie, lay." One can think of its meaning as that which underlies, which lies within, nature and society. The laws of life are those qualities of being which are inherent in it. For example, creativity is a law of life, as is dissolution; community relationship is a law of life, interdependence, as well as differentiation. The law of clay is plasticity, but it is also brittleness, fragility. And it is also transformability through fire.

Many of us in American culture are ambivalent toward form. We have more often experienced its shadow side, its negative aspects. We mistrust it, tending to think of it as restrictive, as authoritarian, as external to personal truth. We tend to think of form as imposed from without, by tradition or personal force, and thus much of our art and education is dedicated to the destruction of forms, a clearing of the boards. Or, turning to the unconscious as the creator of inner forming, we open ourselves to the daimonic. Perhaps history asks for this, so that a new beginning can be made. Certainly when forms die and are not discarded, they become lifeless, artificial, and antagonistic to personal growth. And certainly the unconscious is mother to birthing forms. But she too may endanger us with her flood.

There is another way of coming to an experience of forming, from the inside, and in conscious relationship to the archetype. Archetype generates the motif of forming. We can gradually come to develop an organ of inner seeing, which discerns

the archetype. This is the artist's talent and path. It is an intuitive seeing, which comes about as a result of exercising and experiencing one's physical senses imaginatively, wholeheartedly, and wholesoulfully. This is why artistic practice is so important in all learning and education. This is why neglect of the artist in each person is so impoverishing to society. Without this spiritual sense organ, this way of seeing the formative forces at work in a physical process, we are blind and duped by appearances. There is always more than meets the physical eye, or ear, or touch, or smell, or taste.

If we could rely on our physical senses alone as guides to truth, it would be a very different world than it is. How to tell what is good for us from what tastes good, smells good, looks good, feels good, sounds good — ah! Behold the beautiful toxic corn which is killing the birds, the luscious sweets that make us sick, the graceful bodies who despair and kill themselves. No, there is more to our universe than appearances; and that "more" is the frontier of our time.

Waldorf education stands in that frontier, and Rudolf Steiner's life and work were dedicated to the prophetic awareness that the next step for science is to deepen its awareness of the world of inner formative processes, the invisible world of the archetypes, the objective world of spirit and psyche. Steiner's effort was to begin to articulate a grammar for that new vocabulary of science, based on his own pioneering in perception. He combined in his training, both the traditional knowledge of contemporary technical science and the inner development of a sense of law, of what underlies. For twenty years he tested these experiences before he began to share them publicly, speaking to the needs and intuitions of many people who were ready to join him in pioneering the renewal of education, society, science, art, religion, medicine, agriculture, and architecture. The Steiner schools, now sixty years old, are the strongest growing movement in independent schools in the western world.

This law of inner forming, which Steiner observed, may be experienced in a simple way, in an organic form. Take a carrot, for instance. Who would guess that *that* is what would come out of a tiny greyish-brown speck of a seed: a big orange root, ten inches long, with all that green leafy foliage! And all that natural sweetness! Where does it come from? It surely wasn't contained in that grain of matter called a seed. And it certainly wasn't poured in from outside. To start with, there would appear to be nothing but a speck of dried substance. But put it in the earth where it gets needed moisture, warmth, and nutriments, and it opens up and out of it a form begins to unfold. First root, then shoot, then fine feathery leaves. The root develops to maturity and if let go, unharvested, the green top develops seed. The

forms come from the inside, from invisible formative processes. These formative processes which work so closely with the materials of the mineral world, bringing them to their appropriate physical form, are like another kind of body. As was said in the previous chapter, this is the ether body, or etheric body. It is a body of flowing forces in various subtle substances or ethers. This is part of the grammar for the new vocabulary of science.

In the world of animals, yet another kind of body appears. For whereas the plant is rooted and stationary, the animal is two- or four-footed and is mobile. The animal has a consciousness which the plant does not have. The animal has feelings and kinds of sensations which the plant does not have. It has moods of sympathy and antipathy; it defends and attacks. These affects make up the astral body, the body of desires, of sensations and feelings, the body of consciousness, but not yet of self-consciousness. (It is called astral because it is connected with the stars, and the Latin word for star is *astrum*.)

With the human being the fourth member of our being is added: the body of the ego, which works upon our other bodies, enabling us to stand upright, to walk, and to speak. And, at a certain time, to say "I," the only word each person can only say about oneself.

A sense of the flowing intercourse of these bodies, their interrelationships, their individual rhythms of unfolding and transformation, informs the teaching in the Steiner schools. When we are conceived, there is no perceptible evidence of what we will look like or who we will become. To the outer eye we are like that tiny carrot seed — a riddle. Our biography lies like a secret within the embryo. Our visible form gradually develops, from birth through infancy, through the preschool years, the grade school period, adolescence, young adulthood, middle years, and later years. And this form changes markedly. To follow its changes is a study in itself. Likewise the invisible forms of our being gradually unfold: our powers of imitation, of sense perception, the ways we think and feel, the way we relate to others, our initiative. It is a real and remarkable experience of form unfolding. The thresholds of physical changes are also the thresholds of inner development. In *Spiritual Ground of Education* Steiner says:

When one can view the nature of man in this way, not despising what is physical and bodily, one can do a great deal for the children's health as a teacher or educator. It must be a fundamental principle that spirituality is false the moment it leads away from the material to some castle in the clouds. If one has come to despising the body, and to saying: O the body is a low thing, it must be suppressed, flouted: one will most certainly not acquire the power to educate men soundly. For, you see, you may leave the physical

74

body out of account, and perhaps you can attain to a high state of abstraction in your spiritual nature, but it will be like a balloon in the air, flying off. A spirituality not bound to what is physical in life can give nothing to social evolution on the earth: and before one can wing one's way into the Heavens one must be prepared for the Heavens. This preparation has to take place on earth. (pp. 110–11)

To experience oneself as a form, in this sense, is a step in understanding reality. And to experience the formative processes in nature, in the minerals, the plants, the animals, to discover how the human being shares in these wisdoms, and adds its own — this is also a step in understanding reality. A picture of the earth and its creatures, of the universe of stars and planets, of both outer and inner history, the interconnected wholeness in which every bit of being participates, begins to awaken. Like an artistic image, this awakening to wholeness is an experience of form, inwardly sourced and outwardly expressed. This makes it no less mysterious, no less of a riddle. What it does is to give a sense of meaning, of spiritual contour. One lives within it as within a presence as real to one as one is to oneself. In this inner landscape, one is supported from every direction by the movement of other beings. The human being is a crossing point through whom this double landscape courses.

One feels oneself in an ongoing, living presence, a living being in a living world. A sense of aliveness, through all life's forms, including death, begins to quicken. The best way I know at this moment to describe this quality is to call it an ability to participate in *formness* . . . to have a sense of what forming is . . . to experience it, to live in it, as a space of imagination, inspiration, intuition . . . a place where perception is ensouled and inspirited. In this state, inner and outer marry, and one lives within their union, not as an abstract idea, but as a concrete experience.

What makes this possible is that there is a wholeness that contains us. And we contain it. We can't fall out of the universe. We can't fall out of interrelationship. We can't be nonparticipants in the real world of body and of soul and of spirit. We can't refuse to be human beings. We can be unconscious, asleep. But to be awake is often just a simple matter of being willing to feel the connection, to feel the presence of more than ourselves, not in a romantic or mystical way — but in a plain common-sense way, taking in all the facts and data. We are obviously a part of something bigger than ourselves, and our health and well-being are interdependent with weather, plant life, animal life, and social life.

A crisis of recognition befell me on a trip to the British Isles, to Iona, off the west coast of Scotland. I had first seen Iona mentioned on the bulletin board of Emerson College (an English Steiner school for adults) as the destination of a student excur-

sion at Easter. Why were they going *there* at Easter, I wondered. My curiosity was aroused, and I went to Iona the following summer. It is a small and holy island. The Book of Kells was begun there. Historic French kings are buried in its ancient yard. Its abbey has been reconstructed through the efforts of an international Iona Community.

I stayed in a croft and walked every day to the abbey, along with the sheep. I went to the daily services, broke bread, tried to sing, but wept so much I couldn't keep to the tune. Some old wound, some obsessive pain, would not give up its power. Finally in exasperation I said to myself, "What *are* you crying about?"

"I am homeless and unloved."

"Are you really? Are you really? You have no friends? No one in the world cares for you? No one will take you in?"

I could hear my inner lying, feel my arched back and clenched heels, stubbornly refusing to step over the threshold of separateness and woe into the circle of love.

I walked across the island to the cove where Saint Columba had arrived in his coracle from Ireland in the fourth century to build the abbey and create the Book of Kells. Cows were standing in the sea. Up the slope of the beach an archaic fairy ring lifted the sod. I stood outside it, and then I took a big step, literally raising my foot into the air, and stepped inside. I stepped inside, and my hard-won separateness yielded in the next stage of unfolding into the circle of living warmth and interconnectedness. And the sphere turned inside out. The inside is forever the outside as well now.

I had come to Iona, not knowing where I was going, but going there. And once there, my conscious spirit took its next needed step. No longer self-enclosed, loneliness turned into warmth.

I tell this story because I believe that a sense of being "outside" is commonly shared. Some people say they feel "lost." What they may not know is that it may be a matter of simply deciding to take the step, of literally stepping inside. Everything changes. One is in a new support system, like a free being in an ensemble of soloists, or in a music made by the mutually supporting orbits of the stars.

I use the image of music deliberately since it is the archetype of universal harmonics and since it is by music that we are to approach the future, according to Steiner. Music is part of the daily life in the Steiner schools, to be sure. The little children start in first grade to play recorder and to sing. By third grade they are singing two-part and three-part pieces and starting another instrument. Music is part of the curriculum not because it is a cultural status symbol, but because music is one of the laws of cosmic wholeness. It is fun and feels good *because* it deeply

belongs to our deepest nature. Music mirrors our experience of time, of interval, of pause, ratio, tone, and soul. Music is not the same as sounds, nor the same as noise. With its redemption of sound and noise, it heals the bodily rhythms, heals the soul. It is prophetic in its humanity. Its speech is esoteric, heard in the inner ear, the breath, the pulse.

To enter into the world of forming, to be cocreator speaks to our sense of creativity, our artistry, and our sense of adventure. We wish to be fully ourselves and at the same time, as a part of a self-realization, to offer and share with others, so that our own welfare comes to be experienced through the welfare of others. This seems to happen naturally as our inner form evolves. So long as suffering exists in the world, we will feel its pain.

This awakening to form is very enlivening to me personally. As a child I trusted social forms, family, school, and church. Then in early adulthood, I began to question conventional forms and to seek freedom from them. I enjoyed the perils and pleasures of unform until once more, as if after a long sleep, my life looked for root and shoot, felt the seedcase break open, and the touch of warmth, the smell of good dirt, the delicious rain, the wild deliberate snow, the stirring within. I had rejected the brittle academic forms which were imposed and which constricted growth and change. But I had no real knowledge of their original purpose or source. I did not know how forming comes about, how forms congeal, how they call for renewal or how mobile life is in its continuum. I didn't know how consciousness creates social forms. I had not been taught the history of consciousness nor the evolution of consciousness as reflected in social institutions. I felt jeopardized by history, because I had very little access to its interiority, except through the great spirits and personalities whose poems and philosophies I read. There I felt part of an invisible community. Gradually, I have come to feel the inner formative unfolding of history — an inner scenario, an inner theater, a theater of the world, men and women players in role after role carrying the threads of karma and destiny — all part of a form which is living and ongoing. As a result, I am no longer such a mystery to myself. For example, why am I interested in both the physical world of handcrafts and agriculture and in the world of psyche and eros? Why does the archetype of wholeness speak so strongly despite a society where specialization and prejudice are touted? Why did I start out wanting to be a student of ancient Chinese language and history, a culture in which writing was a form of painting, and in which language was valued both for its poetic feeling and for its artistic form in calligraphy? Why do I feel the mystery of the word so strongly, as a sacred presence, in nonverbal as well as verbal forms — in pots as well as in poems? Why

do I keep asking why? — probing for the essence, the being, what stands within, behind? Why is an interdisciplinary impulse now surfacing not only in my own life but in many? These themes — physical nature and inner world, East and West, interconnection of subject matters — reflect a historic stream larger than any one individual.

We can find our companions, our inner community, living in ancient India, in China, in the Kalahari Desert, in Persia, in Egypt, in Greece, in the Middle Ages in Europe, and in native America. Our work has been and is once again to investigate the nature of the divine world as it manifests everywhere in the physical world. We are physicians, scientists, artists, priests, shamans, playwrights, dancers, social reformers, hunters, gatherers, nomads, farmers, and singers. Our intuitions tells us the earth is a temple, the body an altar. Being is Buddha, is Christos, is Allah. It may be on earth as it is in heaven.

Human beings are certain kinds of creatures. The earth is a certain kind of place. Substance has certain properties. Seasons are in a certain sequence. What we think or feel creates chemical reactions in body tissue. And as Rudolf Steiner said in *Spiritual Ground of Education*, "We must know and do a spiritual thing in order to promote a physical thing" (p. 51).

Waldorf education starts living and learning, then, from this beginning point. Education is an art. It has a form. It pays attention to details. Certain things are done at a certain time, corresponding to the chronological age of the children, because rhythms of growth follow certain laws. Certain subjects are taught and in certain ways. It is not that forms are followed. It is that forms of human and cosmic reality are given space and time and favorable conditions in which to unfold and ripen.

In many ways it is a new culture. It is putting down roots. It is not discontinuous with previous forms of culture, but growing out of them, the next step, like pioneering, going west.

"We need a complete change of direction," Steiner said at the conclusion of the lecture course just cited, given to teachers in England. We need "a knowledge of the world in which education is implicit, so that a teacher having this knowledge is also possessed of the art of education, and can exercise it spontaneously, instinctively." We have to talk so much about education, he pointed out, because the rest of our knowledge contains so little impulse for it.

This is the real reason why the Waldorf teachers do not cultivate a definite and separate pedagogy and didactic, but cultivate a philosophy of life which by teaching them knowledge of man makes it possible for them to have spontaneous impulses for educa-

tion, to be naive again in education. And this explains why, in speaking of a Waldorf teacher, one must speak of man as a whole. (p. 133)

This also precludes, he said, the possibility of fanaticism in Waldorf education, for one must look at things from the most manifold standpoints and dwell in many-sidedness.

If, he explained, one finds fanaticism and dogmatism within the movement, these rigidities come in from outside, they are not inherent. For the aim of Anthroposophy, he repeated, is to make universal what has become one-sided. If unfavorable impressions and misconceptions arise, he advised people to search out the facts and to learn what actually the Waldorf school lives by. "Then one will see that Anthroposophy can indeed give life to education and teaching, and that, far from pursuing anything preposterous or falsely idealistic, it seeks only to realise the human ideal in living human beings." The human ideal reunites imagination with cognition and reverence.

Whatever its shortcomings, Waldorf education shows a specific concern for the wholeness of the person. Rudolf Steiner starts with the classic admonition "O man, know thyself!" To ask the question "What is wholeness?" is a new beginning. We can grow toward answers. To ask the question is a foundation stone to build upon.

Rudolf Steiner insisted that education be practiced as an art because the world is art, and art means continuous connection. The root of the word "art" means "to fit together" as in the Greek "harmos," which means "joint or shoulder" and which appears, for example, in our word "harmony." It appears also in "order," which originally meant a row of threads in a loom. Through another variant, "art" appears in the root of "ratio" and "reason" and "rite" and "arithmetic"!

Education as an art, then, follows the inner form of the archetype itself, joining body and reason and the science of numbers and ritual. Order is created by interweaving threads from opposite directions.

Like other artists, educators rediscover spirit through turning to the physical world. In the same lecture course, Steiner directs our attention outward, to every flower, every animal, every person. We are to look upon the plant not merely externally, but to participate in all its processes, so that our thinking joins in the life of the external world. We are to sink into the plant to feel how gravity goes down the root into the earth, how formative forces unfold above ground; we are to feel from the inside the blooming and fruiting.

And then, O then — one is taken up by the external world. One awakes as from a swoon. But now one no longer receives abstract thoughts, now one receives imaginative

pictures. A materialistic view would not recognise these pictures as knowledge. Knowledge, it is said, proceeds in abstract, logical concepts. Yes, but how if the world is not to be comprehended in the abstract concepts of logic? How if the world be a work of art? Then we must apprehend it artistically, not logically. Then logic would be a means of discipline only. We should not understand anything about the world by logic. Thus we must enter into the objects themselves. We must go outwards, and endeavour in this manner to unite ourselves with all things. (p. 28)

These are the basic concerns which connect all the learning communities based on Steiner's indications, whether they be schools or farms or industries or therapeutic villages. They share an emphasis upon land care and practical work and handcraft, upon the festivals of the seasons and the cycle of the year, the rhythms of day and night. Schooling is based on sensory observation and imaginative participation. Art, as here described, guides child and teacher into reality.

Teacher Training and Handwork

It is surely uncommon in our country to connect teacher training with handwork. In Steiner education the connections between thinking and feeling and doing are maintained across the board, for teachers as well as pupils. Artistic activity is as central to the training as it is to the classroom. There is a kind of schooling we all need, grown-ups and children alike. We all need to grow toward soul-filled sense perception, toward a feeling for materials, toward a responsiveness to colors and to sounds, toward making something, connecting doing with knowing about. Don't just study agriculture in geography blocks, Rudolf Steiner advised. Make a plow and let the children guide it in the furrow. Let them cut with a scythe and thresh wheat with a flail. It makes a difference in your feeling to actually do something.

Gaining experience in how these activities flow into one another is part of Waldorf Teacher Training. How does imagination help us to perceive, to create, and to respond? How does handwork help us to think? How does painting speak to our souls through our senses? This clear relation to the physical world characterizes the Waldorf approach. Soul quickens within the membranes of body. Renewal of the inner life is brought about by learning to see and experience formative forces which work in nature all about us and through us. We move toward spirit by learning to see clearly into the physical world. And we learn to see that world in many instances by handling it, by working in dialogue with it. This approach has as much to do with science as it has with art.

Handwork and its marvels strengthen these intuitive connections. The senses can be gateways. A person dialogues with the world through touching with the hands. Color and curve, tool and edge, powers of metal and glass and clay and wool and wood, are garments of the gods. Learning to use them wisely can become a discipline of the whole person. We are moved by the materials of handwork — of painting, drawing, sewing, carving, building — because they are the bodies and

gestures of spiritual agencies; they are revelation. We turn toward them to receive, to transform, and to offer again. So much of the communication in our world, so many of our social arts, depend upon the labors of our hands. We need places to practice the feeling of intelligence in our fingertips, the wisdom in the movement of our limbs. Such places exist in Waldorf schools, where natural materials are given into human hands to be experienced fully.

The intellectuality and technology of public education tend to make us less intelligent by depriving us of the full resources of our being. In my own life search, I have found that true intelligence appears to be more than intellectual cleverness, more even than art and community, unless certain other qualities enter in.

The development of character, wisdom, inspiration, compassion, and freed perception are lofty goals. These are the goals of Waldorf teacher education, which offers not only technology but substance.

Waldorf teachers become involved in various ways. Some individuals begin as assistants or apprentices in a school. They develop a feel for what is going on, become oriented toward the progressions in the curriculum, and learn something about Anthroposophy. You don't have to be an Anthroposophist to teach in a school. But you do need to be open-minded.

The core of teachers who make a commitment to the school is called the College of Teachers. This group makes policy and takes responsibility for initiatives. Other members of the faculty may wish a more tentative or ambiguous connection. Their relationship is respected and their contribution valued. Apprentice teachers do not usually become a part of the College until they feel ready to commit themselves.

There are several teacher training centers in America, where anyone interested in Waldorf education may go. The Sacramento Center for Anthroposophical Studies, now called Rudolf Steiner College, offers a Foundation Year and a Teacher Training Apprenticeship Program. It has applied for state approval to give an MA in education and a BA in Anthroposophy. Its catalog describes the center's emphasis as "seeking an understanding of America's role in today's world. The faculty is working toward an ever deeper awareness of the spiritual roots of this country, its relationship to the world and world evolution. . . . Courses are gradually being added to the curriculum out of this research." The Waldorf Institute of Mercy College of Detroit gives the Foundation Year, and other programs in early childhood education, in Waldorf teaching, and in special (curative) education. The Detroit program leads to state certification and the possibility of a major in Anthroposophical studies for the BA degree. The Waldorf Institute of Southern California is offered by the teachers at Highland Hall in Los Angeles. It includes

the Foundation Year and classroom experience. At the Threefold Educational Foundation in Spring Valley, New York, there is a Foundation Year and a four-year Eurythmy School. An in-service training program is available at the New York City Rudolf Steiner School.

Each center is different, and some offer more than others. A first year of orientation may include such courses as the Development of Human Consciousness, Fundamentals of Meditation and Self-Development, Man and Nature, Man and Society, Philosophical Basis of Anthroposophy, Reincarnation and Karma in Western Thought, Projective Geometry, and artistic disciplines, such as painting, modeling, eurythmy, and weaving. In the second year, specialized subjects are offered in child development and learning, music for teachers, art for teachers, Waldorf methods of teaching arithmetic or science or language arts, and others. Classroom experience is part of the second year. In early childhood and special education, other courses are given which apply to these concerns. A three-year Seminar in Curative Education is given by Camphill Special Schools in Beaver Run, Pennsylvania, with a fourth year now available toward state certification for teaching in private schools for special children. Waldorf and Camphill schools are growing, and there is a need for teachers.

There is also a Eurythmy School in Fair Oaks, California. Biodynamic agriculture is taught at the Rudolf Steiner Summer Institute and in summer conferences sponsored by the Biodynamic Farming Association. There is a biodynamic apprentice program at the Farm School in Harlemville, New York. Camphill Village at Kimberton Hills, Pennsylvania, is developing an agricultural course as well. Living and working in any of the Camphill Villages with the mentally handicapped, one may be exposed to biodynamic methods and share in the harvest. The chapter on Camphill in this book describes the opportunity it offers for specific training in special education.

All educational communities as well as schools working out of Rudolf Steiner's indications, are centers of ongoing study and practice. Everyone is involved in the creative endeavors of learning and doing, usually in ways that are new to many. In the adult Camphill communities, the goal is the development of new social forms which will accommodate the whole person, both normal and handicapped. To serve the needs of the whole human being is of course the aim of Steiner/Waldorf schools as well. Our epoch is a time of renewal, in which a new culture is being built, appropriate to new insights of expanding consciousness. Therefore the educational impulse, the openness to learning and to steadfast practice, the artistic approach, permeates all this human endeavor in its many forms.

There is a verse which Rudolf Steiner gave to the teachers at the end of his course before the opening of the first Waldorf school and which appears in *Study of Man*. He had been emphasizing the importance of approaching education as an artistic process. He had been trying to encourage and strengthen the teachers' imaginations — their trust in their own creativity and initiative. At the same time he acknowledged the problematical aspect of imagination: how one fears to fall into falsehood and wishful fantasy. Steiner urged them to move freely in thought, to be courageous and independent, and still to unite themselves with the spirit of truth. "Be courageous in what concerns the life of the soul," he pled with them:

Imbue thyself with the power of imagination,
Have courage for the truth,
Sharpen thy feeling for responsibility of soul. (p. 190)

This is an inspiring meditation. It brings together and fuses qualities which are not usually connected. It "centers" *imagination, truth,* and the *feeling* of responsibility. To take ourselves on as creatures who imagine, as creatures who seek knowledge or truth through learning, who live in a society with others whom we affect through our feeling and our thoughts as well as through our acts — this is a lot to put together. It takes practice. At the beginning of every faculty meeting at the Green Meadow School years ago when I was briefly teaching there, we said this verse. God knows I wasn't used to saying verses in a faculty meeting! And I certainly wasn't used to hearing phrases like "responsibility of soul." But something in my own soul seemed to respond. The atmosphere smelled good, like something alive and growing, something original and brave. Because irony is more common in our culture, the verse had a solemnity I had to get used to.

That is one of the things I keep repeating, not only here but to myself: there is something expressed in Steiner/Waldorf educational impulses which does not come from mainstream culture. Nor is it a reaction against it. It seems to come from another source, from a deep well or an underground river, or it might be from a ray of the sun. It is like a new color on the palette. And it may take a while even to see it.

Our heads may have all kinds of different reactions to what we hear or read about Steiner/Waldorf education. We may think this or that. But when I first came into contact with it, in America in 1956, my own intellectual agreement or disagreement was not enough. I read the books. Some seemed challenging. Others kept echoing in my imagination. That was not enough either. I wanted the feel of

real experience. In order to understand these unfamiliar ways of approaching education, I knew I would have to jump in; otherwise I would tend to be reacting to words, phrases, concepts. I know by now how tricky it is to translate experience into words and achieve a successful, accurate transmission and reception. Steiner has had no better luck with that than the rest of us. It is hard to talk experience, and it is hard to hear it. I find I have to slow down and ponder and not jump to any conclusions.

So I enrolled in a teacher training course at the New York City School. This was in 1958, when Francis Edmunds was in the United States from England, helping to begin the New York City high school. He, Karl Ege, John Root, Christy Barnes, Arvia Ege, Kari Van Oordt, and Ruth Pusch met with our group twice weekly. Since then, the teacher training opportunities have grown enormously in this country. What goes on now in Detroit and Sacramento and Los Angeles and Spring Valley is a full-time activity. My experience was in an early stage of the history of such programs in this country. Even as such, it may make a living bridge for some readers.

The discussion classes were interesting. We read Rudolf Steiner's *Theosophy*. I began to get a better idea of why it is useful to be able to distinguish the etheric body from the physical body. And the astral body as another cluster of elements. Likewise the ego, and how it has a chance to work with the other bodies, in dialogue, like a potter with clay. It gave me a sense of what goes on when we talk about "self-creation" or "self-realization." A psychological physiology seemed helpful. I began to understand how children are very different from adults, and how we can be stuck or retarded in certain parts of our development, or overaccelerated in others. We can be bright in our heads and childish in our feelings. We need emotional schooling as well as intellectual and physical instruction. I began to understand that there is also a kind of body in society, and that masses of people can behave in a psychologically undeveloped manner even though their bodies are mature. Objectivity in self-knowledge is not a reproach, it is an insight and an opportunity. Society also, I could see, reflects the threefold membering of the human being, and therefore it will be well for us when we can disentangle economics from politics and politics from the free cultural life.

History, personal biography, and social data can be approached as symptomatology, to use Steiner's word, which, in German, has no medical connotation. That is, they can be understood as stages in the development of an organism. Self-knowledge is an ability to see where we are, and to pace ourselves. Often we can see much more than we can bring about. Insight may be instantaneous, whereas

growth takes place over time. We may learn also, if we observe ourselves, that the powers of will and the powers of consciousness are not well integrated in our epoch. While consciousness is expanding, behavior seems to be still attached to old patterns. We can see that we need to enliven our wills and to bring their natural creativity into expression. We need to lift the will, the ego and the feeling life, toward the head, as Rudolf Steiner puts it. The future depends upon what we *do*. It comes out of the limbs: thus the importance of developing spirit-willing. And thus the importance of concentrating on artistic work and sense perception. They activate the will and the "awakeness" that lies in our unconscious but may not have surfaced yet. There is an awakeness in our sleeping, says Steiner, that we need to bring into our daily life. It takes time to learn to do this. It takes time to do the opposite as well: to learn to take our daily life with us into sleep and to feel it return digested and transformed.

The artistic activities in the teacher training course were especially problematic for me at that time. I was immersed in avant-garde culture and had never questioned its mainstream. My attitudes and preconceptions about painting and dance and theater had been formed largely at Black Mountain and in the Artists' Club in New York City, and they were fairly fixed. Self-expression was certainly one of the jargonistic terms, though I had some vague intuitions about the powers within art itself to affect others. What was the self that was being so insisted upon? Were there powers in the colors and movements themselves, as well as in the hand and body? Did we really know what art was? Maybe it is an even deeper mystery than we generally assume. In *Art in the Light of Mystery Wisdom*, Rudolf Steiner shares some of his arresting insights in this domain.

At the New York City School the eurythmy classes were the hardest to get the feel of. I had excellent teachers, but I was looking for a different kind of action. We did certain exercises, "making space breathe," but were given no explanatory context. I couldn't get into it. So I talked with the teacher and expressed my frustration. I said I came to the classes from teaching English at City College, and I was ready for some physical release. I wanted free movement which would refresh me. I felt tight and congested. And here I was being told how to move, where to move, and what to feel. I certainly couldn't feel very much since there didn't seem to be any place for *me*. The talk was all about space and breathing in and out, and about vowels and consonants, and never about the individuals present. We could just as well have been interchangeable. Or angels. I didn't know what was going on, and my sense of virtue wasn't enough to make the experience artistically convincing.

Gradually I learned that release does not come from starting with vigorous limb

movements, but from *breath*. Eurythmy is not dance movement; it is not personal expression in the popular sense; it is a vocabulary of movement like the alphabet we have in language. It is an art of visible speech. We don't make up the alphabet or the language each time we want to say something. The language is there. It is a social form. It comes from deep roots in body formation, breathing, and feeling. Eurythmy is usually performed to spoken poetry. There is also "tone eurythmy," which is a visible music.

Eurythmy is an activity of primarily the etheric body. It is an inner speech which takes on outer movement. Its gestures are drawn from the movements of the larynx. Most of the movement therefore is shown in the arms and carried by the legs in continuous forms over the surface of the floor. Drawings of eurythmy forms are curved and sweeping and intricate, with sudden changes of direction. Group works are like Celtic interlace, those intricately interweaving forms on old Irish manuscripts.

Eurythmy, in its specific forms, may be therapeutic as well as artistic. Breath provides an imagery of person. It moves in two directions, in and out. It forms our silhouette by inhalation and exhalation. It circulates in the blood as oxygen and warmth. It carries the exchange of oxygen and carbon dioxide. And it is the breath center, in the collar bone area, which is source for this art.

As I have experienced eurythmy over the years, I have been able to come in phase with it more and more and to feel the dynamic flow of the etheric movement through my body. There are joy and drama in the group forms, and eurythmy movement is basic to impulses in sculpture and in writing. Many explorations are still to be made in this area.

For a person as Dionysian as myself in temperament, eurythmy offers an Apollonian counterbalance. Archetypal movement begins to awaken in consciousness. Contemporary art education has already given generous attention to exploring personal feeling and personal imagery. Always, of course, something more than personal enters in. But there is a marriage of the personal and the archetypal in eurythmy that is unique. Bodies move fluidly in powerful gestures like hieroglyphs, or in dramatic embodiments of mood from such great literature as *Moby Dick* or *King Lear*, as it is read aloud. Words and tones manifest in air, through limbs and breath.

In the schools, eurythmy is basic to the curriculum. And, like painting, it is considered a healing activity whenever it is offered in conferences and nonschool communities. The children perform it to music. They move in geometric spirals and figure eights. They also move to verses they have learned, feeling the sounds

form their movements in space. They learn the social art of moving in groups without bumping into each other! Eurythmy is often choreographed for their dramatic productions. Copper rods are used in exercises which help to develop a sense of space around the body and space into which the arms extend. (Copper is a metal that responds to human warmth.) Coordination exercises are mastered, and left-hand and right-hand dexterity are developed. Eurythmy is prescribed in special therapies.

One of the most appealing features of this new art is that everyone may participate in it. Children, the middle-aged, old, male and female — it is like Tai Chi in this respect. It is not confined to the young and the athletic. The most memorable eurythmy I have seen was by a seventy-year-old Italian artist, who moved like a passionate flame to a sonnet by Savanarola, and like a soft mercurial pulse to a Chopin nocturne.

At a recent conference where we started the day with eurythmy, we began by running in a circle holding our copper rods high, as warriors might. We stopped and planted them in the earth where we stood. Then we heard the sounds of a drum and *eee ohhh oooh,* and we stepped sideways and backwards and forwards in a three-sided figure. In our measured tread to the sounds of the drumbeat and the chant I felt an American Indian dance, deep in our roots.

How is one to become open to these unfamiliar experiences? There is an exercise in working with clay which helps in the necessary stretching and deepening of awareness. It focuses on an inner image of the vessel, of intentional emptiness. It is best done in silence. It is a simple step-by-step meditation.

The exercise is to open the ball of clay slowly, very slowly to widen the bottom from the inside, to press open the sides, and to lift and widen and thin the rim, and slowly to pinch out the rounded form, slowly, pinching, stretching, touching the clay and rhythmically turning it round and round, touching it everywhere. As the vessel begins to take form and the clay to stiffen slightly upon exposure to air and manipulation, one can exert a stroking stretching pressure, opening the form, stretching it, thinning it, little by little, until it is a thin hollow sphere, stretched and strong in its form to contain what comes towards it. This is an inner experience at the same time. One stretches, gently, rhythmically, opening bit by bit, turning all sides of oneself in one's hands, as it were, touching everywhere, supporting, widening, rising, deepening. We are making the inner vessel as well, creating our space, awakening our sacred space, which is our theater in the round, our begging bowl.

In the first painting course of the teacher training program, we used water colors on wet paper and painted from the theme of a fairy story told by the teacher. We used powdered colors mixed with water rather than dry cakes of paint, because the colors flow more easily. We were encouraged to work freely with the colors, experiencing their quality, rather than setting out immediately to make shapes. The forms were gradually built up from the touching and overlapping colors. We were asked not to draw and fill in. This was an interesting approach since most of my work with a brush had been more in the nature of drawing or writing than of "painting." Though we tend to call anything "painting" that uses colored paint, actually painting is working with the color itself, allowing forms to arise out of color. Another kind of gesture is used when one paints calligraphically, painting faces or stick figures or animals or leaves, by fixing a shape first and then applying color. I let the color follow my fingers rather than try "to make a picture." Up to this time, I had supposed that the image was what one started with or aimed for. In this painting course, the image or content came slowly out of the working itself. It is the difference perhaps between *using* color, and *living in* color. Also one learns to see that objects are not bounded with lines, but that they are bounded where their colors meet. The color changes, we move from green to blue, from field to sky. There is no horizon "line."

Since I was not expected to make a beautiful picture right away, I appreciated the warmth and lack of stress in the atmosphere. I was taught to stretch my paper, to mix the color, to use the brush in a variety of ways, just as the children are. I was encouraged to let my imagination and my hand and eye lead, rather than aesthetic standards. And again there was an experience of slowing down. We did exercises in just one color, for example, experiencing yellow, feeling it intensify and ray out and fade. Likewise we tried to come to know blue. We were asked to observe the yellow of the sun, how it condenses in a center and then gets lighter as it rays out. And how the blue of the sky is darker at the edges near the hills than at the top of the sky.

I was not accustomed to making psychological or emotional associations with color, and I had difficulty with expressions like "cheeky red." I learned that Goethe, in his *Theory of Color*, had discussed a psychology of colors, and so I read his book. Since then I have become aware of the traditions of symbolism in color, and of the feeling quality in the human aura. However, I still feel cautious about reading color psychologically, or deciding in advance what a color is going to say. Passages from Rudolf Steiner's notebooks on color, I am told, indicate that he was well aware of the ambiguity and versatility of color "feel." The use of painting in

art therapy, or "curative painting," as it is called in Waldorf education, gives an opportunity to observe relationships between soul and color. In general, all the class teachers in the Steiner schools paint and teach painting in their Main Lessons. It is a part of daily life. At conferences too, there are always times set aside for painting and other artistic activities.

In the speech course, we were given exercises in vowel and consonant enunciation and word games, which exercised our tongues and palates and cheeks and breath. The following is an example of an exercise for flexibility of the mouth, lips, tongue and teeth. It should be said rapidly and with a feeling of *turning* of the sounds within the mouth:

sip	flip	fife	
flap	faded	feather	
plump	for	plug	fallen
prop	flop	finishing	

The following exercise is directly based upon one involving the same sounds, given by Steiner, and practiced by most children in the schools, since they start learning German in the early grades:

Pfiffig pfeifen
Pfäffische Pferde
Pflegend Pflüge
Pferchend Pfirsiche

Pfiffig pfeifen aus Näpfen
Pfäffische Pferde schlüpfend
Pflegend Pflüge hüpfend
Pferchend Pfirsiche tipfend

Kopf pfiffig pfeifen aus Näpfen
Napf pfäffische Pferde schlüpfend
Wipfend pflegend Pflüge hüpfend
Tipfend pferchend Pfirsiche knüpfend

There are countless exercises in the different vowels and consonants which are fun to do; and these lead to further exercises in sound shifting. "With the cultivation of meaning, speech alienates itself more and more from the *musical* element." "The *poet* must be able to return to what the speech organs themselves want to do." "The *musical* element enters speech by curving the words and the lines."

These are excerpts from Steiner given to me by a speech teacher. When one comes to the saying of any particular line of poetry or prose, one feels a new athleticism of speech organs and of breath and of feeling.

Members of the training class were made aware of speech formation in their bodies, and we were encouraged to experience it deeply. The vowels are, as we have said, connected with feeling: Ah, ay, ee, eye, oh, ooh (Ah, a, e, i, o, u). The consonants are housing for the vowels. It is fun to feel the shape of a word like *quack,* the sharp k's like the bill of a duck opening to let the *a* through. Or a word like *head* or *might* or *blue.* We sounded each letter, in a speech gymnastics aware of the expressive quality of each movement, and experienced concretely the sensuous feelingful rhythmic breath-form of the *word.* Each word becomes a being who breathes and means.

We were also given exercises in voice athletics of another kind: or "speech formation," as it is called. We learned to throw our vowel sounds like a javelin across the room. In some training centers, speech has a full curriculum to itself. In our course, we could begin to feel the archetypal powers in speech, and to hear something like a common or universal *tone* enter into speech when it is carried on the breath in the right way. When speech accompanies eurythmy or in ritual theater, it is filled out with this fuller sound formation. In writing poetry, sound is considered the animating element.

The introduction to speech is artistic, not intellectual. It appeals to the imagination and the senses. The powers of speech as they come to be understood in grammar and syntax are meant never to lose these undertones. Speech and writing and spelling are presented not only as social arts, but first of all as experiences of breath, ego, and the genius of language. In modern linguistic theory, it seems evident that a spirit of language does exist in the human unconscious, and that forms and meanings constitute what Benjamin Whorf long ago called meta-linguistics. Language already lives in the unconscious, from which we learn it. Its powers are enormous. It is the Waldorf teacher's aim to awaken in the child the powers of language, in speech as well as in writing and reading. In order to do this, the teacher's own relation to language must be awakened and developed.

The Waldorf teachers are as involved as the children in continuing to learn, grow, and develop. There is a spirit in the schools of steps being taken together, toward a new culture which is in its early stages. At times, defensiveness and fanaticisms occur, but, as Rudolf Steiner pointed out, they are not part of the undertaking but come in from outside. They come in from our vanities and insecurities. Transforming these is part of the art of education as well. At the end of the year,

the teachers should feel that they have learned more than the children have, Steiner insisted.

In modeling, the other trainees and I worked with balls of clay, shaping them solidly from the outside and then hollowing them out and forming them from the inside as well, so as to experience the polarity of density/hollowness and gravity/levity. We also modeled the human head. The culminating exercise was to model the capitals of the carved wooden columns in the original Goetheanum building in Dornach, Switzerland. This building burned to the ground on New Year's Eve, 1922–23. It had been handcrafted by artisans from many countries who had gathered there during World War I to build together under the guidance of Rudolf Steiner. The woods were carefully selected, a new process of carving stained glass was developed, and murals were painted on the two interior domes, which were set on carved wooden columns. It was called House of the Word and was meant to be an environment of forms and colors which would speak to the innermost human being. Its destruction was a catastrophe.

The seven capitals were carved in the forms of a continuing metamorphosis through seven stages. To model them in clay is an exercise, at a far different level, like the one previously mentioned: it takes one through the inner experience of metamorphosis. These leaps of form, as illustrated by the "gap" between the caterpillar in its cocoon and the winged butterfly that emerges, are difficult for the rational mind to see. Living into forms through modeling them with our hands, we can begin to feel a transformation of our perception into a more intuitive cognition. We begin to see from the inside out.

The artistic exercises in the training of teachers grow out of that fundamental physiology which we described earlier in the discussion of the education of the child. Indeed art is grounded in human nature itself. You will remember that distinctions are made between the essentially mineral physical body which decomposes at death, the etheric body of life forces which form the mineral elements into a living organism, the astral body of sensation and emotion and consciousness, and the ego. The gravity-bound physical body can be understood by modern anatomy and physiology, but not the etheric body of formative forces and the astral body of consciousness and the individual ego being. Steiner explains in *The Essentials of Education:*

> We understand the etheric body when we live into the sculptural moulding process, when we know how a curve or an angle grows out of the inner forces. We cannot understand the etheric body with the ordinary laws of nature, but with what we get into the hand, the spirit-permeated hand. Hence there ought to be no training of teachers with-

out activity in the spheres of plastic art, of sculpture, an activity proceeding from the inner being of man himself. When this is absent, it is much more unfavourable for education than not knowing the capital of Rumania or Turkey, or the name of some mountain, for these things can always be looked up in a dictionary. It is not at all necessary to know masses of modern examination matter. There is no harm in referring to a dictionary. No dictionary, however, can give us that mobility, that able knowledge and knowing ableness, necessary for an understanding of the etheric body, because the etheric body does not proceed according to the laws of nature; it permeates the human being in plastic activity. . . .

The astral body is not natural history, natural science, or physics; it is music. So true is this that it is possible in the forming activity within the human organism to trace how the music of the astral body is formative within man. (pp. 50–51)

The astral nature is understood through musical perception — it is like an instrument played upon by the ego organization. And if we learn to experience intuitively what is working in speech, "we learn to know through the structure of speech the ego organization itself," Steiner continues (p. 52).

[In Tone Eurythmy] we call forth in the child movements which correspond to the form of the astral body, in Speech Eurythmy movements which correspond to the ego organization. We are thereby working consciously at the development of the being of soul by bringing the physical elements into play in Tone Eurythmy; we are working consciously at the development of the spirit by bringing the corresponding physical elements into play in Speech Eurythmy. Such activity, however, can only proceed from a complete understanding of the human organization.

What we must be conscious of may be expressed as follows: First period of learning — we learn to know the physical body of man in an abstract, logical sense. Then we turn to the plastic formative activity with intuitive cognition and we learn to know the etheric body. Third period: as a physiologist one becomes a musician and looks at the human being as one looks at a musical instrument, at an organ or a violin in which one sees music realized. Thus we learn to know the astral human being. And when we learn to know the genius of speech as it works creatively in the words, not merely connecting it with words through the external memory, we gain knowledge of the ego organization of man. (pp. 52–53)

The artistic element must not be allowed to exist in civilization as a luxury, Steiner says, but must permeate the world and human beings as an inner harmony of law. It is an inspiring context in which the teachers undertake artistic experience, however modestly: to feel themselves a part of cosmic artistic process. From the being of the universe there comes into human nature a formative activity which works from the periphery toward the center of the earth, just as earthly gravity works from the center outward. In clay modeling one experiences these two different forces, the sculptural and the physical. Similarly, cosmic music works in the movements of the starry constellations from the periphery, Steiner explains.

And that which really makes man into man, that principle which was divined in ancient times when such words were uttered as, "In the primal beginning was the Word and the Word was with God, and a God was the Word," — the Cosmic Word, the Cosmic Speech, is that which also permeates the being of man, and in the being of man becomes the ego organization. If we are to educate, we must acquire knowledge of man from knowledge of the cosmos, and learn to mould it artistically. (p. 54)

Why does the human being long to work artistically? Why are the art programs in the public schools and communities so popular? Because there is a natural enthusiasm for creative activity built into our bodies. There is an essential connection between artistic activity and human nature, between art and nature and universe and human being. Painting, modeling, music, movement, speech, architecture, and drama are not electives. They are the ground of our intuitive understanding of ourselves and the world around us. It is this knowledge which renews a Waldorf teacher's inspiration and effort.

Another aspect of the training course was a development of a sense of the curriculum as a whole, from first grade through eighth grade. We learned to prepare material for class use. We made up animal fables and nature stories, and practiced telling them rather than reading them. We learned not to hurry the children into reading, but to start them first with writing. We made up stories about the consonants which we would tell the children, leading into writing first through a story, and then by painting and drawing the letter, and only later into handwriting. The *B* can easily be turned into a bear, or a *K* into a king with a sword, or an *M* into a mouth or a mountain, a *W* into a wave, an *S* into a snake, or an *F* into a fish.

A teacher should be careful to develop writing out of painting and drawing until the child is able to write down what it inwardly experiences as word or sentence, Steiner said. *Essentials of Education* continues:

> The child has now reached a certain stage of development. It speaks, and can set down in writing what it says. Only now has the time come to pass over to the teaching of reading. Reading is easy to teach, if writing has first been developed to a relatively perfect stage. Only when the child has worked over in its own being, in the motor and movement systems, the content of what is written and read, when it has inwardly participated in the coming into being of the reading matter, is it ripe enough for a one-sided activity. Then the head, without danger to the development of the human being, can be brought into play in order to convert into reading what the child has first learnt to set down in writing. (pp. 56–57)

Steiner felt that writing was closer to the child, and reading was more intellectual and one-sided. If writing comes first, then reading what someone else has written makes more sense. There is some idea of where it comes from.

The teacher sees how the musical element of speech flows into a harmony with the sculptural moulding processes of drawing-writing during elementary school. This insures that writing shall be an exercise of the whole person, arms and hands and ears and eyes and spirit. This way of teaching writing keeps it from becoming abstract. Its connection with handwork sowed seeds for many later developments in my own life. What we have come to think of as interdisciplinary, a cross-over between writing and handcraft, is based on a primal union.

My exposure to Rudolf Steiner/Waldorf education has affected my teaching in college, in public schools, and in workshops. During the Title Three program in the northeast, I gave creative writing workshops to teachers in Connecticut elementary and middle schools. I took artists' materials and began with hand and eye and voice and movement rather than with content. The content came out of exercises I gave. Sometimes I team-taught with a dancer. I borrowed a selection of children's Main Lesson books from the New York City Steiner School to show the teachers what is possible. They feared that working with color would interfere with the nitty-gritty of spelling and grammar. I testified that children working artistically are more careful of how they write, more eager to make a beautiful book of their own. "Oh," said one tired young teacher, "my pupils would love to do this if I would let them."

My impression was that the teachers were not in the habit of connecting pleasure with serious learning. Nor were they accustomed to enjoying themselves in their work. We arranged to give a workshop for teachers and children together. The children caught on quickly. They gave generous moral support to the more fearful adults. In one school there were Puerto Rican children who knew almost no English and were therefore difficult to motivate in their reading and writing lessons. With colored pencils in their hands, they wrote their names over and over with great joy. Their teachers were astonished at the rise in energy.

At Haystack School of Crafts, I introduced a workshop called Writing as a Handcraft, and began my unending campaign to renew the arts of the scribe. I have tried to promote, mostly unsuccessfully, workshops in papermaking, bookmaking, calligraphy and illumination, both in traditional and nontraditional ways. These would not be for professional writers but for the general writing public and for teachers. I designed a program for Penland School of Crafts called Cross-Over: To a New View of Language, Verbal and Non-Verbal. I learned from British print-maker Michael Rothenstein the art of relief printing so that I could make an edition of poem-prints, combining handwriting with relief imagery. My intuitions from the beginning have been that hands and tongue have a common root. From Waldorf

95

teacher education, I learned more particularly how the formative moulding forces and the musical speech forces combine in the mysteries of word and form.

Although the hand is brought into all subjects, handwork as such is usually taught by a specialist teacher. It begins in the first grade with knitting. Boys and girls knit together, using large wooden needles and wool yarn of different colors. I asked one handwork teacher why the schooling starts with knitting. Her answer was intriguing: "Knitting develops out of a continuous thread." A continuous thread! Looping and ducking in and out and around and through, a continuous thread, like learning to tell a story or write a sentence or listen. She quoted Rudolf Steiner as saying, "Thinking is cosmic knitting!" Thinking could be thought of as a continuous thread that develops into whole thoughts, whole patterns. Through the limbs, one can awaken the head. The activity in the limbs is not mechanical but spiritual. On this point Steiner is quoted in *Education Towards Freedom,*

> When one knows that our intellect is not developed by the direct approach, that is by cultivation of intellectual pursuits themselves, but one knows rather that a person who is unskilful in the movement of his fingers will also be unskilful in his intellect, having less mobile ideas or thoughts, and that he who has acquired dexterity in the movements of his fingers has also mobile thoughts and ideas and can penetrate into the essence of things, one will not undervalue what is meant by developing the outer human being, with the aims that out of the whole treatment of the outer man the intellect shall arise as one part of the human being. (p. 49)

In an earlier chapter, I spoke about experiencing oneself as a form, a form unfolding, a form of moving forces, a form in whom earthly history takes place. A sense of participating in human history is stimulated by the Waldorf curriculum. Not only the external history — in the development of agriculture and metallurgy and industry, the exploration of continents and seas, the building of cities and nations, the changing relationship to the physical world through the history of science, the culture of the arts — but the inner history: the history of inner development, the evolution of consciousness and the unfolding of individuality toward freedom. This wholeness, or overall formative process, differentiates into stages of development, just as in our individual lives there are stages of development from infancy to age, marked by both physical and inward changes and a process of ripening. We do not merely change. We change in relation to an ongoing formative process. Changes then become transformations, metamorphoses in an ongoing continuum. As in the plant world, the changes all lead to the seed, which is cast in autumn and

quickens into new life in spring, so the human being bears himself like a seed, cast into spiritual realms at death, quickened into new life at rebirth. The stages of human history are at the same time stages in our own cosmic biographies. We are players in the theater of the world.

It is with this sense — that human history lives in the unconscious of each person and that the evolution of consciousness is recapitulated in our own growth from infancy to adulthood — that we meet the experiences of Waldorf education. The child is surrounded with what is suitable for his age. At the time of "an eye for an eye and a tooth for a tooth," Old Testament stories are read. At the time of adolescence, the Renaissance is studied, and the American War of Independence, and the French Revolution. As emotion becomes more individualized and more acute, Shakespeare and romantic poetry are read. In the mythic period of early childhood, folk plays from Central Europe are performed by the faculty for the children at Christmas time. The children are delighted with the devil in the Paradise play, and with the tipsy shepherds in the Nativity play . . . madonna, angels, magical star, visiting kings with exotic presents, a babe in a cow stall. On the whole, parents express little difficulty with these archetypal themes. For example, the sophisticated families of New York children (Jewish or Gurdjeffian) say they appreciate the atmosphere of devotion and respect which their children learn to share at school. Though the religious festivals are celebrated in a Christian vocabulary, their spirit is nonsectarian. A deeper unity is intended.

The handwork accompanies this unfolding process. Knitting comes in first grade with the first dawning of "thinking." The children begin to retell the stories they have heard, to make letters, to read. Knitting is part of the waking up that comes through the limbs into consciousness.

The handwork teacher rarely confronts the children with the bald statement, "Now I am going to teach you to knit." That would be risky as well as unimaginative. However, she might come to class carrying a golden box filled with golden threads. She might tell the children there was something in the box for each of them, thus building anticipation and encouraging their fantasies. They might "go on a journey" to the back of the room, where she would open the box and take out a thread of gold wool. She might then take one of the children on her lap to start the process, moving her hands and the child's hands in the gesture of making a loop, a bow, a slip knot, a chain. When each child has received a woolen thread and has made twelve perfect loops, then these will be slipped on a wooden knitting needle (usually made from a dowel and sharpened on a pencil sharpener!). Then the children will be invited to bring their needles and wool into a circle, and

97

the work of knitting will begin. Each teacher finds his/her own way of being creative on the spot.

It is not only an awareness of his/her hands and their abilities that is gained by the child, but a step into awareness of the materials of the earth: for example, the wool comes from a sheep! And this opens up another study in itself. Only such natural materials are used. The children learn about where they come from, and how the plants and animals give their gifts. Every few inches the children change the color of their knitting, and before long they have a bright scarf or hat to take home! The hat is made simply by knitting a length of scarf and then folding it over and sewing up two sides. The children are thrilled. "Teach to the highest level": one child finishes his/her hat, others notice, and soon there are many hats!

In the second grade, the children learn to crochet with cotton yarn. There is the feel of geometry here: making a circle, a rectangle, a star shape. A sense of space grows. A purse is easily made by folding up two sides of a small form. The children love to make things they can use: a recorder bag, a snack bag, a pencil case, a pot holder, a little vest. One teacher told me she starts with paler colors in order to help the children to notice more, instead of going automatically for familiar bright hues. Later she will bring in more vivid and darker colors. She will have to help some children develop a sensitivity to color. All has to be done in a living way, nothing rigid.

In their Main Lesson, the children may be learning numbers, counting, or subtraction. They may be running around the floor making geometric forms. A sense of form in space is encouraged in a variety of ways: by what is called "form drawing" as well as by eurythmy. The handwork class may crochet a hollow sphere and stuff it, making a ball. A feeling for form draws on a part of oneself which connects with the archetypal forms that stand behind geometry, one handwork teacher explained to me. She has been teaching handwork for twenty-five years and counts it a daily joy. She works closely with Main Lesson teachers and feels the deep connections between handwork and the curriculum as a whole. Handwork seems a kind of balance wheel.

In third grade, the children learn to thread a needle and to sew in a running stitch — still that continuous thread in and out, over and under. They make designs and learn back stitch and blanket stitch. They may make a bean bag or a bag for their eurythmy shoes. In this grade they are probably hearing Old Testament stories and making pictures expressing themes of the creation of the world, Adam and Eve, the ark, Jacob's ladder, Elija and the ravens, David the harpist, and his friendship with Jonathan. The pictures they make with crayons may then be trans-

lated into stitchery, using long stitches and tiny stitches, working freely on an image they particularly like.

In fourth grade, the children learn cross-stitch, as this is usually the ninth and tenth year period, when the child's ego takes a step of independence. Crossed arms are the eurythmy movement for the sound of long *a* (as in *hay*), and indicate a sense of boundary, of resistance, and sense of self. The cross-stitch comes from both directions, right and left, and is more individualized than a running stitch or satin stitch. At this time, the children will probably be reading Norse myths about the twilight of the gods. They are becoming more conscious of themselves, less dreamy. The movement of the stitch helps them to get into their bodies.

A bigger sewing project may be undertaken in this grade, something that will take a long time to complete, such as a pillow in cross-stitch. In their form drawing, the children may be doing exercises in symmetry and in mirror pictures. They will make a freehand design on graph paper which will be used as a guide for the cross-stitch project. Aida cloth, which is a cotton mesh with small holes, will be used, and cotton thread.

In fifth grade, the children will be knitting four-needle socks, learning to turn a heel, make ribbing. They may get to gloves and mittens, argyle socks, and ski caps as well. One of my first experiences in a Waldorf school was to come into a classroom and see the children all knitting beautiful diamond-patterned winter wear and chatting together. In their Main Lesson, they may be studying Greek mythology, and using clay to model vases or make masks.

In sixth grade, stuffed animals are made, different from the simple bean bags of third grade. The side pieces are drawn and cut out, and then the pieces across the back and under the belly, the top of the head and the throat, giving the animal width and girth. Woodworking is also done in sixth grade, hollowing out and rounding. Acoustics are studied in Main Lesson, and often bamboo recorders are made in crafts.

Actually acoustics are begun in grade five, through the observation of sounds. The teacher may put up a screen, and behind it rustle leaves, drip water, or sprinkle sand. The children concentrate on the quality to identify the phenomenon, paying careful attention. In grade six, there is a transition from the "Greek" feeling for the phenomenon to a sense of law: what principles govern the pitch and tone of a sound. In making the recorder, the students must learn where to put the holes and how large to make them. This is practical acoustics in artistic form.

An interesting connection is made between the development of the child's body at this stage and the shift in scientific approach. About this time, the cartilage

99

thickens, and one can feel the result of tightening muscles and tendons. A sense for cause and effect grows organically at the right time.

In seventh grade, the children make handsewn clothing: aprons, shirts, skirts. In eighth grade, they learn to use the sewing machine. They should be learning new embroidery stitches in seventh grade to put on their handsewn articles, and on their machine-sewn clothing as well. They may use a pattern for a shirt, and then learn to make a pattern.

The children help each other with their work. They are allowed to talk as they knit and crochet and sew. The mood is quiet and social — "relaxation without chaos." These handwork classes meet usually twice a week. The program may vary from school to school, teacher to teacher, but the intention and approach are shared.

In the high school, crafts are taught by master craftspersons, who treat the students as apprentices. Weaving, woodworking, pottery, sculpture, basketmaking, and painting are taught in blocks of three to six weeks. Bookbinding and cardboard boxmaking are taught in eleventh and twelfth grades, as are lettering and batik. Carpentry and cabinetmaking are a special skill taught in some schools.

The artistic process moves in two directions, inward and outward. Handwork leads toward mobility of thinking and guides the will. An ethical attitude toward the world is encouraged through a respect for the life of materials: "the way the stone is," "the feeling for the material," "the one who cares about the world learns to behold the world." A social impulse lives in the crafts. The children begin to look at what people do, what they wear, what they make, and at the objects around them. How are they made? Where do the things come from? Their handwork awakens consciousness of materials and processes and the crafts of different cultures.

There is an inner experience as well, an inner picturing, an inner feeling which is expressed through the limbs in a social deed, an outward expression. These two realms of outer and inner are connected through the artistic process. "The bowl is not only beautiful but holds the rice." Art is intrinsic to the wholeness of life. It is the crossing-point in the human being, where outer and inner are united. We live in this double realm.

This connecting of the realms is another example of how the whole is reflected in its parts. The practical bowl reflects a fineness of artistry. Art is the most practical activity as it brings the human being into a complete physical expression. The concept of "practice" is common to spiritual disciplines and to learning in general. It is a physical path toward an inner capacity. As described earlier, we stretch the

clay into a vessel and feel ourselves gradually increase in our capacity to contain reality. The "practical" is never divorced from inner awareness in Waldorf schooling, but rather, is the expression of soul and spirit. This dynamic of art is at the heart of life. It engages us wholly, inside and out, head, heart, and hands.

More on
Curriculum/Methods/Teachers/Children

TEACHERS DO NOT WORK DIRECTLY UPON THE BEING OF THE CHILDREN. They surround the children with what is suitable for their age. Intellectual development is not the focus of concern with small children, but tends to awaken naturally later at puberty.

Children grow through the activities and environment which surround them. The real goal is not the subject matter itself but the development of human capacities. Steiner's *Discussions with Teachers* states, "It is less important to us that the child remembers what he is told than that he should develop his soul faculties" (pp. 41–42). Intellectual skills and intellectual knowledge are part of the picture. The other two main parts are emotional development, and development of will through rhythms of work and artistic activity. These parts flow into one another. Age groups are kept together partly because, though intellectual activity may vary widely in the group, the emotional development will be similar. Intellectual development does not need so much direct emphasis at this stage. If certain emotional and imaginative developments do not take place now, they will be very difficult to achieve later without the help of illness.

In an earlier chapter the changes in childhood and their physical signatures were discussed: the change of teeth and puberty. The change of teeth, Rudolf Steiner explained, is a signal that the child has, in a certain sense, become the master of his/her body. It is now the child's body, not the inherited body from mother and father. The teeth are the final stage in the transition. One becomes the sculptor of oneself. One separates from the bosom of the mother, the bosom of the family, and goes into the world, goes to school, joins a group of one's own years, one's peers. The experience of interchange, the social element, becomes very important.

The forces that formed the body are now free for imagination, memory, and rhythmic work. Waldorf education takes account of these modeling forces and concentrates on those experiences where the children feel most at home: the arts, music, spoken language — all in some sense formative work. The force which gave the child its physical growth, now becomes the vehicle of imagination, of inner picturing. In *The Kingdom of Childhood* Steiner says:

> And so between the change of teeth and puberty you must educate out of the very essence of imagination. For the quality that makes a child under seven so wholly into a sense-organ now becomes more inward; it enters the soul life. The sense-organs do not think; they perceive pictures, or rather they form pictures from the external objects. And even when the child's sense experiences have already a quality of soul, it is not a thought that emerges but an image, albeit a soul image, an imaginative picture. Therefore in your teaching you must work in pictures, in images. (p. 36)

Inner life and physical body are connected through a process which helps to form them both. The physical vehicle of the feeling life is the rhythmic life of the body: the breathing and circulation of air, the pulse and circulation of blood. The rhythms of the body, of the day, of the week, of the semester, of the seasons of the year, are observed in the school life. Regular sleep habits are encouraged. The meaning of sleep in relation to learning and harmonious development of body/soul/spirit is stressed over and over again by Rudolf Steiner, not only for children but indeed for the human being. Sleep is not only a time of physical rest for the physical and etheric bodies, but a time of special awakeness for ego and astral bodies. The rhythms of waking, dreaming, and sleeping are related to thinking, feeling, and willing. And the way we enter into sleep and the way we wake are not without importance. One way of understanding meditation, at an advanced level, is that it is the ability to remain conscious during sleep. This implies that the sleep state is a portal into an altered state of awareness. In daily life the teacher and children give special reverence to the experience of sleeping. Rudolf Steiner suggests that disturbed sleep habits are a symptom of society's imbalance. We need to develop a renewed intuitive contact with these basic rhythms.

The school day has a certain rhythm. The children seem to like that quality in Steiner schools, and they look forward to the day with lively anticipation. In all the grades school begins with a verse, written by Steiner, which Waldorf school children and teachers say every day (in various translations).

103

MORNING VERSE
(For grades one through four)
The sun with loving light
Makes bright for me the day.
The soul with spirit power
Gives strength unto my limbs.
In sunlight's radiant glance
I reverence, O God,
The human power which you
So lovingly have planted
For me within my soul,
That I with all my might
May love to work and learn.
From you come light and strength;
To you stream love and thanks.

MORNING VERSE
(For the upper grades)
I look into the world
In which the sun is shining
In which the stars are sparkling
In which the stones repose.

The living plants are growing
The sentient beasts are living
And man, imbued with soul
Builds there the spirit house.

I look into my soul
Which lives within my being.
The World Creator lives
In sunlight and in soul light
In world space there without
In soul depth there within.

To thee, Creator Spirit
I would turn to ask
That blessing and pure strength
For learning and for working
May ever grow within me.

During the term, themes that are broached early in the year are brought up again and reviewed at the end. A theme struck in an earlier grade is returned to later at a different level. Natural science, for example, is taught in the early grades as nature study, largely through story and picture, using the child's natural feeling for plant

104

and animal. Later, when the children take up botany in grade five, mineralogy in grade six, or zoology, nutrition, acoustics, optics, chemistry, physics, the child is ready for more objectivity, more information. Again in high school, when the themes of history are reintroduced, they engage the student in a much different way: the history of art, for example, taught in grade nine, reaches the child differently than earlier studies of Greek vases and Dürer etchings in grades five and six. Since in elementary school the Main Lesson teacher ideally stays with the class, s/he has an opportunity to develop and interweave these strands sensitively in relation to the growth and development of the students.

The seasons of the year and their rhythms are continually a source for special attention and enjoyment and celebration. The Christmas season, as was mentioned, is introduced with an Advent Garden and an Advent Wreath. Each day the candles in the wreath are lit: one the first week, two the second, three the third, all four the last week. An Advent Calendar is made for the month, and each day the door to the day is opened showing the picture within. On Christmas, the manger scene is revealed. Beeswax figures, tissue-paper stained-glass windows, handmade candles, and cards and ornaments are made. For sophisticated modern children who are so used to store-bought things, making their own can be a revelation. There is often a Christmas Fair. In this season the teachers perform a traditional play for the children. A sense of wonder is in the air, at how the world turns around at this time, and how the sun starts back.

Michaelmas is another festival which receives special attention. It comes at the end of September, the twenty-ninth. It is a harvest festival, a time of gathering and seed-sowing. It is also the time of the great myth of Saint Michael and the Dragon. The children sometimes make kites and fly them like dragons in the sky. Plays are created, pictures painted. Michael's iron sword is felt as individual strength. The inner meditative life of the teacher stands behind these festivals and helps to create a strength of mood and rich enjoyment. Easter and Saint John's Day (24 June) are also abundantly observed.

The children always have something to look forward to. This is an important ingredient of their teacher's relationship to them. They are given an idea of what lies ahead, what is coming, what they will do next week, next year. The young first graders look forward to becoming, in their turn, a second grader, third grader, and so on, and to doing the things they see their comrades in those grades learning to do. In the school assemblies, which happen regularly every week, I've noticed that the presentations are announced, not by children's names, but by grade. "First grade will now say a poem." "There will now be a geography lesson by fifth

grade." "Seventh grade will perform a recorder piece by Bach." The children in each grade seem to enjoy a strong sense of identification and of worth — a sense of pride in sharing with others what they have learned. Twelfth grade performs a play as part of its graduation week. The play will be a significant artistic and human experience for the entire school.

The aim is to give the child concepts which can grow as the individual grows. The aim is not so much to learn to define, as to learn to characterize from different points of view.

Rudolf Steiner has called the preschool child "a sense organ," who drinks the world right in, and reacts in imitation. The kindergarten teacher keeps this in mind always. The kindergarten is not a classroom but a playroom. The kindergarten teacher observes the children at their play, knowing that the way they play will be reflected in the way they work when they are older. They begin to be aware of one another. The teacher tries to awaken an imaginative concern for taking care of things by personifying objects and giving them feelings. "Look at Poor Coat lying on the floor all forgotten and crumpled up. Doesn't he have a friend who could help him find a place to live?" The children's toys and clothes "live" with them in the room.

In the first three grades, the children are naturally lively. They can't sit still. On the other hand, they shouldn't run wild. What is a good balance? There must be some time of sitting quietly if certain things are to be learned. The answer seems to be to organize their urge to move! Let them run about the floor making the shapes of letters. Let them beat a drum in the rhythms of multiplication: tap tap BOOM tap tap BOOM, while the other children chant "one two THREE four five SIX;" and then leave out the "taps" and the numbers in between, and rhythmically beat in silence shouting out every third beat ". . . three . . . six . . . nine . . . twelve . . . fifteen . . . eighteen . . ." Let there be vigorous opening exercises every morning: stretching, songs, poems said loudly and softly, eurythmy. Let the children feel welcomed, body, soul, and spirit.

It is helpful, Rudolf Steiner advised, to seat the children in groups according to temperament, though it may be a few weeks before the first grade teacher can gather a sense of the dominant quality. Is the child primarily phlegmatic: an inward child, interested in food, often blond and chunky? Or melancholic: also an introvert, tending to be slender, tall, tender-minded and vulnerable, interested in reading and puzzles, observant, not overly social? Or sanguine: curious, happy, interested in everything, with a short attention span? Or choleric: aggressive, passionate, carrying his/her forearms like hammers, a natural leader, adventurous,

sometimes destructive? We are all mixtures, but one or two traits tend to dominate. Seating the children by temperament provides an opportunity for them to tone each other down or, in the case of the phlegmatics, to wake each other up! It also gives the teacher a sense of physical relationship to the class, like a symphony conductor with an orchestra. The different instruments are grouped together, the violins here, the bass there, the percussion over there, and the cellos in front. When s/he tells a story or describes a horse, for example, s/he will know that the phlegmatics will want to hear about how much hay the horse gets to eat and how many pails of water to drink. The cholerics will want to hear about the cowboys and how fast the horses can gallop. The sanguines will want to hear about the ponies and how cute they are and how they can pull carts and be petted at fairs. And the melancholics will listen seriously while the teacher tells how the horse's hoof is really the third finger of the hand! So the teacher prepares his/her presentations with a feeling for the different kinds of interests that different children may have, and tries to speak to the children's natures to bring about a kind of balance. Steiner's *Practical Advice to Teachers* says, "For his will life you will be a good educator if you endeavour to surround every individual with sympathy, real sympathy. These things belong in education: antipathy that enables us to comprehend and sympathy that enables us to love" (p. 39).

The teachers are advised to watch their own balance, and to be aware of the abuses any one-sidedness can commit. A bad experience with a one-sidedly choleric teacher, or a phlegmatic, or overly melancholic or sanguine one, can sow seeds for physical illness in the student's later life. Steiner's *Essentials of Education* explains that the relationship between adult and child will inevitably affect breathing habits, digestion, limb mobility, and heart rate.

Teachers should keep alive in themselves a sanguine temperament, which is the one most characteristic of childhood. To remain a child in part of oneself is necessary, Rudolf Steiner observed in *Discussions with Teachers*, for creativity and artistic work.

What is the poet's productivity actually founded on — or indeed any spiritually creative power? How does it come about that a person can become a poet? It is because he has preserved through his whole life certain qualities which belonged to early manhood and childhood. The more a man has remained 'young,' the more aptitude he has for the art of poetry. In a certain sense it is a misfortune for a man if he is not able to keep some of the qualities of youth, something of a sanguine nature, his whole life through. It is very important for a teacher to be able to become sanguine out of his own resolve. And it is moreover of great importance for teachers to bear this in mind, so that they may cherish this happy disposition of the child as something of special value.

107

All creative qualities in life — all that fosters the spiritual and cultural side of the social organism — all these things depend on the *youthful* qualities in man. These things will be carried out by men who have preserved the temperament of youth. All economic life, on the other hand, depends upon the qualities of old age finding their way into men, and the old man is indeed a phlegmatic. The business man prospers most if to his other attributes and qualities there is added a touch of phlegma, which really already bears the stamp of old age. . . . You see, if you are thinking of the future of mankind you must really notice these things, you must take them into account. When a man of thirty is a poet or painter then he is also something more than "a man of thirty," for at the same time he bears within him qualities of childhood and youth which have found their way into his being. If a man is creative you can see how a second being lives in him, in which he has remained more or less childlike, in which the essence of childhood still dwells. (pp. 34–35)

As was said above, the teacher does not work directly upon the being of the child. The teacher provides activities which will foster certain capacities. The being of the child will respond in its own way to certain atmospheres and experiences, and it should be left free to do so. The teachers try to remove obstacles that may lie in the child's way.

Speech is one of the main ways of engaging the deeper being of the child. By speaking creatively, one can affect this being. For this reason it is given so much emphasis. The teacher knows there are ancient mysteries connected with language: the mantra, the rune, the mythos, the logos. There were Logos Mysteries at Ephesus, of which Heraclitus was a priest, and where Saint John was initiated.

The main goal of the education is to help the children feel at home in the world. They feel the connection with nature intuitively, and this is a gift to be treasured. They gradually come to feel themselves as part of humanity and the richness of culture and history. Growth carries with it intuitions of unfolding forms and a future beyond the present. Growth consciousness can become an inner sense, which helps us read experience in terms of its relation to the whole, rather than isolated and disconnected. Growth may be felt as pain. Pain may alert us to something that needs understanding or correcting. Teachers particularly take on the fact of pain, as everyday they experience themselves in human relationships where they always have so much to learn. The children are like Zen counsellors: rapping their teachers over the head when they fall asleep, that is, when they fall into unawareness or, because of their own suffering, are not able to respond generously to another person's need.

The faculty meet together every week. They discuss the children and their own problems. They share experiences and offer help to one another. They usually study a book by Rudolf Steiner which helps to nourish them and helps them to

press on together in their living and learning. In a "case conference," the whole faculty sits together in a common concern over a particular child. If there is a problem, the child seems to benefit simply from being carried in the bosom of the group of teachers, even if no outwardly apparent solution is found.

Ideally, as part of their class preparation, the teachers strive to meditate upon their children individually. At night they call up an inner picture of each child, one by one, re-envisioning the way the child appeared during the day, how s/he walked, spoke, held his/her crayon, whether s/he was gaining or losing weight. The teachers review the day's relationship, concentrating on the child's higher being. They take this picture with them into sleep and again in the morning think afresh of the child. This inner preparation for meeting a class anew each day is said to be very important and fruitful for the children. When for some reason the teacher is not able to perform this meditation, the children are said to be sometimes unruly — and to feel the raggedness of their teacher's psyche. A quality of consciousness offers itself as a vessel in which the children may safely play and go their way.

It is important for the teacher, Rudolf Steiner said in *Discussions with Teachers*, to get rid of the habit of unnecessary criticism. "It is not a question of always trying to improve upon what has been done. A thing can be good in a variety of ways" (p. 37).

In the teaching of the future, Steiner wishes to call to the attention of teachers how important it will be that "we should develop as many social instincts as possible, that we should educate the social will" (p. 42). How is that to be done in a situation, for example, where certain children in a class are like Cinderella, avoided and disliked by the rest? Rudolf Steiner often recommended the telling of a story which will resemble the real situation. After one or two attempts, he said, a friendly, social atmosphere will be restored, with mutual sympathy between the children.

"All actual punishment I should consider superfluous, and even harmful" (p. 62). If damage has been done, it should be made good by the children. If naughtiness persists, in the class as a whole, the teachers may well seek the fault in themselves. "A large proportion of naughtiness comes from the fact that the children are bored and have no relationship to their teacher" (p. 61).

In the rhythms of growth between the changes of teeth and puberty, there are two lesser thresholds which have been mentioned. Around the ninth or tenth year, grades three to four, the children become more independent, differently questioning, not so clinging to their teacher. There appears a new quality in their consciousness, as if they are asking, "Was my confidence really justified?" At this time

they need a different kind of reassurance, not in words but in the whole process. The child's ego is connecting more deeply with its organism; differentiation is taking a step.

Then about grade six, around the age of twelve, there is another threshold. This one is marked more visibly by the beginnings of physical change. And this change is experienced by the child in his/her bone structure. The bones are growing, in the face, in the jaw, in the length of arm and leg. Especially with the boys, there is a change in the way the children move, because of the changes beginning in their skeleton. Having reached a kind of Greek perfection the year before, they now become "Romans," as one teacher put it.

The curriculum accompanies this change in the bones, in the flesh, and in the child's awakening consciousness of him/herself as a separate being.

The transition of the nine- and ten-year-olds is accompanied by taking up the subject of "man and animal" — not in fable and nature story as in earlier grades, but by bringing in another perspective. "Man and animal" is taught in the fourth grade and is the children's first introduction to zoology, which will be taken up again in grade nine. The children look at nature and try to understand her forms, and the relationship of her forms to their own. The teachers try to give a living picture of the threefoldness of the human form: how the head, the trunk, and the limbs are so different from one another, and yet together function as a membering of a whole. A sense is given of how the different parts interpenetrate: how there is a limbness in the jaws of the head, and how the heart and lungs in the trunk send air and blood throughout the entire body so that the whole "breathes" and "flows," and how the nerves of the brain and spinal column spread their network of intelligence even to the surface of the skin, from toe to pinky.

The earth, the air, the water, the warmth — all work in the child's organism, and the children begin to get a feel for their connectedness with the mineral world, the animal world, the plant world, and the sun and stars. And they begin to get a feel for the different qualitative contributions of the crystallizing processes, giving shape; the mobility and communication of air; the fertility of water; the healing and lifesustaining warmth. The world of nature actually carries these processes in purer states. And the children begin to see how the human being, by being less specialized, has a different relationship to cosmic forces. Later on, the idea of the human being as microcosm will have roots in these early imaginative pictures.

Meanwhile the children experience how splendid and beautiful the animals are, and how they do many things much better than we can do them! A horse can run, a beaver can build, a mouse can nibble . . . the best! The animals are partial special-

izations of capacities which have remained general in the human being. The human being can do everything, through tools which he chooses. But he doesn't *grow* them: the hooves, claws, pincers, sharp teeth! Instead, he makes shoes, shovels, clamps, knives, and so on. The growth forces which become specialized in the animals are held by humans in reserve and are used in the development of our thinking.

The animal is built in the direction of its motion, horizontal to the earth. Human beings are at right angles. The animal is specialized, we are many-sided. Our erectness gives our heads a kind of independence from our bodies, and frees our hands for manual dexterity. The human head, in contrast to the limbs, is a sphere, with its bony structure on the outside, a kind of closed globe. The legs and arms radiate out, and are the radii of a circle whose center lies outside the body. Our trunk is not so closed as the head nor so open as the limbs. Notice how the ribs gradually open out. The bones of the limbs are on the inside, those of the head outside.

The cephalopods, of which the octopus is an example, are like free floating heads. Their many arms are really part of their lips, which are used for tearing! In man, these become our limbs. The children study the octopus in detail, drawing and painting it, observing it when possible in an aquarium. But the image of the octopus lives first in their imaginations, awakened by their teacher: recalling both its special quality and its relation to man.

And so it is with other animals. The lion is in a sense all chest; his roar makes him king of the jungle. The cow is all stomach, and her digestive genius feeds us. The plants she eats turn into milk. Her manure of fibres, feeds the earth and is used as fuel. And the eagle's noble head is born aloft on mighty wings, flying almost as swiftly as human thoughts. Steiner discusses this in detail in *Man as Symphony of the Creative Word.*

At this time the children visit farms and zoos and bring their pets to class. Teachers can develop this theme as imaginatively as they wish. Their study of man and animal is related continuously to the children's writing and reading and art work and the making of their books.

In grade five botany is introduced. What is most animal-like in the plant? The flower (of course!) with its color, the mood and feeling in the petals and aroma, and with its reproductive organs. What is least animal-like about the plant is its immobility. It remains rooted to the spot, in order to grow. (Air plants are an exception.)

The plants are studied, drawn, and painted. Poems are written about them, and vocabulary is increased: calyx, corolla, fungus, conifer, bulb, monocotyledon, nec-

tar, pollen, botany, caterpillar, chrysalis, pupa. Spelling lessons are enlivened by these new and wonderful words. There is a relationship between the flower and the butterfly, very often in appearance. This resemblance may be expressed in a poem for the children, like this one, written by a teacher for his fifth-grade class.

THE FLOWER AND THE BUTTERFLY

There's the seed and the egg,
Just like one another!
There's the sprout and the caterpillar,
Green sister and brother!

There's the bud and the chrysalis
In their dream beds so tight.
There's the blossom and butterfly,
Born into the light.

Oh blossoming flower
With nectar so rare!
Oh beautiful butterfly
In the sun-lit air!

I see you together
And I know what you do,
You give to each other
As the sun gives to you.

— Clifford Monks

On the day I visited this class, the children copied this poem into their botany books and filled their pages with butterflies and blossoms.

This teacher said that the key to the introduction to botany in this grade is that the plants of the earth are the soul of the earth. This is meant quite specifically, right down to the soul qualities of carnations and sunflowers. He wrote the following poem for his children:

THE SOUL OF THE EARTH — IN TIME

Man has a soul full of qualities
Like purity, greediness and love,
Which every night when he falls asleep
He carries to the heavens up above.

The Earth has a time of resting too,
But she spreads her soul far and wide
And the plants of the Earth are her soul's birth
On the mountains and countryside.

The spring is the time when she starts to dream
So the meadows and valleys begin to green,
And when in the summer she's fast asleep
The blossoms are full in the mid-day heat.

But when she yawns and begins to wake
Then the blossoms turn fruit for us to take,
And not long after it's wintertide
And the Earth's wide awake with her soul inside.

The plant life of the earth is also studied in geographical space, from the ice caps at the poles to the equator.

An analogy is made between the sequence of plant forms and the development of the children. They seem to enjoy the idea of being at first like little mushrooms, then the more mobile lichen/mosses/algae; then the uncurling fern; the conifers, the monocotyledons; the lotus; the dicotyledons; the apple. Extensive comparison is made between the archetypal lily plant and the rose. The lily grows from a bulb underground, out of its own earth so to speak, and has characteristically six petals. The archetypal rose grows from a root, not from a bulb, has five petals, and is the basis of all fruit trees. They are all "roses."

The following are some verses written by the teacher for the various stages. The pictures the children drew to accompany them were delightful.

CHILDHOOD AND PLANTS

When I was a babe so small, so small
I couldn't hardly move at all,
My soul was then so fast asleep,
The mushroom only sleeps so deep.

But when I walked and stood upright
And talked and talked with all my might,
And I knew joy, and I knew pain
Then like the mosses I became.

Then came the time when I said 'I'
By which myself I signify.
My soul stirred more; I could remember,
And like the fern I wakened further.

So more and more my soul did wake
And wiser still became my state,
And at the age of four or five
As cone-rich conifer I did thrive.

113

I came to school and learned with joy
And did my mind with skill employ;
I blossomed then in simple way
A *daffodil*, a *tulip* in glad display.

Eleven years is now my age
And very special is my state;
I'm like a *lotus*, betwixt, between,
I sleep not, nor wake yet; but quietly dream.

I look to the future and joy to see
What in my life will come to be;
A mind awake; a heart that knows,
A blossom wondrous like the *rose*.

An explicit connection is made between the musical scale and the progression of plant forms. In a grade five which I visited in the Sacramento Waldorf School, the teacher Richard Atkinson had prepared a block called "Botany — As Music and Poetry!"

As an introduction to our study of the plant kingdom, I led the children from a dramatic story of the seed's awakening to their own creative expressions of this birth of life forces. Each child discovered a tonal harmony which we then moved to by using our cupped hands to be the seed. Then as the melody was played, our hands followed the opening of the seed, roots' first search, uplifting of the seed-enclosed seed leaves, breaking into light and warmth, spreading of the seed leaves, upward striving of the stem and then — the first true leaves. All this formed by a few notes! A poem-like expression followed.

The children each wrote a tune, which they played on their recorders. It was called "The Seed's Awakening." And each child accompanied this tune, in written form, by a poem. The children's ability by grade five to play the recorder, to read music, and to write music, has been developed along with their other studies. Here are a few of the poems these Sacramento children shared with me.

The little seed awakes so slow,
Then digs through the earth like a mole.
Soon after the leaves bud at a slow rate,
Then the stem pushes through so very straight.
The starter leaves have now shriveled up,
New leaves sprouted at the top,
They will keep going — they won't easily stop.

114

In the cold dark earth lies a seed,
Then spring comes,
The earth awakens!
Something happens to the seed —
A crack comes through,
The root takes hold.
A stem pushes its way up,
With two small leaves so bold.

The tiny seed lies in the ground.
Nothing humbler can be found;
The seed cracks open, and sends out shoots,
Which grow into a sprout and roots.
Finally after days of toil,
The seed breaks out of the cold damp soil.

The warm seed is in the ground
The roots pop out and look around; then they dig in the ground.

Then the stem begins to grow
and then the leaves come very slow.

The sun begins a shine
on his face — just like mine!

Botany as music! That was their theme. In every child's Main Lesson book there is a page with that title, with the music written underneath, and then the poem. The pages are decorated with drawings in colored pencil inspired by this experience, each in his/her own way.

At this time, the children may begin to draw more consciously from nature, whereas earlier the imagery of their painting and drawing came more from their own inner life.

Geography is also taught at this time, in an imaginative way that is meant to guide the child from an experience of the local, home region to a sense of the continents and oceans and rivers and mountain ranges and cities and rural cultures and peoples of the earth. Geography is considered a basic integrative study, a source which flows naturally into many subjects. Artistic work grows naturally out of map making and the study of the earth and its physical cultures. In later grades, much is made of the fact that the great mountain ranges of Europe and Asia run east and west, those in the Western Hemisphere from north to south. These mighty gestures indicate a morphology of the earth which corresponds to the tensions of its soul, ultimately to be reconciled in the universal symbol of the cross. Rudolf Steiner

gave many helpful suggestions for the teaching of geography, as a key image for knowledge of the world.

As changes in the children's skeletons become more apparent, geometry is entered into more fully. The children begin to use rulers, compasses, to enjoy straight lines, and to work very carefully and exactly with a sharp-pointed pencil. They make the different geometric forms, color them, and project them in colored string constructions. Later on, in high school, these forms will be *proven*, but for now they are absorbed more artistically. At the same time, freehand drawing is continued. The children do some surveying, and begin to be able to imagine that a line has no thickness and a point no diameter.

Mineralogy is studied in grade six: the formation of the land around the school is the starting point. Is it granite? limestone? chalk? slate? Field trips are taken. Precious stones are studied. The children are entering more consciously into their own bodies, and therefore can feel the earthly connections more and more consciously. Physics begins now with experiments in acoustics and in optics; followed by ones in heat, magnetism, and electricity. Chemistry and nutrition and physiology may also be introduced at this time.

History in grades six and seven covers the scope from Rome to modern times. History of the Romans through the Middle Ages, to about 1400, is taken first. Then the Renaissance, its discoveries and inventions: Copernicus, Kepler, Galileo, Columbus, Magellan, Vasco de Gama. A history of the United States is begun, relating it to the sweep of world history. The time of revolutions and wars of independence is upon the child as well. For history is not only the external movement of people and development of machines and institutions. There is the emotional history of humanity — the interiority of spirit which empowers the changes. Biographies of great individuals are read and plays are composed on themes of discovery, change, and struggle.

In grade seven, perspective is introduced in the art lessons. It is part of a shift in the child's growing consciousness: perception of the three-dimensional, and more awareness of the positioning of the observer. The meaning of "perspective," of individual seeing, and of seeing from different points of view, is touched upon. Consciousness of perception itself opens up more in high school. In grade eight, the history of civilization from 1600 to the present day is recapitulated.

I am not attempting to give an exhaustive account of the Waldorf curriculum. My hope is to create a feeling for the spirit in which the work is done, and to give a sense of the formative unfolding of consciousness which underlies the sequence. Rudolf Steiner gave many indications of what should be included, but always

stressed the freedom of the teacher and the need for review as times change. The Waldorf School Movement comes at a certain point in history and enters upon the work necessary for this time. It is not a mechanical or absolute blueprint. Its study is that of the human being, both historical and prophetic. And the educational impulse which vitalizes it, works to transform the teacher as well as to teach the children. Education in the "new age" involves us all, as we all are entering into a new development of human consciousness and the social order. Part of the appeal of Waldorf education for young teachers is that they are not stuck in what they have already mastered, but are entering into a dynamic situation which will ask them continuously to grow and to learn. Fuller documentation of curriculum can be found in books more specifically devoted to that purpose. (See the works of E. A. Karl Stockmeyer, Caroline von Heydebrand, A. C. Harwood, Hermann von Baravalle, Werner Glas, and the many educational lecture courses by Rudolf Steiner, as listed in the bibliography.)

The curriculum in the elementary school may be viewed as a counterpart to the gradual process of incarnation, that is, the process whereby the children become *awake* to themselves in their bodies in feelings, in mind, *here now*. High school is a period of what Francis Edmunds, a noted British Waldorf educator, calls "penetrating phenomena." It is a time of entering into the experience of conscious individualized knowledge.

The curriculum in high school is not organized chronologically. For example in grade eight, modern history is studied. In grade nine, it is studied again, but in a different way. This repetition and variation makes a "hinge" between grammar and high school. In grade ten, ancient history is taken up once more. In grade eleven, medieval history. And in grade twelve, world history. The Waldorf curriculum from grades one to twelve moves like a spiral, similar themes reappearing at different levels. It is strikingly cumulative in effect, extending and broadening a given subject as the students' consciousness matures. The children want to feel that when they enter high school, they are taking a real step into something new.

In high school they work with specialists, no longer the class teacher. The math teacher, for example, will teach all four years of the subject, and thus continue to provide a continuity of relationship. For the teachers this is a fertile method. It allows them to develop their sequence of courses from one year to the next taking into account the actual unfolding growth of a particular group of students.

There continues to be a strong community feeling in a class, but there is not the same orientation around the figure of the teacher. The children are internalizing their experience of authority and preparing to take on their own powers of imagi-

nation, of initiative, of courage for the truth, of responsibility of soul. They have experienced the archetype of the teacher as a faithful sympathetic friend and guide and earnest source of knowledge. Later on, they will make a relationship to their own inner teacher. It is possible that the mistrust of power and authority which characterizes our social culture may have its roots in the unsatisfactory relation of the public school children to their teachers. It is possible that the lack of earnestness is communicated.

Personal wholeness as a path for teachers in their own professional endeavors is not the usual concern of public schools, nor of college education departments. The inner life of teachers is hardly taken into account, let alone respected and nourished and drawn upon, which may account for many of the symptoms of boredom, fatigue, cynicism, anger and duplicity. There may also be a connection between the lack of soul-to-soul relationships in public schools and the fact that the schools are run not by the authority of teachers, but by legislatures and administrations. Money and policy come from school boards and state government, and policy is often connected to money rather than to human needs. Many schools have chronic difficulty with staffing and curriculum, because they do not know what the state government will vote next. The Waldorf School Association supports strongly the movement for Independent Schools. They believe that education should be free of government control and should be run by the teachers in a school.

The relationship of teachers to their wages is another point to consider, since there seem to be powerful psychological-ethical side effects of financial practices. The primary concern of many public school teachers, as with our citizenry as a whole, is the salary check. The teachers organize in unions to protect their jobs, to make salary demands, and to limit hours of work — furthering the idea of teacher as commodity, which can be bought, paid for, and contracted for specific services. This is far from education as an art, and the teacher as artist. And this atmosphere is communicated to the students. Yes, it is far from being the communication between soul and soul, which Rudolf Steiner said is fundamental to early learning, with people caring about each other, both in faculty and student body. In public schools the commitment seems to be to the contract, rather than to the persons.

Education is part of social life. It has therefore its appropriate relation to economics, politics, culture. To make teaching a commodity is to build a source of error into the social organism at its root. Work is a personal offering. Money must circulate, like blood, in the social organism if the society is to be healthy. It must *move.* Money is a source of initiative, of possibilities. It is a right. It should therefore be administered — not owned. It should be available where it is needed. This

fundamental social law is exemplified in Camphill communities which will be discussed in chapter 7.

It appears that new age schooling, in whatever form it appears, develops out of a new age concern, and the wholeness of this concern seeks inevitably to manifest as well in a new social order. In a society where human beings cannot be bought and sold, they will not be enslaved by money. As it is now, money and persons are so scrambled together that it is often hard to know where the authority lies: in the person or in the money. In the Waldorf schools, the teachers are witnesses to the distinction between individual freedom in work and the proper fraternal uses of money.

The clarity of their commitment — to the children and to each other, to the being of the school, to spiritual entities who live in the subjects they are teaching — this clarity and sincerity communicate themselves to the children. The spirit of the teacher can be counted on, even when disagreements take place. Confidence in one another is grounded in ongoing participation. This is the function, in part, of the long rhythms of association in the class, and in the rhythmic repetition of themes and practices. Confidence is the necessary ground for human society. Waldorf education in the elementary and high school helps to gather this ground.

Naturally, since this is earth and not heaven, efforts fall short. But the staying power comes partly from a shared awareness of the ideal which is commonly served. Much of the nourishing substance of the Waldorf schools comes from this: the spirit one attempts to serve, with others; and the specific practices through which one's service may ripen. Teaching is a means of personal transformation. The children sometimes appear to be a choir of mischievous angels, egging one on and seeing one through.

At the end of the course Steiner gave to the teachers of the first Waldorf School just before it opened, and published in *Practical Advice to Teachers*, Steiner said:

> The teacher must be a person of initiative in everything that he does, great and small. . . .
>
> The teacher should be one who is interested in the being of the whole world and of humanity. . . .
>
> The teacher must be one who never makes a compromise in his heart and mind with what is untrue. . . .
>
> The teacher must never get stale or grow sour. . . .
>
> During this fortnight I have only spoken of what can enter directly into your practical teaching, if you allow it first to work rightly within your own souls. But our Waldorf School, my dear friends, will depend upon what you do within yourselves, and whether you really allow the things which we have been considering to become effective in your own souls. . . .

I do not want to make you into teaching machines, but into free independent teachers. . . .

Let us in particular keep before us this thought which shall truly fill our hearts and minds: That bound up with the spiritual movement of the present day are also the spiritual powers that guide the Universe. If we believe in these good spiritual powers, then they will be the inspirers of our lives and we shall really be enabled to *teach*. (pp. 199–201)

Teaching and the preparation of the teacher is a spiritual practice. But again let us ask what this means. For, as has been suggested, one does not go directly to something termed spirit, but rather one works through physical materials, activities, relationships, perceptions, meditations. In order to affect their mobility of thinking and their individual creativity of will, the teachers practice the various arts of painting and music and eurythmy, poetry, and whatever else may attract them. To affect their feeling life, they attempt to observe rhythms in their waking and sleeping; to work imaginatively in their class preparation, using stories and colors and sounds and movements and play; and to care for one another. This last is the hardest of all, of course. To care for another person more than for oneself, to let the ego of another person live in oneself as vividly as one's own — this we can barely begin to do. The teachers, through their faithful companioning of a group of children through continuous years of schooling, have an opportunity to practice this high art, and to try gradually to develop a true sense of "the other."

Rudolf Steiner did not originate this idea. Many people feel the aspiration, whether or not they have heard of Waldorf education. Great souls like Martin Buber have written inspiredly on the theme. But what is striking in Steiner's pioneering, is that practical work, done in certain ways, may bring about this inner schooling. I am reminded how often during my young womanhood someone would tell me to "grow up." And I can remember answering, "I would like to. How do you do it?"

Waldorf teachers and students have a sense of making something new in our age. Their starting point is an inwardly sourced teaching and educational practice.

Camphill in America: Mental Handicap and a New Social Impulse

Let us look at the human being as a living picture, as the teacher in the Waldorf school learns to do. This is what teachers and coworkers in the schools and villages for the mentally handicapped, also based on Rudolf Steiner's indications, learn to do. In America, the work with the handicapped is done primarily in the Camphill centers. Camphill is neither the first nor the only setting for the handicapped based on Steiner's pioneering, but it is the primary instrument so far in this country.

Camphill is an international movement, founded in 1940 by Karl König, M.D. (1902–1966). Its name derives from its first home, Camphill House, near Aberdeen, Scotland. There the movement started, when Dr. König and a group of young associates from Vienna left their homes to begin a new life in a place offered to them as sanctuary from Nazism. The decision to take on a work with the handicapped was made partly because of the striking similarity in the life situations of the handicapped children and the homeless doctors, artists, and teachers who came, sometimes in great secrecy and danger, from Central Europe. Both groups were estranged from the normal flow of social life, both wounded, and in need of healing. Both, for quite different reasons, were in some special way prepared by destiny to receive a new social vision and to work together to build a new culture.

Unfortunately, the refugee company had no sooner landed in Britain than the men were interned as enemy aliens. The women pressed on without them as best they could in the chosen work, until the men returned.

In "The Camphill Movement," Dr. König describes the genesis of the Camphill impulse thus:

There was, from the beginning on, a task which we had set before us: Curative Education. Some of us were trained in this work and the rest were willing to grow into it. We felt it as a special kind of mission to bring this work about. We had learned from Rudolf Steiner a new understanding for the handicapped child and we had seen this work in several homes and schools on the Continent and in Great Britain. To add another place to those already existing, was our first goal.

At the same time, we dimly felt that the handicapped children, at that time, were in a position similar to our own. They were refugees from a society which did not want to accept them as part of their community. We were political, these children social refugees.

The symbiosis between them and us seemed to work very well. Already the first children, who were given into our care, felt quite at home with us and we had no difficulties in accepting them fully and wholeheartedly in our midst. They gave to us the work which we wanted to do; they provided us with the conviction that we fulfilled a necessary task and were not superfluous and useless members of this country. Through the children, we were enabled to earn our livelihood and not be dependent on public help and charity. The most important fact was, however, that these children demanded of us a special way of life. It was not only up to us to educate and train them; it was they, also, through the simple fact of their special existence, who asked of us a set of qualities which we had to develop. They asked for patience, equanimity and compassion. They asked for an understanding of their ways of peculiar behaviour. Every day was, for us, a new trial in humanity and self-education. It was a tremendous opportunity which had been given into our hands.

At the same time, we had to learn to care for the grounds and the garden, to look after the house, to do the cooking and all the other domestic work as we, from the very beginning, had decided not to employ any staff or servant but to do all the work with our own hands. We used this work as one of the means of Curative Education and the children, in so far as they could manage, helped in every domestic task.

Our own children became part of the whole house-community and, in this way, the supposed barriers between mentally defective and ordinary children were completely abolished. It was, to many of us, a revelation to see how "normal" handicapped children are. Day after day, the whole field of Curative Education assumed a completely new form of approach. We realised the need of these children to be accepted into a closed social surrounding which, on the one side, would provide for them a sheltered environment and, on the other side, the possibility to unfold their individual qualities.

Gradually we grew aware of the necessity and the strong and urgent claim made upon us to undergo an inner training in self-knowledge and self-recognition. Rudolf Steiner's books and lectures provided us with the necessary advice and from there we drew our guidance. We discovered, furthermore, that for the children as well as for us, a deeply religious life was a need. The observation of the festivals, the recognition of the Sunday, the common prayer for the whole house-community in the morning as well as in the evening, grew to be an indispensable social factor. We observed how the ordering of the day helped our children and gave them an inner hold. It supported us also in our effort to become our own masters.

In this way, a closely knit fabric of human relations developed. It became the basic structure of all the further attempts we made in establishing our work. This symbiosis between the handicapped children and the uprooted and homeless refugees had begun

to show its results. Our special situation, combined with the ideas of Rudolf Steiner's Spiritual Science, gave us the possibility to grow into a new social order.

This developing small commonwealth was like the dough; the morsel of the European destiny became the leaven and thus the substance for the Camphill Movement was provided. Its social order and its human structure was to become like a loaf of bread. (pp. 9–11)

Since those early days, the Camphill movement has grown to include several thousand people, over forty communities of different kinds, and is still growing. They have in common the care for and sharing of life with mentally handicapped children and adults as well as responsibility for many acres of land in England, Scotland, Ireland, Germany, Switzerland, Norway, South Africa, and the United States. The adult village concept grew out of the need of the children as they passed school age. The first pilot adult village is Botton, in Yorkshire, England. In England there is also now a development combining to their mutual advantage delinquents and handicapped persons. The delinquents are given responsibility for their handicapped friends, which seems to awaken in them a sense of worth and a new emotional resource. In turn the handicapped seem enlivened by the relationship.

In the United States, there are so far three villages, all in the northeast. Camphill Special School for Children in Need of Special Care is at Beaver Run, near Glenmoore, Pennsylvania. It takes up to seventy children from first through twelfth grade and has a community of teachers, houseparents, and trainees, and children of staff, numbering fifty to sixty. Beaver Run, as it is called, occupies fifty-seven acres of hillside. There are ten households, a hall, a schoolhouse, craft buildings, a small house for offices and guest rooms, and another house for the infirmary, nurse's and doctor's office. There are also a pottery studio, a chicken house, a goat shed, and two good-sized gardens.

Camphill Village, near Copake, New York, in the western Berkshires, is a "working community with mentally handicapped young adults" (who are gradually getting older since the village was founded in 1962). It is organized around handcraft production, gardening, maintenance of roads/buildings/woodlands, and housekeeping. It has over five hundred acres of valley and hillside, some of it good agricultural land. Villagers work in soft doll making, copper enameling, hard wooden toy making, weaving, batiking, and bookbinding. The products are sold through a gift shop with a large mail order business, in local retail outlets, and at craft fairs. There are also a food processing plant, a maple sugaring house, a pottery studio (used for candle making), a bakery that makes all the bread and cookies for the

village and enough for sale locally, a greenhouse, and Sunny Valley Barn. Dairy cows provide milk, pigs provide bacon, chickens provide eggs, and there is extensive gardening. Fountain Hall is the center of community cultural occasions: plays, concerts, religious services, lectures. The village has completed its building plan and stands at fourteen houses, with a total population of some two hundred persons. Other buildings house the craft studios, garden sheds, offices, and equipment garages. As the village reaches capacity, it looks forward to attracting a variety of other "satellite" activities nearby.

Kimberton Hills, near Kimberton, Pennsylvania, is the newest village, started in 1972. It is entirely an agricultural community based on Rudolf Steiner's indications for biodynamic farming. At present it numbers 100 souls and will grow to 140. On its more than three hundred acres, the community sows extensive field crops, has developed vegetable gardens and soft fruit orchards, has a dairy herd, raises pigs and beef, produces cheese. Kimberton Hills is slowly developing an agricultural training course which will be available to outside students, and it hopes to become a focus of biodynamic activity.

The main characteristic of the biodynamic method, as distinguished from the "organic" approach, is the making of certain preparations which are added to the soil in order to bring healing to its life forces. In other respects, the two methods are similar.

Earth, like the human being, is inwardly living. Primitive cultures know this and we are rediscovering it. A Native American medicine man, Rolling Thunder, talked about it with Doug Boyd, who was sent by the Menninger Clinic to observe his practices. In Boyd's book, *Rolling Thunder,* the Indian explains:

It's very important for people to realize this. The earth is a living organism, the body of a higher individual who has a will and wants to be well, who is at times less healthy or more healthy, physically and mentally. People should treat their own bodies with respect. It's the same with the earth. Too many people don't know that when they harm the earth they harm themselves, nor do they realize that when they harm themselves they harm the earth. Some of these people interested in ecology want to protect the earth, and yet they will cram anything into their mouths just for tripping or for freaking out — even using some of our sacred agents. Some of these things I call helpers, and they are very good if they are taken very, very seriously, but they have to be used in the right way; otherwise they'll be useless and harmful, and most people don't know about these things. All these things have to be understood.

It's not very easy for you people to understand these things because understanding is not knowing the kind of facts that your books and teachers talk about. I can tell you that understanding begins with love and respect. It begins with respect for the Great Spirit, and the Great Spirit is the life that is in all things — all the creatures and the plants and

even the rocks and the minerals. All things — and I mean *all* things — have their own will and their own way and their own purpose; this is what is to be respected.

Such respect is not a feeling or an attitude only. It's a way of life. Such respect means that we never stop realizing and never neglect to carry out our obligation to ourselves and our environment. . . . (pp. 51–52)

Man's inner nature is identical with the nature of the universe, and thus man learns about his own nature from nature herself. The technological and materialistic path of contemporary Western society is the most unnatural way of life man has ever tried. The people of this society are the farthest removed from the trees, the birds, the insects, the animals, the growing plants and the weather. They are therefore the least in touch with their own inner nature. . . . (p. 81)

Every physical thing in nature is a spiritual thing in spiritual nature. (p. 124)

The Native American's awareness of the living body of the earth has evolved into an awareness of the earth as part of the body of Christ. In Camphill, this is a living inner picture. At the crucifixion, the blood of Christ entered the earth, and since then, as Rudolf Steiner perceived, Christ's body and the earth's body have become one. It is the presence of Christ forces in the etheric sheath of the earth which enables the modern person to move in free consciousness toward a "moral" agriculture. We know this body through bread and wine. The seeds grow and yield, are harvested, ground into flour, baked into loaves. The grapes turn sun forces into a kind of plant blood, the wine. And all the people work the vineyard, and are branches of that vine. A mighty imagination animates the relationship between earth and those who work it. This imagination opens up when we feel the aliveness of the forms of nature all about us: the colors, the textures, the sounds, the rhythms of growth and decay, the shapes. These speak to our imagination because they live in the imaginal, or rather the imaginal lives in them. This is what the artist in each one of us connects with. Out of this connection comes our poetry, our song and sculpture, our drama and ritual and painting; our daily deeds of conservation and maintenance, of cooking, of care. And out of this connection as well come the festival celebrations of the equinox and solstice, the great planetary festivals of Easter, Saint John's Day, Michaelmas, and Christmas. In addition, the festivals of "Dawn and Dusk," of Sulphur, of Iron, of Salt, of Mercury, and of Calcium, are held in the agricultural community. Like alchemists of a previous age, these modern-day alchemists experience physical substances as spiritual agencies.

Steiner, as we know, insists that we experience life as an art. In art, the image is the bearer of meaning. To live on the earth with imagination is to live the practical aspects of the day at the same level of feeling and sense of meaning and impression of inner truth as one enjoys in the presence of poetry or painting or drama; the same responsiveness; the same impression of universal dimension; of wonder.

Curative education and new social forms are the two sides of the Camphill coin. It is the function of the schools to provide curative education. It is the purpose of the adult villages to create social forms. However, the schools themselves constitute a social form as part of their curative intent, and the villages continue the life-long study and learning which social change and creativity require.

Living and working in a school or village community may well become an inner path. It is an "inner schooling" and is described as such in the announcement of the seminar for trainees. The children's school can be thought of as "a school within a school." The community or village as a whole is a life-school. The total environment of home and school speaks to the handicapped children's needs for secure loving relationships and regularity in daily life as well as in the classrooms.

What is this imagination of the handicapped child, the adult, and the social organism?

First, the person is not identified with the illness. The handicapped child is first of all a child. It is the child who is treated, not the illness. The individuals are intact, though having a problem. They may have difficulty in speech development, social development, motor coordination, physical balance. A child may suffer from epilepsy, brain damage, hydrocephaly, microcephaly, mongolism, cretinism, autism, aphasia, cerebral palsy, deafness, blindness, hysteria, or combinations thereof. But everything is done to help the child not to identify with the handicap. This develops self-respect, and it helps the handicapped to work with their problems and not to despair.

With the adult handicapped, social forms are created which express in daily life a mutual respect for differences. In these forms each individual may find ways of contributing to social life: by doing needed work, developing skills, acquiring culture, expressing creativity, or developing human relationships which are both supportive and independent.

The social organism has a threefold nature, as does the human organism. Its threefoldness is expressed in economics, politics (the life of rights), and the free cultural life. Economics corresponds with the sphere of the human will, the middle sphere of rights corresponds with feeling, and the free spiritual life with thinking. In economics, the moral guide is fraternity and association — sharing in the work and the goods. In politics, the moral guide is equality — each person has the right to work and to have needs met. Wages are not to be thought of as payment for time and work, which are human rights, not commodities. Wages are the administration of money according to need. The motivation for work is independent of money, since money is administered as a human right. In the cultural life, the guide is

freedom of individual contribution and originality. In economics, capital is connected with individual initiative in a context of fraternal association.

The Camphill villages are spiritual communities and social organisms attempting to live in a threefold way. No one takes a salary. All have their needs met. The fact that no one is paid more than anyone else helps to minimize the divisiveness that often infects relationships. There is no "staff" in the usual sense. Everyone lives together, for better, for worse, in sickness and health. The coworkers, as they call themselves, guide the handicapped in their work and at the same time the handicapped awaken the coworkers to their own self-development.

Kinds of thinking and valuing which are patterned after the intellectual standards of our culture are transformed under the guidance of the handicapped, because the handicapped are for the most part free of the compulsion to think abstractly and to suppose that personal gain and happiness are the goals of life. "They are too dumb to be prejudiced," one social worker at a state institution quipped, as she attempted to explain how it was that the recreation in that facility was unsegregated. "Too dumb" to buy cheap and sell dear, to accumulate wealth and prestige, but so many are gifted in human feeling and almost all can be reached by artistic presentation, ritual, social forms which make a space for them, and cultural presentations, including lectures, which appeal in a lively way to the ear and to the sense of humor and drama. As an audience, the handicapped tend to be ready to join in, to groan, to cheer, or to share actively in the silence of solemnity. Many are uncommonly generous and enthusiastic.

At Beaver Run there is a therapy for hyperactive children, which is called a color and sound treatment. The children are brought quietly into a darkened auditorium and are seated. On the stage, behind a light white curtain, a eurythmist moves between colored windows and the curtain, thus casting colored shadows. The flowing forms of the colors are accompanied from time to time with sounds struck on one or more lyres in the back of the room. Sometimes a teacher tells a story to accompany the colored images and tones, consciously adding healing voice sounds. The children sit in striking quietude, freed momentarily from the tyrannical excitement in their bodies.

In the weekly school assemblies, the children and their various teachers share something from their work. They tend to be responsive and cooperative even when confused and disoriented. On the whole they are very manageable, even the very ill children who are accompanied one-to-one by an adult.

For the religion lessons and the services, the children dress carefully and sense already the special experience awaiting them. It is striking to be in a service with

so many ill children who have difficulty controlling their impulses and to feel them quiet and attentive. The children are greeted individually as they enter the hall and leave it. This practice of conscious greeting between child and grown-up is maintained in the classrooms of Waldorf schools as well as in the services for the handicapped. Since a great part of handicap appears to be based on weak ego development (that is to say, the individuality is present, it's just not hitched on properly to the other bodies), the adult friend tries to summon and strengthen the children's egos by looking, if possible, into their eyes and saying their names and asking them never ever to forget what is about to happen or has happened here, and holding them by the hand the whilst. I tend in these moments to identify with these children and find myself deeply touched and wondering shyly whether I too may dare to allow myself the risk of being fully present in response to that hand. There is a kind of sleep or weakness or fear to be struggled against.

The sense of mutuality which is aroused between handicapped and normal persons is central to Camphill work, and indeed, as a pioneering impulse, to human development in general. Standards of handicap are of course based on standards of normality. And normality is very hard to establish, partly because most human beings have a tendency toward some kind of illness or imbalance. In the handicapped, one experiences oneself in a kind of caricature. In "Some Fundamental Aspects of Diagnoses and Therapy in Curative Education," Dr. König says that the task of curative education "will be to study the primal formative tendencies active in man's development and, with the acquisition of the necessary knowledge, it will be recognized that there are not an unlimited number of possibilities with which one has to deal but only a certain number, in tune with the creative forces of the world" (p. 19). He then speaks about the need to find balance between the hydrocephalic tendency and the microcephalic tendency; between movement and rest, activity and listening; between the polarity of the mongoloid and the cretinoid forms. All human beings must continually seek to balance their onesidedness, whatever form it may tend to take.

Man always finds himself poised between the "upper" and the "lower" tendency, endeavouring to hold them in balance. Not until he succeeds in this does he achieve his true "humanity," the faculty of speech, day-consciousness, his individual personality.

He is part of heaven as well as a part of the earth, and he needs the harmonious balancing of the two to fulfill his true destiny as a human being. This is the extraordinary task of curative education, that in each individual child it opens the way to the true human existence and its mediating task. Sometimes this will be achieved, often it will not succeed, but it must always be tried. Indeed, even if the effort remains unsuccessful

now, it is the will to do good that really counts. That impulse continues to work and will become a healing force when the child again finds its way into the earthly world.

The curative teacher should bear in mind that results will frequently not show themselves at once, but only in the course of long epochs, when the child's soul itself will have been able to effect the transformation of what has been bestowed upon it by a therapeutic deed. And the child in need of special care knows better than anyone else the meaning of the words with which Lessing finishes his book, *The Education of the Human Race:* "What would I be missing? Is not all eternity mine?"

Every human soul tries evermore anew to unite and to balance within itself the eternal formative tendencies of the creative forces of the universe. Whenever it does not succeed, curative education has the right to do its healing work as mediator and comforter. (p. 20)

More interesting, even, is the thought that the increase of mental handicap in our time has a prophetic voice — a homeostatic call from life itself to right the balance, to counteract the overintellectualism which goes for the most part unchallenged. This has been one of the central and agonizing questions of my postuniversity adulthood: Why is it, if we are so intelligent and well educated and artistic and creative and academically disciplined, that our social order is so unjust, disordered, shortsighted, and toxic? Sometimes it seems that we go to school to get cleverer about "doing the bad" rather than "doing the good." The human being may need some relief from intellectuality if we are to gain our humanity and have a care for one another and for the earth and cosmos. The question may be: In what quality of balance does true intelligence lie?

The first article I ever read about handicap, appearing in *The Cresset,* proposed the idea that there is a prophetic aspect to the appearance in increasing numbers of the mentally handicapped in our society. This prophetic aspect has two sides to it. One is the capacity of the handicapped to receive and to generate new social impulses. The other is the effect upon the normal person of living and working with the handicapped in brotherly and sisterly association as human beings mutually dependent upon one another for physical and emotional help and spiritual development. The handicapped enable us to feel what we would otherwise be less likely to feel, namely, the presence of an individual soul and spirit in every person no matter what the appearance or behavior may be; the mutuality of giving and receiving between all beings, no matter how little or much they may look like teachers or pupils; the development of an atmosphere of soul warmth as the handicapped and the normal come to know one another and receive from one another; the vulnerability of intellectual assumptions to spontaneous challenge by another order of mind, i.e., the altered state of consciousness of the handicapped. This altered state

of consciousness seems many times to be closer to spirit source than most of our normal daytime consciousness. And perhaps it is for this reason, that it lights up for me personally so often in artistic revelation.

Artistically beheld, the physical world is transparent to imagination and appears irradiated with supersensible light. I walk into the kitchen of one of the Camphill Villages. Two handicapped young women are there. One leans against the sink like a jointed wooden toy and talks about her birthday, gazing with cockeyes aglow. The other peels potatoes slowly, listens, responds, like a sage bewildered to find herself so shrunken. It could be a scene from a drama, I think, as I enter the room. It is alive with sensitive energy. It is alight with inner life. I receive such a sense of its truth and depth and mystery, and I am filled with joyful gratitude, as when I look at one of Pierre Bonnard's painted lavender tree trunks or carmine nudes or see Merce Cunningham the dancer beckon the audience into his slowly turning neck. "Come, come!" they are saying. "The world is real. It is alive and glowing with strange fires. These are living fires. Yes, like gold they do not fall away."

Thinking and consciousness are not uniform. When we undertake to train our thinking, as we say we do in schools, we need to ask what aspect we are training, and what relation this aspect and training have to other aspects and other trainings. This picture of the mind is of a living unfolding entity. It is not prepackaged, defined, static, and determined. Our ways of thinking and perceiving change during the course of our growing to adulthood, and they continue to change, if we let them, throughout life. Also the ways of thinking from one historical period to another are different — and from one cultural epoch to another. These ways are, in a certain sense, available to us all through the rhythms of incarnation and reincarnation. We may not experience these consciously in the present, but they have in some way formed us, or helped to form us. In the same way we see a recapitulation of the species in the formation of the human embryo: now a reptile, now a fish, and so on. We do manage, most of us, to get born in the present. But when a deformed or handicapped child is born, it is usually the case that the incarnation process has not functioned properly, and the child may have remarkable features of consciousness which are like gifts from another time — kinds of clairvoyance, mystical participation in nature, or mathematical aptitudes. Because there may be a lack of balance and a lack of social adaptation, the child is handicapped. But we should remember the double significance of that word. To have a handicap can mean to have an advantage, or it can mean to have a disadvantage. To be able to hold both meanings alive in oneself is to have a lively imagination: to understand Shakespeare's fools, or Dostoievsky's hero in *The Idiot* or the epileptic brother in *The*

Brothers Karamasov or the child heroine of *Mr. God, It's Anna* or the ambiguity of *Equus.* Can we sow this vision into the ground of life again and prepare for a harvest of a more imaginative experience of human handicap, whether acute or veiled by cultural norms?

The patterns of the handicapped may be compulsive in their own way, but often they are so different from our normal obsessions that they are like windows suddenly opening on new landscapes — fresh air — the joyful release of incongruity — the moments of striking clarity and immediacy, such as the one I shared with Mimi, my twenty-year-old friend at Copake, who asked, "Is yesterday gone yet?"

The handicapped often come very physically close, want to touch, want to look into the eyes, want to know our name, our address, our birthday — and will remember these details when we see them years later. Some have remarkable mathematical aptitude. Often they give one a straight deep look, soul to soul, communicating at a level of first things. Of course they want to learn to live in the earthly world as well as the realm of first things. With their presence and help we may dissolve the rigidities of our own partial consciousness and be helped to reposition ourselves in the crossing-point of spirit source and archetype and imagination.

When working with clay with these persons, I find them more open and enthusiastic than their normal companions. They do not want to throw everything away because it isn't good enough. On the contrary, they want to give it as a present to someone they love. They do not need to try to distort, they need to try to give form. They know well what distortion is and long to make forms which can hold water and carry food and bear light and "be a picture." They work so close to the unconscious that a study of their spontaneous creative work is extremely fruitful for the normal artist who may be seeking contact with source. It is also fruitful to notice the difference between what they cannot help making and what they may be helped to make. We seem all to be artists coming quite differently to the experiences of forming, deforming, and re-forming. (I have written about my personal relation to Camphill in *The Crossing Point.*)

The handcrafts in Camphill Village in Copake show how expert and professional work of the handicapped can be. Their craft is not therapeutic activity, except as learning and making can be intrinsically therapeutic. It is production weaving, copper enameling, doll making, bookbinding, batiking, wooden toy making, and so on. Georgia, a large, young woman who cannot speak (she roars and barks) and who is given to violent outbursts against herself and others, weaves like an angel yard after yard of intricate patterns. I, who can speak and am fearful of violence,

131

cannot weave a stitch. I am overwhelmed by the complexity of warp and weft, of loom, and design, and the physical coordinations required for the operation of the loom. See how the balance tips — now here, now there.

How refreshing it is to come free of sentimentality and to begin to be able to experience one another quite objectively, that is, quite *really* as persons. How grateful I am to be with people who are not driven to adapt themselves continually to culture and its standards — who disregard like inspired poets our solemnly arrived at intellectual structures. The handicapped seem somehow to be more directly related to their experience and to what seems good. Thus they contribute a new impulse in the renewal of society, a new perspective.

Thomas Weihs, M.D., who has been physician and superintendent of Camphill Schools in Aberdeen for thirty years, put it this way in the 1977 Stanley Segal Lectures at Trinity and All Saints Colleges, England:

> However, with the mentally handicapped we have created small social communities in which such a new social experiment is being done. The handicapped are less prejudiced. So, what I have said may sound very odd, but to the handicapped it is quite natural — that work should be satisfying in itself and does not need its reward in payment but in the satisfaction of what is done. I believe that the handicapped can help us if we accept that they are people with different potential, people in whom the intellect has not got the predominant leading influence, but where often forces of intuition, imagination, forces of artistic abilities are fully developed and available. With them we could try to develop small experimental communities in which we could endeavor to prepare new ways for the future. Our organization is trying that. We do not only do this work with the handicapped adults because we feel we want to help them. Rather than that, we feel they have a task and mission to show new ways in the development of our society and we want to help them with that, acknowledging that they have a contribution to make to our future. I want you to know that I say that out of my personal experience and out of my awareness that what has helped me to mature and to live without fear and anxiety and with an unusual degree of fulfilment and happiness I owe to the handicapped.

In this same lecture Dr. Weihs urges doctors to reconsider the mood in which they tell a new mother that her child is handicapped, in this instance, with mongolism or the Down's syndrome, as it is technically called. He sees no need to be depressed, or negative, for what is a mongol child after all, he asks, but a child who "suffers from" a prolonged youthfulness, a "neoteny." The mongoloid child is like a baby all its life: round in shape, unsexual, playful, mischievous, imitative, affectionate. It often walks on slightly bowed legs which tend to be short, has slanty eyes, a long tongue, and short fingers. In any group of children or adults, the mongol child is a great favorite, being so lively and loving — though stubborn-

ness can be a problem. Dr. Weihs goes on to describe the gift of the mongol to autistic or psychotic children who "panicked in the face of their own ego development" — children who cannot say "I" to themselves. They develop bizarre and tortuous rituals and taboos to protect themselves from the experience of their own ego humanity, remaining isolated and frozen. Because they will not make eye contact, will not respond, they are difficult to help. And most normal human beings find it hard to keep their warmth of feeling flowing when it is met with continual coldness and rejection. But the mongol children go on loving even if there is no response, and their warmth and devotion to their autistic friends does much to bring about, in some cases, an eventual thaw.

The schooling for the handicapped child in Camphill follows the general form and sequence of the Waldorf approach. In first grade the children start in their homeroom with a teacher who, if possible, accompanies the children throughout the eight grades. The teacher presents the Main Lesson to the children, telling the stories, involving the children artistically in the making of their Main Lesson books and in the saying of the morning verse, singing songs, and playing recorder. As one teacher said, "We address the higher being of the child, because sometimes that is all there is." After the Main Lesson period in the morning which lasts about an hour and a half, the children are divided into ability groups and are helped individually with their lessons. Some go for specific therapies at this time: as prescribed by the physician who is part of the school. These are educational therapies stemming from speech, movement, sound, color, taste, and smell. In the afternoon, there are classes in handcraft, work in the garden, and special projects for the high school students. König's "Fundamental Aspects of Diagnosis and Therapy" explains:

> Curative education has as its domain the therapeutic method, not medicine, nor teaching. Teaching can, when necessary, be modified, slowed down or accelerated, simplified or complicated, made more imaginative or more abstract. The boundaries are here, as in all life, fluid. However, the method applied by curative education is not that of education, but it is "curative" education. Its constant task is to apply such methods as to restore the disturbed equilibrium in the developing child within the formative tendencies. That can be done in many different ways. Music and singing, eurythmy and curative eurythmy, speech and gesture, painting and drawing, crafts, and the development of memory lend themselves to this. (p. 9)

The main difference between regular education for the normal child and curative education is that in the regular education the child is surrounded with what is suitable for his/her age. Lessons correspond to the child's development. The teacher ed-

133

ucates the soul of the child through its activities of thinking, feeling, and willing, and only indirectly influences the child's constitution. The individuality of the child is never interfered with. In curative education, because of the insufficiency of the ego development, there is a direct working with the constitution of the child and a determination to influence and to interfere. The child is not accepted as s/he is, but is continually being corrected and encouraged to overcome disabilities. The teacher dynamically confronts the child in order to call up enlivening forces. The teacher's will and sympathy try to evoke what is good for the child. The inner development of the teacher acts upon the child's nature. The teachers feed the children through their own being. I have observed that the question of control, which so often comes up in discussions of dealing with the handicapped, is answered at Beaver Run by the way the children sense the presence of their teachers and seem little by little to be able to take a consequent form because of the quality of their being.

The inner development of the teacher is thus part of the pedagogy. It is this fact which gives uniqueness to Waldorf education. It helps to explain the lively energy in the schools, where the teachers work hard under trying circumstances and yet seem perpetually self-renewed.

During the course of the year, each child is the center of a case conference, or college meeting, at which are present all his/her teachers, the houseparents, the physician, and any coworkers who have contact with the child or who are particularly interested. The mood of concentration created in this conference is one of the social forms upon which the children's village rests. There are two other "pillars": a Bible Evening every Saturday night and a redeemed relationship to work and money.

The Bible Evening consists of a simple meal and the reading and discussion of a gospel passage. In the school community, Bible Evening is held by adults as an occasion of social contact and sharing among themselves at a level other than the usual hurly-burly of daily duties. In the adult villages, Bible Evening is participated in by all; each house has its own way of celebrating the occasion, except for special common evenings held in the large hall. During the week, the Bible passage will have been read each day at morning prayer before breakfast. Thus there is a continuity of meditation throughout the week, in preparation for the gospel reading in the Sunday service. Though attendance at Bible Evening and Sunday service is not required, many people seem to like to go. There is a continuous concern for ways of renewing the spirit of the Bible Evening, of keeping it fresh and credible, for indeed it seems a curiously old-fashioned social form trying to find a place in contemporary spiritual life. I will speak more about this later.

The third pillar is what Rudolf Steiner called "the fundamental social law," which he described in *Anthroposophy and the Social Question:* "In a community of persons working together, the well-being of the community will be the greater, the less the individual claims for himself the proceeds of the work he has himself done; i.e., the more these proceeds he makes over to his fellow-workers, and the more his own requirements are satisfied, not out of his own work done, but out of the work done by the others" (p. 32). All social establishments among a community of people which contradict this law, are bound to lead, after some time, to need and poverty. So the law states.

Though each school and village is economically independent, all follow this fundamental social law. It is an economic counterpart to the social principle of brotherhood. This economic form allows for differentiated human need, and at the same time it gives a mutual form to the relationship of each individual to the common money. Everyone contributes earnings to the common account; each person draws what s/he needs from the account; the money each person uses has been contributed by community members. The flow of money, giving and receiving, is the counterpart to the flow of human relationships. In ordinary society, human relationships are obstructed by inequities in pay and status. It seems a simple step to create a different relationship to money in order to free human relationships from these pressures. Also there is a glorious spirit to it: I am spending the money you earned; and you are spending the money I earned! And those who cannot for some reason earn money, these spend the money we earn! Many people contribute qualities which are not income-producing: artists, for example, and homemakers and elderly companions who bring a blessing of life-wisdom. The value of the work and the satisfaction come from an experience of responsibility for whatever one is doing and the awareness that it is part of the life of the whole community. The spirit of community is felt by all its members in what they do. Money makes it possible to continue to live and to work.

I know how difficult this point of view can be for others to accept because of cultural attitudes. I too was brought up with the idea of "paying one's way," "not being dependent upon others," financial independence, privacy in money matters, and so forth. The salary check was the measure of achievement. The more money one was paid, the more important one could feel. To change these attitudes is to separate from cultural norms, with the hope to transform them. Another imagination of reality has come into play. One has to see interdependence in economics as in bio-systems. One has to see intrinsic value in working whether or not one is paid. The big question may be: if I don't need the money, will I work? If I don't need to work for money, what will I do with my life?

The ability to separate working from wages is a step in self-development which is undertaken at Camphill. And I do believe it is for all of us a matter of inner development and the transformation of thinking. At Black Mountain College, where we had a needs policy in the payment of faculty salaries, we had finally to give up the policy because of the embarrassment it caused certain faculty members. They could not bring themselves to say what they needed. To ask for money was humiliating and in conflict with the social attitudes of popular culture. It was an imaginative loss, with dire practical consequences later on. In Camphill the policy is clearly stated from the outset, as König says in "The Camphill Movement":

> Instead of being paid a salary, we learn to arrange the income and expenditure of the unit in which we work according to our discretion. Each house, each workshop, each working centre is an independent economic unit which is responsible for its own finances.
>
> In this way, the Camphill Movement has overcome the necessity of employing people. None of us is an employer or an employee. None of us regards the money which goes through his hands as a personal possession. We do not earn money; we administer it. This we try to perform in the best possible way, but each one does it according to his own responsibility and insight. We have appointed councils which control our management and give us advice and help.
>
> Our work in whichever sphere we do it is done without the expectation to be paid; but we do expect to live under conditions which are appropriate to our personal needs. Thus we try to arrange our lives in accordance with the fundamental social law which Rudolf Steiner formulated: "The welfare of a group of people who work together is the greater the less the single person claims for himself the profit of his labours."
>
> That it is possible to work under such conditions and to share our efforts with our neighbors and not to claim profits for ourselves is due to the establishment of the Bible Evening and the College Meeting. These two institutions permeate our lives with a higher aim so that we work in order to fulfil our ideals. Here again, a fundamental indication of Rudolf Steiner's gives us guidance and direction. He says: "If a man works for another man, he must find in the other the purpose for his own labours; and if someone has to work for a whole community, he has to sense and to experience the value, the being and the meaning of it. This is only possible if the community is something other than a more or less undefined sum of single people. Such a community must be permeated by a true spirit in which everyone of its members partakes. . . . The community must have a spiritual mission, and every individual should have the urge to help so that the mission may be fulfilled."
>
> In former times, a nation or smaller social communities such as municipalities or counties were filled with a common task. The building of a temple or a cathedral, warfare, conquest or pilgrimage were such communal deeds. Conditions have fundamentally changed, and today it is only possible for such common tasks or missions to begin to live again in spiritual communities. . . .
>
> When we more and more learn to manage this form of economic life, the Movement will plant a seed for a new social order. In the same way that money shall never be our personal property, also our houses, grounds, equipment — are not personal possessions.

They do not even belong to the Movement but are, like the money, administered by it.

The single individual may possess whatever he may wish. He might still feel the need to own furniture, books, capital; in so far as he is an individual, he may be in need of earthly goods. As a worker in the Movement, he is without any property, without any income, and equal to those who work with him. . . .

We work for the sake of work; we do not expect a return because we gradually learn to understand that the returns are a gift, a donation, an act of good will which the others provide for us. We give and thereby we receive. Thus the innermost secret of all labour begins to reveal itself: it is love and nothing but unending love. (pp. 43–46)

A radical aspect of this love is the ability to receive as well as to give. It is an inspiring picture of economic liveliness in a social organism. It appeals to one's human imagination as a way of practicing realistically the brotherhood we preach.

And where does the money come from? Villagers contribute their social security allowance. Parents pay. Funds are raised from foundation grants and individual gifts. In Copake there is ever-increasing revenue from the sale of handcrafts. In Kimberton Hills, there is some income from the sale of milk, pigs, surplus garden produce, and cheese.

Administration and decision making are undertaken by various small groups within the communities: for example, the finance group, the teachers group, the housemothers, the accommodators, the care group, the land group, the crafts group, the service-holders, the forum. Groups are created or changed according to the social needs. In the adult communities, village meetings are held where general topics are discussed by everyone.

In the adult villages, the spirit of the college meeting is expressed in an ongoing program of adult education. Study groups arise more or less spontaneously out of the initiative of persons who find themselves drawn to a common subject of inquiry. Conferences occur several times a year, when representatives of the different communities gather to concentrate on a theme: for example, Threefoldness in the Social Organism, Color and Light, Karma and Reincarnation, Biography and Destiny, Image and Reality, Gold/Frankincense/and Myrrh.

Perhaps it is this unusual combination of work, social life, and study, in natural surroundings, which attracts students from ordinary colleges to come to Camphill for their work semesters or, in the past, provided a place for conscientious objectors to do their alternative service. There is an increasing interest as well among faculty who are looking for ways to integrate personal search, a healthy life, economic survival, and service to others. Students from colleges which have already in their curriculum an emphasis upon a physical work program, building, gardening, ecology, and social service, come to spend time in a place where a work pro-

gram is part of the life style along with cultural activities and study. The outspoken preference for natural materials, handcraft, nutritious foods, bread baking and food conserving, artistic expression, self-government, and religious feeling seems to arouse the curiosity and hopes of many students and teachers. Certainly it is part of the quest of education in our time, to provide situations and surroundings where the wholeness of the human person may grow and flourish. Camphill attempts to answer this quest in a modest way. Any such effort in our time, however modest, is bound to seem prophetic. Inner development has become a path to social responsibility. It is exciting because it combines idealism with practical steps. It deepens and opens out at the same time.

Carlo Pietzner, who as a young art student came to Scotland with Dr. König's original group from Vienna, was among the first to bring Camphill to America and has been its director in this country. His lectures are an important part of the spiritual life of the community, and his paintings reveal its inner landscape. In "A Ceremony of the World-Order," he speaks to this question of studentship in our time:

> A student can starve to death in his soul on his way through school — just as surely as he would have starved as a child in his body if he had not received appropriate help and attention. Most people die today on their way to be educated without noticing it. As they become more and more flawlessly adjusted to the ways of the world their original purpose expires, their mission withers which was still so radiant around them when they were small. The apocalyptic second death begins today with education — or with the lack and dearth of it.
> Rudolf Steiner founded the first Waldorf School in 1919 — fifty years ago — because he knew of these dangers more intimately and with greater clarity than anyone else. We realize today that he founded it so that an awareness of the wholeness of man may be preserved, that he may not fall away from his original potentialities and tasks, but that his spirit may become ever a more clearly recognizable part of his entity.
> The founding of this school — for the children of the workers of the Waldorf Astoria factory in Stuttgart, Germany—was a humble act amidst humdrum requirements. It was at the same time a supremely courageous deed in a middle Europe exhausted and impoverished by war. Above all it was a deed of necessity. A school had to be founded, an educational impulse had to be made accessible, that would restore the wholeness to man — however gradual this restoration would have to be. And an education had to be inaugurated so that the whole world-order, not merely the earth, would stand by as witness and godparent. One must understand this when one reads the words which Rudolf Steiner spoke in his first address (on August 21st, 1919), when he called the founding of this school "a ceremony of the world-order" (ein Festesakt der Weltenordnung). (pp. 32–33)

The spiritual, Pietzner concludes, will remain "relegated to the attic of the mind as long as the mind itself has not found the source from which it comes." This source pours through the veins of Camphill, and people who come there can feel it.

At Beaver Run (and several European centers), there is a three-year training course for those who wish to live and work with handicapped children. Interested persons are encouraged to apply. There is no tuition. Seminarists work and are provided for in common with other community members. They may be sent to European centers for part of their course. After three years, a certificate is given, which states that the Camphill training has been completed. A fourth year has been added which specializes in teacher education. This will earn a state-approved certificate in special education in private schools. It is not necessary to have taken the course in order to live and work in the adult villages. Nor does completing the course bind the student to Camphill as the only possibility. It may be a valuable educational experience no matter what eventual direction may be taken.

Camphill recognizes itself to be interlinked with streams of unfolding history, in the evolution of consciousness and social forms. The three pillars of the community mentioned above are consciously connected with the work of three historic individuals: Johann Amos Comenius (1592–1670), Count Ludwig Zinzendorf (1700–1760), and Robert Owen (1771–1858). Comenius was a philosopher and educator; Zinzendorf was a Christian missionary; and Owen was a social reformer. Each was connected with community building in his own way.

Comenius's interest was in creating a "Universal College." This is reflected in the Camphill college meeting and in the programs for adult education in the villages. He imagined a "pansophic" (*pan sophia*, i.e., universal wisdom) institution for the advancement of the whole of mankind: for a renewal of learning, advancement of invention, fulfillment of peace and mutual understanding. Zinzendorf's impulse for a new social order was primarily in the religious field. He said that there is no Christianity without community. He founded a Moravian brotherhood, which lived a simple life and shared, like the first Christians, all things. They celebrated a common sacramental meal called a Love Feast, which is reflected in the customary Camphill Bible Evening. Moravians settled in Old Salem, North Carolina, and many of their original buildings and rituals have been restored as part of Winston-Salem. Owen, a Welshman, endeavored to create social communities which would provide education and meaningful work and in which everything would be distributed on a communal basis. His dream was to eliminate poverty and ignorance. His ventures did not succeed permanently, but they did pioneer a form which appeared later and was further developed in Rudolf Steiner's formulation of the fundamental social law. The town of New Harmony in Indiana is the site of one of Owen's most famous experiments in America.

How can I help these forms to live in the imagination of the reader as they do in

139

my own? It is not a matter of agreeing or disagreeing with them, of finding them to one's taste or not, but of letting them live in one's imagination as a reality. This ability to enter into an experience in a living way, without judging it before hand, nor meeting it with either fanatic enthusiasm or cold skepticism, is a kind of participatory consciousness which is the direction of the education or re-education which this book is about.

This is the consciousness one cultivates in the appreciation of art. When we read a novel, we do not ask the characters to be other than they are, if they are to receive our attention and understanding. Actually all their various quirks and special ways, however odd they may seem or questionable or unlike our own, are interesting to us, and they live in the imagination without threatening. But isn't it so, that one reason we teach literature and the appreciation of drama and poetry and the history of art, is to expand human consciousness, to keep it from narrowness and provincialism. The appreciation of literature educates our imagination for life; that is, it helps us to develop a way of looking at things artistically, allowing them to be what they are, to enter into them with our awareness, and to let the experience deepen our humanity and ripen our wisdom.

There is this play space in the mind, where we can try things out without penalty, where we can take on roles, play house, play school, play doctor, get the feel of what it is like to be a fox, a fairy, a witch, a blind child, or Kaspar Hauser, the prototype of the retarded child innocent of cultural greed and existential despair. The theater of the mind is the space of inner visioning, where ideas can be "entertained," that is, "held between" image and reality. These inner visions are real; the experience of Hamlet is real. He dies in the imagination, though not physically upon the stage. Like dreams, they are real experiences of the psyche. This is why it is important to take seriously what we fill our fantasy with.

On this fact, education is based: namely, that what we experience inwardly can prepare us to meet outer reality with understanding. The light that shines in the outer reality must meet the inner light in order for enlightened perception to take place. This is the perception we may develop in artistic activity and the appreciation of art. It is not our main purpose, in the presence of art, to say "I like it" or "I don't like it." Our main purpose is to say "I see" and "I feel." Only then can discrimination follow. Seeing and feeling with this degree of openness creates an athleticism of soul, so that when we are asked to take a leap in consciousness, we find we can do so. We are capable of imaginative cocreation — of giving space to a reality other than our own, of seeing it, feeling it, understanding it. Only when we can offer this to one another, can we be secure in sharing our lives and secrets. We

fear to speak openly because we may be judged rather than experienced. And in just these questions of the handicapped and new social forms, we have examples that ask for imaginative participation.

We need not fear that if we are open to share the lives of others, we will be overwhelmed. Here, too, we may choose gradually to educate and transform ourselves so that we may be both mobile in our ability to identify with others and at the same time stable in our sense of self.

Isn't this both an education and a new social impulse — to invite the archetype of community to rise within the individual and to become an individual capacity?

The religious life of Camphill is expressed in many ways, and in almost every form it takes, there is a freshness of approach, an authenticity in the particular setting. An experience of the divine is awakened in the form of one's own life and surroundings. For example, a new house is to be built. At dawn the community may walk to the site. A foundation stone is laid. The priest of the Christian Community (a new church described in chapter 9) may be there with censer and scenario. He may invoke the spirits of the four directions as he walks the ground plan. The assembled group may sing. The land is being blessed and connected to the community by a living ritual. The house is built, and the time comes for dedication and naming. Musicians may stand at the portal to play and sing. Someone speaks a few words, naming the place. A poem may be read at each of the sides of the house. A present may be given to the houseparents. Everyone sings. There are refreshments or a festive meal. The house has been taken in like a real being to the heart of the community.

Similarly the fields are named and the barn dedicated. The sacraments are offered to the community in what will be the hayloft for the animals. The ceremony feels generous, benign, imaginative.

Plays are prepared as part of the celebration of festivals. Among other plays, Dr. König wrote dramas for Maundy Thursday, Good Friday, Holy Saturday, and Easter Morning, and for Michaelmas. These are regularly performed. At the beginning of Advent, four weeks before Christmas, an Advent Garden is prepared for the children. At Christmas, a medieval folk drama is offered. On Three Kings Day, 6 January, an original Epiphany play may be performed. On Saint John's Day, or Midsummer's Eve, a traditional bonfire is lit, and again an outdoor play by Dr. König or an original pageant is presented.

Drama, as we have seen, is part of the Waldorf educational method — students and teachers regularly participate in it as imaginative learning. Theater is a social form, one might say, and not only as entertainment in the usual, more shallow

141

sense of the word. That is not to say that all the plays are holy. But it is to say that they are performed as real experiences for the actors and as seasonal or festival meditation for the audience.

I make the connection very strongly in this regard with the theater of Antonin Artaud, whose book *The Theater and Its Double* I translated in order to come closer to its meaning. For Artaud, the theater is alchemical, a force for social transformation. Its humor and its cruelty are sacred agents, if rightly used. The intensity of his vision made him seem to some to be deranged. His spirit vision did, in fact, bring him close to lunacy. Would he have had a different fate in the healing atmosphere of Camphill?

At Michaelmas, 29 September, there is usually a common meal held outside, with a harvest altar made of cornstalks, purple Michaelmas daisies, and garden produce. The villagers will have gathered squashes and eggplants and cabbages and beets and pumpkins as part of the celebration of the day. Harvesting does not merely happen, it is celebrated. So is the ground breaking in the spring with the festival of the first furrow, when the plow first cuts the earth. *Festival* is a mood of the human soul, as well as an outer event. Hence the importance and frequency of festivals, based on the course of the year, in Steiner centers.

We may refer to these as social forms, or better, we may say that the life goes on artistically. One inwardly living form grows out of another. In the routine of the day as well, this mood of inwardly living forms is present, from the rising bell (which is customarily a flute played in order to make a tender transition between sleep and waking) to the circle before breakfast when the household gathers round to light a candle, sing a song, say a verse, speak to each other a warm "good morning" — to the breakfast and its grace, usually recited or sung — the preparation for school or the day's work — tidying up and preparing the next meal — gathering to eat and chat — rest — the afternoon's school or work — walks in the evening or field trips — games and puppet shows, evening visits or cultural events, music lessons or artistic workshops, or time alone. These experiences are inwardly felt by both the handicapped and their friends; life is real, alive, and shared. The way of life is being continually renewed through regular review and creative suggestion.

This review is made not only by the individual communities in America, but by the international Camphill movement as a whole. There are frequent international conferences, and regular intervisitation by doctors and coworkers. The multilingual interchange is prodigious.

Now how can we let something like the Saturday night Bible Evening live in our imagination? For this seems to many, who have no relationship to Bible nor to Gos-

pel nor to Christ, an uncomfortable anachronism. Not only anachronism, but hinting at a sectarianism which many have struggled to free themselves from. It is hard to continue to use the language of Christianity and yet to disclaim sectarianism. Yet this is what Camphill does — what, indeed, Rudolf Steiner does. How can we come to this question in a fresh way?

Bible Evening is a ceremony, a ritual. It has a social function. Individuals who have been associating in practical ways with each other all week have a chance to meet at another level, to reveal themselves differently. The first part of the evening is devoted to conversation — a conscious exchange of experiences, usually following a common thread — something meaningful, something to be personally shared. When this can be done without too much formality, it is soul-easing.

And then the Gospel is read: stories and accounts and parables and prayers and exhortations and visions which were generated by experience of a certain quality of being. This being is an acknowledged mystery. No one has been able to settle its riddle. In the Bible Evening we open ourselves to this riddle. What was said? What was done? What was reported? What was conveyed? We spread the white cloth, light the candle, pass the bread and salt and juice, open our books — and meditate on *the word*. Why? Because in "the word" lives a spirit who acts upon us as a fine oil. "Christos" means "the anointed," anointed with oil. This spirit, like a fine oil, enables each of us to move freely in touch with all others and yet to retain our own form intact. It is a spirit who is undivisive and yet who blesses the uniqueness of every sparrow, every hair of the head, and each person. It advises us how to come to self-forgiveness, kindness, and honesty.

I suppose the reason why the community gathers around the Bible, rather than around the works of Emerson or Plato or Anne Lindbergh, has to do with the "primal mystery" of what Rudolf Steiner called "the Mystery of Golgotha." Golgotha is the hill on which Christ was crucified. Christ's blood entered the soil, thereby uniting Christ with the earth. This cosmic integration has affected human history more than any other event. It offers the possibility of a specific encounter in one's depths: an intimacy of relationship expressed in the mantric phrase "Christ in me." This personal relationship stands at the core of the Bible Evening. The paradox of the spirit who connects and who quickens in the pulse of one's secret being — this is a dramatic and moving imagination. We are asked to experience it consciously, in company with friends. The Mystery of Golgotha is spoken of in more detail in chapter 9.

This point of view makes possible a receptivity which is free of prejudice or preference, which allows the inner vision to play freely. This is part of what education

asks: the willingness to look at something dispassionately, to experience it free of previously formed likes and dislikes, to feel enthusiasm for the experience rather than for one's own tastes, and to practice a kind of innocence.

Innocence is the ability to stand free of cultural conditioning, to maintain contact with one's energy and idealism. It is the innocence of the adult who chooses to perceive directly from source. One of the reasons Steiner education is significant today is that it is not a cultural product. Actually it wishes to supply qualities which the culture does not easily make available. Thus it appears both inspiring and controversial.

But let us look at this point a little more closely. We can think of culture as the reflection of values in institutions. We can say that because we believe popularly in competition, our public schools are competitive. On the other hand we can say that although we believe in peace, we continually prepare for war. In this case, as in many others, our wants are conflicted.

It is also possible to think of culture at a deeper level, unfolding and evolving, healing its conflicts. Thus, we could say that Rudolf Steiner is not a product of nineteenth-century culture, in that he is neither a materialist nor a positivist nor an idealist. He starts with living substances and processes and environments as revelation of spiritual forces. But he is a product of the unfolding evolution of consciousness that works below the surface symptoms. A time is due when the truths of matter and of soul and of spirit will metamorphose into a new threefoldness and fourfoldness, and when the individuation process will generate a new stage of community. Or one could say, out of the individuation process of the modern age there evolves the next formative impulse: community building.

The community that comes about as a result of individuation is different from that which precedes it. Community is not uniform. There is the unconscious community of family and tribe, of nation and faith. There is the conscious community of individuals who *decide* to live and work together, not because they are friends or even particularly compatible, but because, as in Camphill villages, they are building a new human consciousness and social order — together. They may learn to like one another. One hopes so. But "liking" too undergoes a transformation. From something that might be called "natural feeling," or spontaneous attraction, there develops a capacity for friendship which has a more imaginative base. We could say here the same thing we said earlier about responding to art: it doesn't matter whether one "likes" the other person or not; what matters is that we offer respect, kindness, tolerance, cooperation, faithfulness. Maybe this is learning to love.

Maybe love too is not uniform. Maybe there is the natural emotion which one

falls into and which wishes to possess what it loves and to ignore what it doesn't love. And maybe there is a love which gradually outgrows babyhood and offers to participate imaginatively in the universe. It is as if we have within us, as Goethe wrote, two souls. One develops out of the other. Baby love never disappears nor need it do so. But the love of friend for friend, the meeting, as Dr. König said in "The Meaning and Value of Curative Education and Creative Work," "of Ego with Ego — the becoming aware of the other man's individuality without inquiring into his creed, world conception or political affiliations, but simply the meeting, eye to eye, of two persons creates that curative education which counters, in a healing way, the threat to our innermost humanity."

This is curative education in a wide sense, which is the sense in which ultimately all these educational impulses must be seen: widened from specific practical art to a quality and a concern which is, as it were, distributed throughout the body of our consciousness. König sums it up, "In its widest aspects, however, curative education is not only science, not only practical art, but human *attitude*. As such, it can be given like a healing medicine to those who stand under the crushing threat to the human person. This, however, is the destiny of every human being today. To counter that threat, to help and to receive help, is the meaning and value of curative work."

EIGHT

Education and Community: A School of Life and A Re-schooling of Society

In the whole man everything must be connected with everything else.

— Rudolf Steiner, *The Tension between East and West*

In every human being there is a region called the solar plexus. It is in the center of the body, behind the stomach. It is a network of nerves and ganglia extending in different directions. It is a sun, raying out. "Plexus" means "network" or "interlacing" and comes from a root image of plaiting or braiding. Such a picture, of the human being containing an inner sun which rays out in many directions, gives us a way of beholding that quality called wholeness, in which "everything must be connected with everything else." The human being is the matrix; the sun source shines through us. Each ray expresses some part of ourselves, which we can call the artistic, the scientific, the religious. In our period of modern consciousness, we can differentiate these "colors," although they sparkle together across the early morning grass. Modern consciousness is now generating a strong inner movement to integrate them at another level.

At the same time, other aspects of human existence have become separated in today's consciousness, and similarly they are becoming reconnected in holistic awareness and social forms. One of these separations is evidenced by the polarity of the individual and the social community. Another is the articulation of society itself into a threefold organism of economics, politics, and cultural life. These are stages of development having their source in the nature of the human being. Differentiated features make up the human countenance. Physically, our eyes, our nose, our mouth perform different needed functions, but only together do they

146

form Person. In society, it is through economic fraternity, political equality, and freedom of the individual in cultural life that the threefold social organism functions. Liberty, equality, fraternity are the special contributions of each of the three spheres.

Wholeness is not uniformity. It is a *universe*, that is, a way which is both a oneness (uni) and a movement or a turning (verse). How close to a potter's image this is! A turning oneness! It is extremely important to remember always that wholeness is dynamic. It bears within it polarities, paradoxes, contradictions. It is a differentiation of interests and activities. It is an organism made up of many moving parts. And, because wholeness lives, it follows the rhythms of growth and decline which characterize all living forms. Growth and decay form the polarity of ongoing dynamic life. Decay is implicit in growth forces and must be understood as part of their wholeness. Decay enables energy for growth to continue to develop and transform. The trick is to stay in touch with the whole rhythm and to see that clinging to old forms is antilife. To be willing to die into renewed life, to be willing to relinquish that which now needs to change, is to be willing to live creatively. This is not sentimental bosh. It is an objective law, an inner form which we can all see if we look at nature and at history and at society and ourselves. Fidelity and flexibility are subtle inner attunements.

The educational impulse in the activities which have developed out of Rudolf Steiner's indications is broader than schools. It implies a re-schooling of society. It is a point of view which finds "the teacher" in life itself. Human teachers are to be trusted as those who are committed to life, looking at it from many different points of view. They are like mathematicians, Steiner says: students of mathematics know that the teacher is helping them to understand a language which is common to all. As Steiner explained in *The Education of the Child* (see chapter 3), the new educational forms are implicit in the nature and needs of the child. We have but to learn to read nature and ourselves. It is not a matter of school reform and abstract utopianism. It is a matter of a renewed comprehension of humanity — *anthropos sophia* — as observed in concrete physical-soul-spiritual detail.

This is a dynamic view to take of learning and of authority. It helps us to look at the whole span of life as schooling and to be open to the developmental changes in body and perception which characterize it. It helps us to look for the connections and the changes between childhood and old age, and between human values and social institutions. It helps us to investigate what we can do to prevent illness and to heal illness. Not only schools as institutions of learning, but many new social forms are part of this overall educational concern.

147

It is dynamic too because we are not locked into past forms. We are free to change and evolve. We are free to learn, to correct mistakes, to take hold of experience in ways which reflect the new insights of any age. "Man is not a being who stands still," Rudolf Steiner said as quoted in *Healing Education Based on Anthroposophy's Image of Man*. "He is a being in the process of becoming. The more he enables himself to become, the more he fulfills his true mission" (frontispiece). Thus we may revise our conventional attitudes toward "failure," for example. What is often feared to be failure, may be in fact a willingness to change! If we have imagined that success means doing the same thing all your life, then the inner developments which are bound to arise naturally seem threatening. "Failure" may often be the expression of freedom from the tyranny of ambition, freedom from anxiety, freedom from social conformism. We need to awaken, in the wholeness of our imaginations, a sense for all the seasons of growth, and to recognize their "plexus," their interweaving in our souls. We tend to be more comfortable with spring and summer, less attuned to autumn and winter. And yet autumn is the season of nature's seedsowing and winter is the genesis of spring.

So in our thinking about education and community, we may also accept the reality of change. Every hour is an hour of transition, in a certain sense. What are the changes working up from the inner depths at present? We have surely learned to distinguish between the change which is simply a reaction against what has gone before, a swing of the pendulum, and a change which comes from free conscious deliberation and choice. This consciousness will be intuitive and imaginative and inspired, as well as practical. Here is another "plexus," another interweaving within our wholeness.

The word "school" contains the clue. Its root gives us the image of "a pause." It means "to hold back." Wait! Break the pattern! Stop, look, listen! There may be something to learn! This is a divine pause, this space between — divine because it is not an experience of *time* but of *freedom from coercion*. In this *pause*, we can choose out of our essential being the path we will take. What will be the next step? At its root, "to learn" means to follow a furrow, a track. To follow a seed-force. To follow a sign, an imprint, a script of nature. Rudolf Steiner insisted upon the necessity in our time for this checking back and forth between physical nature and inner perception. Spirit translates itself into substance, and substance is the bearer of soul and spirit forces.

The handicapped in Rudolf Steiner homes for those in need of special soul care are given therapies intended to awaken the senses and to harmonize the bodily elements of warmth, air, fluid, mineral. The children learn to taste bitter and sweet

and salt and sour, to touch different textures and temperatures, to feel the qualities of colors and to gather themselves into listening to sounds and playing them on lyres and simple flutes and xylophones. Their fragile inner sense of themselves is awakened and nourished by outer sense experience, and the difficulties they may experience in entering consciously into their physical bodies may be thus relieved — while at the same time their social relations are improved. Rudolf Steiner is quoted in *Healing Education:* "Play works from within outward, work from outside inwards. Just in this we see the immensely important task of elementary schools that play is gradually transformed into work" (p. 157).

What a re-schooling this implies: that we learn more and more to feel the inwardness of the external world and that we see how we may be enriched and strengthened and made more loving and wise and creative by activating our sense perception as a function of our whole being. Steiner's *The Tension between East and West* says:

> Man can attain true self-knowledge only if, by strengthening his otherwise dormant powers of knowledge, he attains the capacity to explore with his self the outside world. It is in the world outside that man finds his real knowledge of self! . . .
> The will can be developed to such an extent that the whole man becomes a kind of sense-organ, or rather spirit-organ — becomes, that is, as transparent in soul and spirit as the human eye is transparent. (p. 89)

To develop work habits then can be thought of as developing the ability to observe something outside ourselves faithfully and well, to relate to it, and to know that our inner being is thereby matured. Play is essential. Work is essential. Inwardness and outwardness. They feed each other, in a balance of originality and social labor. I am particularly impressed by this and challenged by it. In my recent teaching of college students, I have noticed how one-sided their approach to learning tends to be. Either they are entirely taken over by personal feeling, or they are submerged in external adaptation. "Feeling" tends to be limited to kinds of personal enthusiasm or distress, or to kinds of ambition. They have separated feeling from cognition. And what they are now painfully attempting to learn is a *feeling* which can see, and remember, and document, as well as invent and adorn and express its moods. They long for a felt cognition which can illuminate! For some of us it is an exciting step to learn that feeling is not only inwardly generated but may be originated by outer activity as well. Source-Sun shines from without as well as from within! Pleasure may indeed be a starting point, but it may also be what is created by the working process. To experience personal enthusiasm for doing what

149

needs to be done may be something we will want to learn. This is a holism particularly fruitful in moving from formal education into a school of life.

Similarly, the awakening of the self in its community aspect may be learned. Notice that this does not mean that we are *taught* to live as individuals in a community of free beings, but that if we follow the track, this is the "learning" which is implicit in us. Early schooling may be an important guide in this direction.

We begin life as members of social groupings based on blood ties — that is, on family ties. Historically, as well, humanity began with blood ties in tribe and nation. In this new age, the human soul is beginning to outgrow those earlier forms, which are still reflected in nationalism. We grow to be individuals through a kind of loneliness and separation; sometimes hostility and aggression break out. Gradually new capacities begin to stir within and to emerge. We begin to experience "human society" as an aspect of our self. The sense of *the other* ripens in us. Concern for their welfare is the form our individual growth may spontaneously and naturally take, if we follow the furrow. The cost is that as we awaken "the other" in ourself, we experience their sufferings as our own. The joy of conscious community is balanced by its pain. This polarity of "I" and "the other one" is intrinsic to our developing will to work. It is a crossing-point which contains both, and it is intrinsic to our human path of learning. *The Tension between East and West* explains:

Only by achieving a true understanding between man and man, so that what the other man needs becomes part of our own experience and we can transpose our self into the selves of others, shall we win through to those new social groupings that are not given us by nature, but must be derived from the personality of man.

All our social needs spring from the self. People sense what is lacking in a social order. What we need to find, however, is a new understanding of what human fellowship in body, soul, and spirit really means. This is what a social order ought really to be able to bring forth out of the self.

The great battle that is being fought over the division of labour — fought quite differently from the way such battles have ever previously been fought under the influence of human individuality — is what underlies all our social shortcomings. Nowadays, we found associations for production; we participate in them, concerned not with their role in the social organism, but with our own personal position — and this is understandable. It is not my aim here to complain, pedantically or otherwise, about human egotism. My aim is to understand something for which there is considerable justification. Without this sense of self, we should not have advanced to human freedom and dignity. The great spiritual advances have been possible only because we have attained this sense of self. But this in turn must also find a way to imaginative identification with others.

There is a great deal of talk nowadays about the necessity of conquering individualism. This is not what matters. The important thing is to find society in man himself.

150

The Oriental had to discover man in society. We have to discover society in man. We can do so only by extending on every side the life of the soul. . . .

You encounter many people in this purely intellectual age who find their own profession uninteresting. It may have become so, perhaps. There must come a time, once more, when every detail of life becomes of interest. Whereas formerly what was interesting was the nature of objects, in the future the interest will lie in our knowing how our every activity is articulated into the social organization of mankind. Whereas formerly we looked at the product, we shall now look at the man who requires the product. Whereas formerly the product was loved, the love of man and the brotherhood of man will now be able to make their appearance in the soul that has developed, so then men will know the reason for their duties. . . .

Thus the present time occupies a position not only between abstract concepts of individuality and community, but also in the centre of something that pervades man's soul and brings every individual human being today into action in defence of his individuality. We are only at the beginning of the road that leads to the right relationship between self and community. It is from this fact that the shortcomings of the time, which for this reason I do not need to enumerate, derive. . . .

It is from a standpoint such as this that we must consider . . . whether we are not justified in thinking that mankind can still, through the development of what lies dormant in its soul, prove capable of choosing a time when understanding shall be achieved, and that what faces us is not the death of this European civilization, but its rebirth. (pp. 144–46)

We can sense how certain needs or truths or laws already are implicit in what we have observed. If we follow the furrow, we begin with a care for the living earth: we re-school our agricultural practices. If we work not for wages but for the needs of others, we re-school our economics. If our human development undergoes such deep change and metamorphosis as part of its nature, we re-school our image of the human being, and permit moments of transition, re-evaluation, and re-creation. Maybe we have to learn, at this point, how to enable ourselves "to become." And if the new learning comes from keen and soul-filled observations of the sense world, we re-school our sense of truth and create communities of living and learning where the "school of life" is taken seriously in minutest detail.

The communities which are springing up based on an Anthroposophical image of the human being are permeated with the wholeness of these concerns. Some of them are trying to live the new economics, the new agriculture, the new medicine, the new architecture, education, the school of life — to re-school themselves from the whole into every part.

The Camphill Villages, discussed earlier, represent this new social impulse which contains impulses in curative education, agriculture, architecture, and the other arts. These are part of an international Camphill movement.

In Spring Valley, New York, on Hungry Hollow Road, there are a cluster of activ-

ities which reflect these broader educational goals. The nucleus of this center has been a few individuals who formed the Threefold Commonwealth Group in New York City in 1923. In 1926 they bought what has become Threefold Farm in Spring Valley. It consisted then only of a part of what is at present the main Guest House and orchard. The area now includes expanded guest house facilities, many private dwellings, biodynamic gardens, a Eurythmy School, a Seminar in Adult Education and Waldorf Teacher Training, an auditorium and conference center, Weleda Pharmacy for healing medicines and herbs and cosmetics, the Fellowship Retirement Community, Anthroposophic Press, and the Green Meadow School. A small industry produces handmade and painted wooden toys. Threefold Farm has now become the Threefold Educational Foundation and School.

The Threefold Foundation is a community with a strong dedication to adult education. Since 1933 it has sponsored summer Anthroposophical conferences with distinguished European and American lecturers, art conferences, and biodynamic farming conferences. From 1939 to 1961, Dr. Ehrenfried Pfeiffer conducted a biochemical research laboratory there, developing techniques of blood and plant crystallization which are used in medical diagnoses and plant research. Pfeiffer worked personally with Rudolf Steiner, and he was an outstanding figure in introducing biodynamic procedures in this country: composting and the making of soil preparations. *Bio-Dynamics*, the magazine of the Bio-Dynamic Farming and Gardening Association, was begun by the Threefold Foundation. Green Meadow School was started in 1950 as a nursery. In 1956 the first grade was added and the first new building designed. A new grade was added every year, and in 1972 a gymnasium and high school building were added, as the ninth grade began. More recently an arts building has completed the architectural complex. The Threefold auditorium was also a special architectural creation, distinguished by its fine acoustics and asymmetrical shapes. It is a center for concerts, performances, and lectures.

In 1965 there began one of the most unusual and vitally successful undertakings: The Fellowship Retirement Community. It has grown steadily in buildings and activities. Now about sixty retired persons live there with twenty-five coworkers and their children. Two doctors and their families are part of the community, as well as individuals who give specific therapies in massage and baths. Since the retired persons may live there until they die, some become infirm and need special nursing. A community brochure states: "At the foundation of all our activities is the older person and his care. A deep concern of ours is that the abilities of the older generation come into a working relation with the potentials of the young."

The presence of children on the grounds and at mealtimes is conspicuous in the

Fellowship Community. "The Child's Garden," a preschool, is conducted in one of the houses. There is a feeling that little children should remain part of the family, so their schoolrooms are part of the older folks' living quarters. Students do not come to school every day. They spend some days at home, learning by imitation in play — outside in the gardens, inside in housework — with older and trusted adult friends.

There is a day school for children in need of special soul care, named after Otto Specht, who was the retarded boy tutored with such remarkable success by Rudolf Steiner when he was a young man. The community as a whole provides a model, as the handicapped learn to garden, do carpentry, help an older person, prepare or process food, mix herbs. There is a pottery studio in which they and other members of the community are invited to participate.

The spirit of community is shared by all. The older people find plenty to do that interests them. Mercury Press, for example, is situated in the basement of one of the houses, and publishes lectures and booklets relating to the medical aspects of life processes: the physical organism and healing forces. Older residents help with collating and assembling the books, in addition to contributing art work. There are three and one-half acres of biodynamic gardens, and help is always needed and welcomed in the different seasons. Those who are able to, chip in during harvest season when many fruits and vegetables are processed for freezing and canning. The Weleda puts together some of its herb teas and cosmetic preparations nearby, and members of the community help with mixing the rosemary and lavender and putting the aromatic healing creams, such as lemon and calendula, into containers. Candlemaking and woodworking and jewelry making are among the activities enjoyed by the members, and an extensive library is kept in order by its older users.

The retired residents make an initial financial contribution and pay a monthly amount for food and services. If unusual physical nursing is needed, a special fund has to be created. Coworkers participate, as they do in Camphill, without salary in the usual sense. They submit a budget of needs, and these necessities are met out of community funds. Submitting a budget of needs enables the coworkers to clarify exactly what they do need and gradually to decrease their needs. It is the new age principle of doing more with less: the principle of conservation. All income from medical practice, printing, crafts, garden, and Weleda shares, goes into the common fund.

There is an effort made to educate the coworkers for community life and for their special tasks, such as gardening or therapy. Everyone meets the same challenges. They call their educational impulse "a school of life." Through Anthroposophy

153

one takes up one's life on earth with an intensified sense of its meaning and relevance. Spiritual life is developed here in physical life. Our spiritual tasks on earth are to learn to love and to become free in our initiative. These lofty lessons are met in daily attention to detail, the head physician explained to me: "Is the doormat askew, could someone trip on it? Straighten it out! Are the wet cleaning rags hung out to dry? Are the six needed items in each of the buckets in the cleaning closets ready for daily use?" There is continual observation of physical symptoms: skin color and temperature, facial tension, voice timbre — learning to pay attention, learning to see and to understand, and to direct activity accordingly.

Community thrives when it has something real to do and to care about. The human beings are replenished. And the mutuality of the work stimulates inner growth. Much of the learning is how to "cognize" what is experienced: to wake people up in their senses, to learn to see phenomena in relationship, and to find an inwardness of spirit by looking outward to the world. They learn to look at substances and at forms in a way that awakens a sense of their inner quality. There is a research laboratory in the Threefold Community where chromatography and crystallography are practiced in order to test vital forces in plants and blood samples. An effort is made to keep science, art, and human caring under the same roof.

Fellowship Retirement Community is a school of life in which people are trying to learn to see the human being and the earth in their living qualities, and to care for them in ways which develop these qualities. Life qualities may be related to physical matter in various ways. This is one of the lessons learned by observing childhood and old age in a common setting.

The design of the environment itself is meant to reflect a determination to connect the artistic and the practical in meaningful form. Since Goethe was one of the first modern men to search for a new science which will comprehend the element of life, structures in Anthroposophical communities often bear his name. In Hill Top House a new wing has two large spaces in its center. The Goethe Room is a septagon, a seven-sided room, and another a pentagon, five-sided. These adjoin, with a space ratio of three to one, which is the same as in the original Goetheanum. A newsletter at Easter, 1976, says: "As the original Goetheanum was built as a 'House of the Word,' so we hope we can find a way to make our building into a house of healing. The smaller pentagonal room is surrounded by rooms for the ill; the larger septagonal room adjoins work areas. Thus these large rooms for cultural-spiritual activities are surrounded by areas for work and the care of the ill. Here is represented spacially the effort to unite work and healing with the cultural-

spiritual life." This is a concrete example of the attention given to the soul-qualities of architectural shapes, as part of an overall commitment to healing.

The cultural life of the community is lively, with music and plays, square dancing and eurythmy, painting and crafts, and the social exchanges among the different ages. There are picnics and outings in summer. A steady flow of visiting lecturers is supported by the work of the different groups meeting almost daily. Snack times twice a day furnish brief but important moments for spontaneous social contacts, even for residents who are very weak and in wheelchairs. The laundry room is in the center of the living quarters, so that it serves easily as a natural gathering spot combining work and visiting, and one where help is readily available.

The residents have private rooms, some with kitchen facilities. They all take their midday meal together and may take breakfast and supper according to their preference. Summer produce from the gardens is shared throughout the community. The members represent a wide variety of life-styles and degrees of independence.

The community attracts numerous volunteers to help with the unending labor of care, maintenance, and cultural offerings. Volunteers, too, appear open to reschooling in significant ways. Individuals interested in becoming coworkers are welcome to visit and to apply.

This Fellowship Retirement Community reflects a common concern in our time, and one to which Rudolf Steiner's investigations were addressed. Its path is to develop truths out of the physical, which, if transformed into impulses of the whole person, provide a framework for understanding social life and shaping social forces. Like Camphill, what has begun as a specialized community may be a pioneer in a new form of total community, in which the elderly and the dying are resources. The renewal of spiritual life may be stimulated by the practice of daily care which many elderly and dying persons require. The old and the young are integrated in a common setting because of their usefulness to one another.

Aging adults express the mysteries of body, soul, and spirit as vividly as do the other age groups. And communities which give opportunity for the expression of their life-wisdom as well as their dependency and their ongoing growth in creativity through the arts become nuclei of quickening life. It is the old who stand closest in consciousness to birth and transformation.

As in other contexts, Steiner points to physical facts as the means for spiritual development. If we heed faithfully the lessons from the school of life, we will be led step by step to new social capabilities.

NINE

Waldorf Education and
New Age Religious Consciousness

For the true nature of man rests on the fact that through him new
forces are continually coming into existence. It is certainly true that,
under the conditions in which we are living in the world,
man is the only being in whom new forces and even — as we shall
hear later — new matter is being formed.

— Rudolf Steiner, *Study of Man*

In new age consciousness, the religious impulse continues to evolve. Like the sun,
it shines across all divisions. And like the sun, it works deep in the processes of
earth itself. To become undivisive in our science, our emotions, our creativity — to
live in the paradox of separateness and connection, differentiation and mu-
tuality — is an imaginative frontier. An avant-garde!

In this chapter I want to engage directly Steiner's approach to Christianity and
the flavor it gives to the Steiner schools. It is difficult nowadays to use the language
of Christianity to say a new thing. It is so karma-laden, so ritualized, that we tend
to react to the words and not to hear their deeper meaning. How is one to speak of
the Christ impulse (a recurring phrase in Steiner's speech) and feel free of stereo-
type? How transform what has been the most sectarian faith into a nonsectarian
perception which heals divisions?

Rudolf Steiner tried to, as demonstrated in the following passage from *The
Younger Generation: Educational and Spiritual Impulses for Life in the Twentieth
Century:*

We are standing inevitably before a new experience of the Christ Event. In its first form
it was experienced with the remains of old inherited qualities of soul; they have van-

156

ished since the fifteenth century, and the experiences have been carried on simply by tradition. For the first time, in the last third of the nineteenth century it became evident that the darkness was now complete. There was no heritage any longer. Out of the darkness in the human soul, a light must be found once again. The spiritual world must be experienced in a new way.

By no means superficially but in a deeper sense, it is clear that for the first time in the historical evolution of mankind there must be an experience which comes wholly out of the human being himself. As long as this is not realized it is impossible to speak of education. The fundamental question is: How can original, firsthand experience, spiritual experience, be generated in the soul?

Original spiritual experience in man's soul is something that is standing before the awakening of human beings in the new century as the all-embracing, unexpressed riddle of man and of the world. The real question is: How to awaken the deepest nature within him, how can he awaken himself?

This lies at the root of a striving in many different forms during the last twenty or thirty years and is still shining with a positive light into the souls of the young. It expresses itself in the striving for community among young people. People are looking for something. I said yesterday: Man has lost man, and is seeking him again. . . .

In short, human beings, in community life, must mean something to one another. It is this that from the beginning radiated through Waldorf School Education, which does not aim at being a system of principles but an impulse to awaken. It aims at being *life*, not science, not cleverness but art, vital action, awakening deed. . . .

Yes, my dear friends, if an awakening is to take place, the Mystery of Golgotha must become a living experience again. (pp. 22–27)

We cannot suppose that we already know what Steiner means by the "Mystery of Golgotha" and therefore not bother to inform ourselves. It is not so much a case of "what he means by it" as what he experienced, because of his unusual openness and freedom from preconception. He was able to become a "listening ear" to a remarkable degree. This is a capacity we may all develop. To listen.

Steiner was perceiving, not in dogmatic forms, but in the inner spiritual landscape of our modern epoch. He knew that it is not a religion in the old sense of belief that is resurrecting in our hearts, but a perception of the physical universe throughout as spiritually alive and moral. Moral, that is, through the spiritual agency of mankind, in whom Christ works as Wonder, Conscience, and Compassion.

He saw the Being of Christ as a formative force within the sphere of the earth, as well as beyond it. Christ belongs to the religious mysteries of the sun, which have been so celebrated in the religious life of our planet through the ages. This mighty Being of Love suffers the conflicts that characterize the spiritual planes as they do the earthly. Christ is not above the battle, as it were, though undividing warmth may flicker in the fires of the battles themselves, as Krishna tries to explain to Arjuna in the epic dialogue of the *Bhagavadgita*.

157

There is no nonnegotiable abyss between Jew and Christian and Buddhist and Aborigine, between physicist and mystic, poet and economist. The sayings of Christ respect separateness and connection as reciprocal. The problem is that as soon as you name something or someone, it sets them off against others. To learn to name a Name that does not do that — a Name that contains not only the human family but the earth and nature — is the direction the unconscious psyche wants to take in our time. The inner movement of the human soul is toward unity through diversity. Rudolf Steiner in his book *The Gospel of St. John* said that Christ is "the Spirit of all-inclusive Knowledge" (p. 80).

Can we try, in this chapter, to re-imagine the vessel of life's wholeness? Perhaps the most important new age element is the freedom to be new! This is not to be mistaken for novelty or compulsive innovation. The freedom to be new is the freedom to follow the course of spiritual evolution. The Way is on the move. It may integrate traditions consciously. But it moves clear of unconscious habits and mechanical repetition.

We may take our cue from the word "religion." It comes from the Latin *re-ligio*, *re-ligere* and it means "to bind together, to bind together again, to be concerned." Exploring the ways in which a religious impulse — a "binding together again, a being concerned" — works in the fabric of nature and of life itself, as well as in our relation to ourselves and to each other, is a frontier today. As Rudolf Steiner suggested in the passage just quoted, the religious experience occurs afresh within individuals when they awaken to their inner "I am." The real question, he said, is how to awaken the deepest nature within us, the inner self. And in the awakening of the inner self, he indicated, we approach the Christ within. The word "Christ" then takes on its nonsectarian universal meaning. The word, like experience itself, is transformed and renewed. Consciousness sheds its sectarian aspect and becomes the "living word" of human brotherhood and sisterhood. Thus do words evolve as we evolve. As the inner self awakens to its universality, to a love not only of its neighbor but of its enemy, it experiences the spirit of Christ. As with human beings, the historic destiny of Christianity unfolds: from spirit realms into incarnation and biography, and from historical biography into transcendent interconnection.

In modern depth psychology, one finds a similar observation of what is taking place in the evolution of human consciousness in the new age. Where the Jewish relation to God was through *law*, and the traditional Christian relation to God was through *faith*, the new mode is centered in *experience*, as Edward Edinger recently wrote in "Depth Psychology as the New Dispensation." To recall Steiner's words

once more, "If an awakening is to take place, the Mystery of Golgotha must become a living experience again."

Elsewhere Steiner described how the Christ Being brought into earth evolution the individual "I am" experience, which had been prepared for by the Buddha's earlier gift to humanity of compassion. In *From Buddha to Christ*, Steiner said, "The mission of anthroposophy today is to bring about a synthesis of religions" (p. 93). In *The East in the Light of the West*, Steiner gave an account of the evolution of eastern and western paths of inner development, of their initial union, their separation, and their emergent re-integration at a new level of consciousness. He also gave a striking picture of the World Christ, built into the earth itself in the cruciform directions of its geology, a great figure both male and female and lifted into the forms of earthly landscape. The meditations appropriate to the new age are evolving beyond the past of both the East and the West. When the Christ Being comes into earthly existence again, it will be through the hearts and deeds of human beings. The Second Coming will be our Coming.

To feel the whole in every part applies to the entirety of cognition: scientific, artistic, religious. A threefold light illumines experience, and we begin to intuit how life is art is religion is cognition. In order to live in this threefold light, daily, we are asked to be in touch with our deepest nature. The religious life, then, like the intellectual and artistic, becomes a part of education in a natural way, as it is part of all life. It may become as well a conscious commitment to daily economic and political practice. When we can begin to integrate the universality of our religious intuitions, as well as their individual particularity, with economics and politics, we will take a big step toward wholeness. For the facts of economics are the expression of the "religious" facts of human brotherhood and sisterhood and their expression in the associations of producers and consumers. And politics is the expression of the equality of all individuals as spiritual beings.

To be able to meet one another in the matters of money with a sense of human flow and interweaving, and in matters of justice with a sense of the absoluteness of individual identity and its rights equal before the law because equal in divine presence, is to begin to approach a new age religious consciousness. To be able to confess wrong, to ask forgiveness, to seek humility rather than pride, to offer respect to wrong-doers, to grow toward serving others — these will be steps toward a new social culture. They may be human arts through which we integrate religious practice and social practice. The flavor of this practice is given by the universality of the Christ Being, who manifests in each person's uniqueness, in each blade of grass.

159

One of the many interesting things that Steiner said about practical life is that economic problems cannot be solved by economic means. Economic issues are basically issues of human self-respect. The relationship to themselves and to the world which people hunger for, will never be satisfied by money, as example after example has demonstrated. For the respect can come only from the spirit within oneself. The desire for money seems unquenchable, for it is often used to satisfy the craving for a sense of identity and a sense of purpose. Money, Steiner said, should circulate in the social body as blood does in the human body. It makes activity possible. But the sense of self is an inner awakening, it is an experience of reconnecting, it is a religious experience. The lack of this religious sense of self is the cause of neurosis, Jung was convinced.

How does the awakening of the inner self come about? It is the bud resting invisibly in the bulb of the flower. It rises in warmth. Of itself it contains the Way. It is the child within.

Such a picture may rise in our imagination as we think anew of pedagogy. The word "pedagogy" contains within it the image of "child" and of "guide." Pedagogy is meant to be a crossing point of child and teacher. It is our inner child who is our growing tip, our creativity. It is our poet, our redeemer: "Be ye as a little child." An inner vision may show how the child in us rests in the arms of its guide, our "I am." Their hearts are one. If we project this picture upon the world, we try to create a schooling in which the child is nurtured and in turn nurtures the adult. It is not far to leap to name that Heart in whom we "children" live. It is each one's heart, it is the shared human heart, it is the divine Heart who embraces all beings. In the Steiner schools an attempt is made to bring human warmth and numinous imagination into its pedagogy. It is an expression of religious consciousness, and it is inspired by Steiner's remarkable penetration into Christology. We must bring "the sacred" out in front, let it be revealed in the facts of life, and unrepress its expression in our society. And when we bring it out, from whatever direction we come, whether from Native American wisdom, or Buddhism, or Judaism, or Bahai, or Sufism, or Hinduism, or Islam, or atheism, or Druidism, or Christianity, we see that what characterizes the sacred is another kind of time and space. Time, as we ordinarily experience it, is a sequence of events, discrete, interpreted in minutes, hours, days, years, centuries, and on. We do not, in ordinary consciousness, see through its divisions into timelessness or simultaneity. We may say that it is opaque to us, like space. Ordinarily we experience space through its surfaces, not through the invisible living entities whose activity manifests in any given shape. Sacred time and space are transparent, in that we can see through the

divisions and external forms to the underlying living stream. In this stream, we move as both separate and interconnected with all other beings. We can be mystically united and individually conscious at the same time.

Rudolf Steiner said that unless we get sacred time and space into our consciousness, unless we awake into the dimension in which Christ lives, we will continue to be asleep to reality, and we will continue to call upon ourselves the social disasters which seem to have become a way of life. He saw education as a way of waking into that living dimension, the realm of formative energies which are "life-bearer" to physical matter. The way we learn arithmetic, algebra, geometry, he observed, affects our moral imagination. If we start with units, with atoms, and try to add them together, it is difficult to come to an experience of wholeness, of ONE. We tend to remain in the world of quantities. Our arithmetic may be at the basis of greed and anxiety. If we start with one, and find all numbers within the sum of that whole, our experience is integrated at the outset, and carries the quality of oneness with it throughout all the operations. There are inner connections between numbers because they are part of a whole. Even the negative numbers. Even imaginary numbers. Even counterspace.

To Steiner, geography illustrates both the sense of connection and the sense of differences. The child is confirmed in a joy in localisms as well as in the instinct for identifying with the whole picture.

The language arts, music, painting, movement, drama — all these stir deeply in the foundations of our human nature. Time and again in his lectures on education and on art, Rudolf Steiner indicates their source in the depths of our connections with the whole of life. This concept challenges contemporary obsessions with dissociation, alienation, and absurdity, by awakening our inner picture of the whole, of which we each are an individual part and which connects us. It is an image of interweaving. It is an image of light passing through boundaries. It is an image of vessel that contains us all. It is an image of formative, personalized energies. It is an image of inner language and speech formation which sounds outside the ability of the physical ear to hear, but within the organ of intuition — a Word that already "means" before it is spoken. These are images expressed in the arts of weaving, of glass, of pottery, of sculpture, of dance, of poetry, of architecture, of jewelry, of painting. Of course we are moved to learn and to create! They are our way of plugging in! Our physical world is where our sacred dance takes place. Our joy comes from feeling "Home free!" as we used to shout in our childhood game of hide-and-seek.

To try to educate ourselves without a sense of the whole in every part is impossi-

ble in Steiner's view. And to pretend that morality is a fragile hope raft, disconnected from the sinewy interiority of the universe, is a conceit, I would add, masking itself with heroics and self-pity. Morality is built in. Ecology has arisen out of life, not out of ideology. The spirit of the universe is moral. That is to say, it is holistic. When we estrange ourselves from it, we feel cold and helpless, naturally. When we are with it, we are warmed as by an inner sun.

It is a koan, a riddle, this question of finding a living connection to the Mystery of Golgotha. By using this phrase, Steiner links Golgotha, the Hill of Skulls where Christ was crucified, with such ancient mystery centers as those in Egypt, Ephesus, and Eleusis, where initiation into spiritual knowledge took place. Unlike the old mysteries, the new mysteries of Christ are open to everyone and represent a step toward wholeness and reconnection at every level. The Mystery of Golgotha was a cosmic happening, affecting the destiny of human beings and of spiritual worlds forever after, as Christ the Sun Being joined our earth. It is for this reason that this event is called the turning point of time. From this point on, new healing forces are available.

In the spiritual evolution of the universe, the coming of Christ was made possible partly by other great initiates, who participated in Christ's incarnation, even in the preparation of Christ's physical, etheric, and astral bodies. Believers of whatever persuasion tend to compete for supremacy and therefore resist becoming parts of a whole. Steiner's Christology delineates an evolutionary relationship among all great teachers, through which they participate in the Universal or Christ Event. In *From Jesus to Christ*, Steiner shows how even Jesus became a vehicle for the larger Christ consciousness.

The spirit of Christ is the spirit of oneness. All faiths may be subsumed within it, as all are reconciled. The spirit of Christ is a door to the development of individuality reconnecting with the spiritual ground of the world. In this light Steiner sees the integration of West and East. With these, North and South are integrated as an alignment of sensory and supersensory capacities. Thus the four directions of the cross meaningfully symbolize the wholeness of this spirit.

The religious life puts the intuition of "feeling the whole in every part" to a tough test. How can the sacred quicken in the pulse of everyday practical experience? How can love and forgiveness and mercy and courage be held in the imagination as divine mysteries, rather than handbook techniques for self-improvement? How can we begin to read the laws of physics as participating in a conscious universe? How can we overcome our fear of truth, as if it might take away our freedom? How can we come to a new sense of truth which will include all the steps and mis-steps along the way?

The Waldorf schools haven't solved the problems. But they are working in this spirit. And the intuition that underlies the mood of their schooling is this one: that the whole lives in every part. The teachers work at it in their own studies and artistic practice. They try to teach so that its spirit may arise freely in the concrete experiences of the curriculum. It is a continuous endeavor, not a package.

I can relate to this endeavor. It's what I am trying to do in my own life. It's what I wrote about in *Centering*, what I learned from throwing on the potter's wheel. Already in that book I wrote that Rudolf Steiner education was the closest thing to a centering impulse in education I had run across. I compared it with A. S. Neill's work at Summerhill. I felt it could use some of the Summerhill trust in the libido, but I felt that Steiner's interest — not only in the child's history but in the child's prophetic qualities — embraced more of human reality. I felt that the concept of the threefold human being could accommodate our developing perceptions.

Centering clay on the potter's wheel taught me how to feel the whole in every part. Hands bring the spinning ball of clay into equilibrium, by squeezing it first up into a cone, and then flattening it into a disk, repeating this rhythmically until there are no pockets of wetness, no hard lumps, no air bubbles. The qualities of moisture, plasticity, and color are distributed throughout the body of the clay in an even grain. The clay turns like an unwobbling pivot, fat and wise and wet, like a baby Buddha.

Thumbs press down into the middle of the spinning ball, opening it into a cylinder. Because the clay has been centered, the inside has the same quality as the outside: same moisture, plasticity, same grain. When we raise the walls of the cylinder, we hold the clay between our fingers at just one spot. The clay turns, and we let it slide through our fingers, which are firm and gentle and steadily pressing and moving upward as the wall lifts. The miracle is that the entire pot takes shape by being touched in only one place. The whole vessel is experienced at every point.

It is a lesson in permeability as well. The qualities of moisture and plasticity and color spread through each other, interpenetrate, infuse each other. They have no strict boundaries, though each quality is identifiable in itself. Each contributes its essential function, and though each quality is distinguishable, it is assimilated into the clay body and the clay form.

When using water colors on wet paper, one may have a similar experience of interpenetration. We may let one color, yellow, float into the white background. Then blue flows from another side into the white and then into the yellow. The colors receive one another. There is the yellow, there is the blue, and there is the green. In the green you can see the yellow and the blue.

Painting exercises in the Steiner schools, for both teachers and students, can

have this character. Water color is used so that light will shine through the overlapping layers or "veils." Individuals experience not only the colors, but they experience their permeability, their interpenetration. They experience softness of boundary. It is not so hard then to think of the body as permeable to air and to moisture, and the mind to thoughts and feelings and will impulses. It is not so difficult to see how permeable we are to one another's influences and how, though each of us has our own color, we make up an in-depth color perspective with other persons. Community has a color, made up of all our hues, overlapping in transparencies. Or one could use an imagery of sound. Each of us has a tone. The tones can be simultaneously heard; a cluster, with one sound made up of many sounds ringing through.

One could say that Waldorf education has a hidden agenda. Its curriculum is described in terms common to public schools in general: arithmetic, writing, reading, geography, botany, biology, handcraft, history, and so on. But in Steiner schools the dimensions of these subjects are threefold: they are artistic, cognitive, and religious. The children work with artists' materials in all their lessons; and in elementary school they approach the entire learning process through imagination. Knowledge and skills are acquired, but it is acknowledged that a certain kind of mood seems to be necessary for successful learning. Nature yields her secrets best to a reverent approach. Students learn to observe, to receive, and to offer.

There is a continual interconnecting, a relinking, a re-ligioning, of one activity with another, one perspective with another. As Steiner put it in *Practical Advice to Teachers:* "Moving from one thing to another in a way that connects one thing with another is more beneficial than anything else for the development of spirit and soul and even of body" (p. 173). We have spoken about how the writing of the alphabet is developed out of drawing and story; each consonant is presented as a picture which is slowly abstracted into the modern letter. Botany, as we have seen, is connected with music and with stages of the child's growth. Geography scoops up just about everything into her big lap, including the peoples, nations, cultures, languages of our planet — its geology, archeology, sociology, anthropology. And what is the wholeness that unites every part? The human being! Us! All subjects meet in the human being. To understand *us*, to know oneself, is to know the world. And to study the world is to come to know ourselves.

Together these vivid colors in the Waldorf curriculum and school life form a rainbow. They are linked in a spectrum of color.

Art is not only painting, but is a capacity within all other behaviors. Science or conscious cognition is not only the goal of intellectual study but is a resource

within all other attitudes: faithfulness to objectivity and unfolding thought. Religion is not an affair for Sunday alone or for theologians and priests. It is a dimension applicable to all our experience. These form our threefold being. They develop differently at different ages, but by adulthood, they may be cultivated consciously in coexistence.

Small children, Rudolf Steiner observed, are naturally religious, in that they identify with the environment, and believe that everything is worthy of imitation: in other words, everything is GOOD.

The child from change of teeth to puberty is naturally an artist and experiences the world as BEAUTIFUL. And after puberty, the powers of thinking develop markedly, and the search for TRUTH accelerates. Though all these have been present from the beginning, there is not a uniform development, and certain qualities take their maximum growth at certain times. And throughout development, the sacred is linked to the child's experience.

A fundamental relinking of the sacred dimension with secular knowledge is through the empowering language of mathematics. Of course threeness, the triangle, the tetrahedron, and the trinity are all mathematical archetypes with strong numinous character, as are other numbers: the one, the two, the four, the five, the seven, the nine, the twelve. But one concept which has suffered grossly from dissociation from the whole is that of "hierarchy." The spiritual hierarchies are the spiritual beings at work in human and cosmic existence. Traditional religion speaks of the ranks of angels, archangels, and archai, and the cherubim and seraphim, and others. Steiner also describes time spirits, spirits of movement, spirits of form. These hierarchies are difficult for the modern mind to accept partly because "hierarchy" suggests elitism and spiritual manipulation. The helpful fact is that "hierarchy" is a mathematical form and function, and once we accept it as an image of the arrangement and relationship of powers, we come to its religious meaning. The hierarchies, that is to say, are part of the morphology of the whole. Each hierarchy, or order of spiritual beings, subsumes within it a variety of individual elements. Ever more inclusive hierarchies extend in ever wider circles. The hierarchies are qualitative orbits which contain within them the movement of other forms. The forms which are governed, in this mathematico-religious sense, by a hierarchy, are its manifestation. Therefore in each person the spiritual hierarchies are present, as in each grain of sand the macrocosm is present. In the power of the small, the hierarchy has its life and purpose. Sand is the ocean's poetry.

It was through mathematics that Rudolf Steiner first found the bridge between the physical world and the meta-sensory forms within it.

165

The special offering of Anthroposophy to the new age is a striving for a spiritual understanding of nature permeated by Christ. This is a radical new perspective. Our minds can barely stretch to imagine what it might mean. It is integrative beyond our present capacities. The wholeness of this radical mystery is sought for in every part of the life of the school. The respect for materials, the reverence for nature, the striving for community, the combination of individuality and fraternity, are evidence of the commitment.

Rudolf Steiner put the Christ Event at the center of earth science as well as human evolution. Oliver Mathews writes of him in "Religious Renewal":

> Rudolf Steiner continually asserted that the time has come when it is necessary for humanity to grow beyond a simple acceptance of Christianity and to penetrate ever more deeply in consciousness to the understanding of the Mystery of Golgotha; but, at the same time, he continually emphasized that this event was a Mystery, the full significance of which would only be realized at the end of earth evolution.
>
> The centre of this evolution is Christ Jesus himself, and what He did and continues to do. The sacraments, from the beginning, Steiner said, are a continuation of Christ's deed. What Christ, as a culmination of his incarnation requested the disciples to do, namely to assimilate his body and his blood, which He was now identifying with the elements of the earth, He continued to elaborate with his disciples during the days between the Resurrection and the Ascension, when Christ withdrew, not from the earth, but into the life sphere of the earth. Henceforth He could unite with the elements anywhere, in so far as human beings gave him the opportunity of doing so. (p. 199)

When an attempt is made to give our cognitive capacity the kind of schooling that will enable it to grasp *the nature of life* and to further it in practical work and action, this is new age Christianity. Some of the most productive scientific research in this spirit is being done by Theodor Schwenk at the Institut für Strömungswissenschaften (Institute for the Scientific Investigation of Water Flow) in Herrischried, Germany. His book *Sensitive Chaos* discusses the living forces of water and air. Elsewhere, in "The Spirit in Water and the Spirit in Man," he presses the question, "How can forces of resurrection be brought into these dying elements of earth?"

> Humanity as a whole, as well as every single individual comprising it, is being called upon to take the step from a rational-soul to a consciousness-soul orientation. This means becoming aware of the one-sidedness that has developed, and taking healing measures based on an understanding of the fact that the organism of the human race is a single whole. The Waldorf Schools, for instance, use the approach from the whole to the part — or, in other words, grasping the part in its relation to the whole — as a methodic principle that runs as a life-pulse through the pedagogy to create, already in childhood, a foundation for a lifetime healing function. . . .

166

In an earlier lecture . . . we characterized the error in thinking henceforth pervading scientific inquiry, which held that everything in nature, living or dead, can be traced back to lifeless physical and chemical causation.

We then went on to show that quite other laws prevail in realms of life — laws in polar contrast to those obtaining in dead nature; that these laws of life can be seen as typically forming wholes, and that they function in rhythmic and cyclic processes.

It is always water that mediates between the complexes of laws that govern what is living and what is dead. And so water becomes the great "teacher" at the moment that abstract consciousness crosses the threshold to that other consciousness which once again befriends itself with laws of life.

How can the death processes now taking place in earth and air and water be brought to a halt, and matter — water, for example — be restored to life? How can the forces of resurrection, wrested from death, find a locus on earth? and this not just theoretically, but practically, organo-technically speaking? How can we give our cognitive capacity the kind of schooling that will enable it to grasp *the nature of life* and to further it in practical work and action? . . .

The problem of revitalizing matter rests for its solution on restoring life-forces to our thinking — for thought schooled in the realm of death can lead only to a further descent. And to achieve this we will have to develop a new kind of science suited to dealing with the life element. (pp. 22–24)

Have we then made some progress in our struggle to see religion in a new way, as a reconnecting? We find that the so-called religion lesson is, in its appropriate form for today, a lesson in reverence for nature — a sense of parable — an openness to human biography as myth. Powerful constellations of forces shape our lives. The religion lesson helps us to listen to each other's stories and to develop an ear for the workings of destiny.

Very few Waldorf schools in America have separate religion lessons. This is because a mood of tolerance and wonder is sought throughout the schooling, and this mood is meant to characterize cognition and creativity as well. There is also another reason. In the original German school, a representative of each denomination was invited once a week to teach those children whose parents requested it. Other parents, not affiliated with a church, asked for some religious instruction for their children. And so the "free religion lesson" came into being. Free (i.e. nondenominational) religion lessons are given as preparation for Sunday services which Rudolf Steiner composed for different age groups of children.

It was Rudolf Steiner's advice that religion lessons need not focus on religion as such. Life experiences, current events, fairy tales, legends, parables, and historical biography are all used. With older children of high school age, the Gospels may be discussed. These provide a sharing which strengthens connections with life and with each other. The power to bless, Rudolf Steiner said, is the flower that grows from a capacity for reverence cultivated in childhood.

167

Among the many and varied works that have arisen out of Rudolf Steiner's life was an impetus for religious renewal started by German pastors who went to him for advice. It led to a movement separate from the Anthroposophical Society. The Christian Community was founded in the Goetheanum in 1922, with a celebration of the sacraments, which are the heart of the renewal. Christian Community priests are often called upon to perform the marriages and baptisms and christenings and funerals and communion services in the Waldorf and Camphill communities.

New age religious consciousness repositions itself at the wellspring. Through all life's channels the source may flow. Even Christianity is changing. It is not belief nor tradition nor institution any longer. It cannot stand without the participation of Buddha and Zarathustra and the other great initiates, all of whom have played their part toward cosmic unity. It cannot be taught directly. Now it is to be freely found by each person out of his/her own experience, through the doorway of the senses awakened from within. We do not give up the world. We enter into it. These are what Rudolf Steiner in *The Christ Mystery in Relation to the Secret of the Pentecost* called "the new mysteries":

> We must learn once more through spiritual science to behold a spiritual in every material creature — a spiritual behind the stone, a spiritual behind the plant, a spiritual behind the animals, a spiritual behind the human being, a spiritual behind the clouds, a spiritual behind the stars, a spiritual behind the sun. When we penetrate through matter to find the spiritual once more in its reality, we shall also open our souls to the voice of Christ, who would fain speak to us if we would only hear. (p. 21)

He is talking here about a Cosmic Being.

The study of the human person in a living context is the new curriculum. We stand within a world speech, to be heard afresh. This seems to me to be new ground, a step forward, as in a season of spring, feeling new growth come. The seeds are planted, in nature and in us. They are ready for harvest at their own time. The roots of Rudolf Steiner/Waldorf education are deep in history and prehistory. One can feel the unfolding forms pulse in the veins of life.

They rise to meet us in the archetypal images of the seven I Am's of St. John's Gospel. Jesus says: I am the light of the world. I am the door. I am the bread. I am the good shepherd. I am the vine. I am the resurrection and the life. I am the way, the truth, and the life.

Light breeds in the dark. Door swings on a hinge, out and in. Bread transmutes fire into body which feeds. Shepherd preserves warmth in aeons of time. Vine is the axis between earth and sun. Life dies into transformation. The Way is the riddle of truth.

Source and human life evolve together. Something newly integrative is creating a religious consciousness all can share. It bespeaks the mystery of wholeness, the oneness of humanity, an encounter with evil and its turnabout, the meta-life of physical matter and its celebration in ritual, star wisdom and guardian angels, and the inner dramas we suffer through as we seek to outgrow our addictions and our ignorance — our opacity.

We are born forward by an inner motif, a living word, which means "heal, holy, whole." We hear it as a music, re-ordering our blood. It passeth understanding.

The TEACHER

There is a wise old saying: one should not mistake the finger pointing for the moon.

Teachers are like fingers pointing. The TEACHER is what they are pointing toward.

I started this book by saying that when we want to know what something is, we look to see what works within it, what stands behind it. In the course of the chapters, I have tried to elicit a sense for the formative character of life unfolding in the growing child and adult. There is an inwardness, an interiority to history, to personal life, and to natural phenomena. I have come to see how this inwardness is as particular in its contours as are the objects of our physical vision. The world of inwardness is not uniform. Spirit and soul are as differentiated as matter. Ideas, forms, and movements engender and respond to our behavior and to nature's.

In pondering Rudolf Steiner/Waldorf education in America for more than twenty years, I have perceived that it is the inner life of the teacher that gives the organism of the school its uncommon energy and direction and humanity and substance and inspiration. Where does the inner life of the teacher come from? It seems to come partly from the teacher and partly from the being of the school. The being of the school is teaching the teacher. The school is a living form brought into existence by a living idea: an idea I have characterized in the following ways. The school is a free and independent entity run by its teachers. The school lives and works as an organic unity. Through it flow experiences of the evolution of human consciousness and of world history. The growth of teacher and pupil are reciprocal. Artistic activity develops creative will and gives practice in the mystery of whole-and-part. The human individual is a spiritual being with a destiny. We live in a continuum of spirit, a continuum from which we are born and into which we die. Education helps us to get soul, body, and spirit together. The way we learn arithmetic affects our moral sense. The way we understand geography affects our judgment. The or-

deals of earthly life are a school in which we may develop consciousness and self-knowledge and become transparent to our neighbors. The transmutations of this schooling through the ages will create new qualities of freedom and of love. We tend to be caught in our bodies' history. To become body-free is to come into a partnership with body, so that it is neither master nor slave. There are moments of freedom from pride and desire which feel prophetic.

Human love and human freedom will be our original offerings to the universe. Coming to understand them wisely is what is at stake in all our struggling.

Such ideas may be our TEACHERS. They may model us into an acceptance of their form. The English word "to teach" means "to cause to accept." And "to accept" means to take on the form of, to participate in a reality, which may be other than the one we may have had a preference for. Our preferences may also be judged in terms of stages of maturity, of fullness of form.

I want to talk about the archetype of the TEACHER. I want to focus our attention for a moment not upon the finger pointing, but upon the moon. One reason is that the moon is there for us all every night. The TEACHER can draw our inner tides and bless our sowing. Another reason is that I have struggled with the role of teacher, the idea of teacher, as have many in our culture. There is confusion all around. If it were not so, we would not have to write so many books about it!

Teaching nowadays is becoming technology, while neglecting substance. Teachers are cautious about substance. They are cautious about truth. Truth is changing from an absolute form, a definition, to a form of relationships. We are in a period when the change is taking place. It takes a while to gain a new footing. Truth cannot be defined. Life cannot be defined. But it can be characterized in a number of different ways. Truth must be come to from a variety of perspectives. The perspectives are living and mobile. And the subject under consideration is also living and mobile. This is the etheric world, the world of formative forces which work within the physical world. We are in an epoch when we are waking up to this realm. It is like learning to walk on water. The human being is 65 percent water. Why? Because water is the carrier of living form. We cannot characterize the human being as if people were composed entirely of minerals. Warmth, moisture, and spirit/breath are important elements. A study of the human being, far from being mechanical, must come from the most varied points of view.

Our instinct for truth has almost died away. It was based on authority, and such a truth, based on authority, has become unreliable and unbearable. Authorities disagree. We think of agreement as being a standard for truth. But those are old forms, old archetypes, which are falling away now and giving space to new. The new is

171

characterized partly by differentiation. Truth is not a uniform static formulation. The spirit of truth lights up in all the parts. The parts can best be understood in their relationship to the whole. The spirit of truth is connected with the art of seeing the whole in every part. This is a new way of seeing. For it means seeing more than one thing at a time. It means seeing a child or a handicapped adult and seeing the higher being at the same time. It means seeing each individual in both light and shadow. The truth, the truth! It means reading contemporary culture as part of a symptomatology of history. It means experiencing summer and autumn and winter and spring as rhythms of the earth's breathing. It means feeling oneself as part of something more. It means, if one is a teacher, seeking to know the TEACHER.

I have been a professional teacher, earning my living in past years by teaching English in colleges, and more recently, pottery workshops and interdisciplinary programs. I started out (as might be expected) in an unconscious fashion, accepting what I was taught by my professors and following the academic culture. I began to ask questions when I could no longer accept the gap between the values we were teaching and the lives we were living. I have already mentioned the break-up and search that followed. I began to doubt the very act of instruction. By what right do we project our own preoccupations on a captive audience? What is there to teach beyond our biographies? I grew embarrassed by the word *teacher*.

I had to let it all go, suffer through the confusion and anxiety, empty the vessel, and clean out my ears. I had to be willing to begin again, to be a beginner, to take one step at a time toward a new way. The most striking element in this new way was the need to become a careful observer. Instead of taking my cues from individual authorities, I cultivated other sources — careful looking and listening. Working with the earth in gardening and with clay and other materials introduced me to a new schooling. When I read in Rudolf Steiner that the new yoga of the West is sense perception, I felt an immediate curiosity. Don't worry about the books, he said. The TEACHER is in life. Though books may be lost, their words remain forever intact in living reality. Learn to read nature. Learn to know yourself. This was Emerson's advice too: know yourself and study nature! These are not easy to do. It is exciting to think about how much there is to learn. Steiner urged us to wake up to life, to be interested in everything! We may have to develop some new sense organs in this new schooling or have to renew those that went out of fashion when reading and writing came along. Remember the stories that Rolling Thunder told us about his relation to the plants.

I do not begrudge a minute of those years of confusion and suffering. The

TEACHER was slipping me the lessons all along the way. "A little more to the right," s/he would say. "A little more to the left." "A little more of the crystalline." "More attention to sound." "Don't jump to any conclusions." "Wait." "Breathe." "Light a candle flame and close your eyes and experience what happens to the after image. Pay attention. The light you see with your eyes closed is the carrier of sense impressions. It is real out there. See how that light shines in every blade of grass. It is not abstract nor mystical. It is living in detail. The physical world is not your patsy — it is not passive. Live in the world as in a person!"

The way led through the eye of the needle — trimmed and scoured, dwelling within my bit of being with greater consciousness. A horrifying encounter with the shadow gave a view of myself I had never had before. I wanted to bear it, but wasn't sure I could. It was a threshold to new ground, a more objective ground for the "I." It was like coming through that squeeze into the "I" as a world being. Having relinquished what it had identified itself with previously — home, studio, garden, job, marriage, community, good intentions — it came to another inner picture. A craggy low rock rising out of the middle of the ocean, grey sky, slapping waves, no land in sight, and I am standing on that rock, alone, in the sea, the weather grey, the water active. It is archaic rock — hard, granite. Out of it, suprisingly, flows a spring of fresh water. At that time, it was bare of other life. Today as I write and turn inward, that rock has transformed into the landscape of northeast Pennsylvania, where I live. Or any other place where I may be.

Here the opposites coexist: the absolute rock and the absolute birth. Why do I say "absolute"? Because I want to convey a sense of something objectively real that one may stand on. The trust one develops in oneself as source through the years of separation reconnects with source in the spirit-sea. The movement is two ways: from the infinite center outward and from the infinite periphery inward. We live in the crossing-point. So do the forms of nature. This is what makes perception so exciting and active and fruitful. The light in us rises to meet the light coming toward us. We see with the same element that exists in the phenomena. Subject and object, as they used to say — that is, me and what's out there — are permeated with the same substance. This light is invisible, as light always is until it is reflected. Until it is reflected, it looks "dark." If we were to think that only what we can see with our physical eyes is real, we would have to give up modern science. We cannot define this light, but we can say something about how it works.

At Christmas time two years before this inner picture of rock and sea and fresh source (taking *source*, as the French do, to mean *spring*), I had written a poem called "Vigil." Later I could see how it prophesied the soul's journey.

173

VIGIL

for Sister Marita

In this leveling laughter of time
 guess what stone crib crumbles,
guess who waits to bloom, who brings kisses and crumbs,
guess what befalls, as fall we do here before this cave,
 this place of fire
 in stone
 in grace
this intimate cold light bright chamber
of every-which-way life and love, this past-all-knowing touch.

Thirsting to wait, blind, empty, a primal ear,
carrying something I do not know, my hands are full.

 O recollection, this bayberry day
 O sacred play, O jewel of joy, O let me wait in this blessed cold.

Ethereal arms of snow fall like music in crystal scales
from brows of angels curving like geese on the wind . . .
O sister . . .

 Waker of day, behold in this grail stone manger your bread and blood.
 Behold us swimmers reach your rock, your dove-perch lovers' bed.
 Canticle: O ring!

Wait oh let me wait here, to hear, in the silence of waters:
 "There is but one altar," you said, "one prayer."
Let me see speaking the sea-spoken dayspring everywhere,
 your white stone and morning star!

 Let it be barren, this light. Let it be no light.
 Let it be bedrock: and absolute birth.

16 December 1974

Are our longings prophetic? Is an "absolute birth" being prepared for, without ornament or cultural aid? It took me through grey and empty Christmases to get there. To get where? To the real Christmas?

The TEACHER says, "Slow down. Wait. Something is slowly growing and coming toward you." If we listen to our inner voice and to that which comes toward us, we may take steps toward a future which both supports and engenders.

There is something in Waldorf education and in the Camphill Villages which keeps people from being teachers in the old sense of authority. One gets the impression that they are listening and then sharing out. The TEACHER stands invisible, like the moon in daytime. Teachers and coworkers are ministers, offering what they receive and what they earn.

174

Who is the TEACHER in these schools and villages? Who is Rudolf Steiner's TEACHER? Jung's TEACHER? Buber's TEACHER? Emily Dickinson's TEACHER? Martin Luther King's TEACHER? Mao's TEACHER? Mozart's TEACHER? Shakespeare's TEACHER? Saint Theresa's TEACHER? Allen Ginsberg's TEACHER? Christ's TEACHER? Buddha's TEACHER? Einstein's TEACHER? Edison's TEACHER? Martha Graham's TEACHER? Schumacher's TEACHER? Black Elk's TEACHER?

By WHOM are we taught?

I notice that the teachers in the Waldorf schools are taught by what they undertake to do. I notice they are taught by the children. I see how the school community is a source of inner schooling for all its members, teaching them to be free beings and yet all one connected whole — teaching them skills and judgment and patience and tolerance and resourcefulness and courage and endurance and humility — and, I hope, a sense of humor. The teachers would be the first to acknowledge the modest distance they have come in their learning. I see how the coworkers at Camphill and at Fellowship Retirement Community are taught by the handicapped, the elderly, and the dying; by the needs to be met; by the soil, the weather, the plants, and the sheep, cows, and pigs. I see that there is a spirit in the being of the school, something in the being of the villages, a being of the community, who teaches. I see how the teachers and coworkers learn, in varying degrees, how to open themselves to the TEACHER who lives in the earth and the stars and in one another. One is so used to floating around in abstract concepts, it is hard to get down to the daily practice of living the TEACHER. It is humbling. One's exaltations and excitements are continually being corrected by experience, which grounds our flights. The TEACHER shines from within the shadow.

I see how the teachers and coworkers learn also from their meditative life, from reading and study groups. Their meditations work within their daily life practices. I see how they are changed by deciding to live and work together, faithfully —making space for weakness, illness, fatigue, accident, and change of direction. A feeling pervades of being pioneers in a new consciousness and social order. The TEACHER guides from within and from without. There is a feeling of being on solid ground and at the same time in the waves and being buoyed by air and tried by fire. There is a feeling of growing toward a future uncoerced by the past — a feeling of quest, of task, of devotion and humor and research.

The way of the Waldorf teacher is a life way. Likewise the way of the Camphill coworker. We who do not work in those schools or villages also belong to this way. It is the narrow path which reflects the heart of our shared planet, as the full moon is reflected in a sliver of sea.

I hope to awaken a sense of common resource. Most of what is called normal life

is driven by unconscious fear and desire. Out of these grow our popular culture and worldly ambitions. As we bring ourselves into greater wholeness of being, we may become willing to allow more distance from our sympathies and antipathies, our likes and dislikes, willing to allow a looser connection with habit and pattern, a freer play between percept and concept. There will be a softening of the edges, making our colors more permeable to light.

There is a new spirit at work in our time. The TEACHER evolves as time carries our unfolding to another stage. In the past one hundred years, something new has been creeping to the surface. It is severely challenged all along the way by old patterns of personal greed and nationalism, and by a lack of understanding of what is happening. It is the phase of decay (which is not a term of reproach, but one of the rhythms of growth) in a period of expansion. The TEACHER tells us in a variety of ways that continual increase in quantity is not healthy. Only cancer grows that way. Do we turn a deaf ear and press on? Or turn into the fresh wind?

Rudolf Steiner did not invent *Anthropos Sophia*. Human wisdom, or the understanding of the human being, the study of man, is given by life. When the student is ready, the TEACHER appears. Karl König did not invent the Camphill movement. The handicapped children and suffering parents were in need and the refugees from Central Europe had a corresponding need. When the coworkers were ready, their TEACHER appeared. In a certain sense the teachers make the school, and in another and perhaps deeper sense the school makes them. The community is making its members. How is this possible? It is possible because school and village and community are inner activities. We may experience schooling when we are inwardly active. We may offer community through an inner activity. Where two or three persons are gathered together, there we may be community to one another when not only our bodies are engaged but the wholeness of our being.

A form is unfolding in our time, one which both separates us and reconnects us. We individuate through a new capacity for aloneness and responsibility for ourselves and, ideally, come into community as a diverse company of free beings. Part of the fruit of individuation is an awakening of a community spirit within the individual. I have spoken earlier of the sense of ego as Steiner describes its development. As "I" grow, the wholeness of which I am a part becomes a more and more conscious activity. This spirit is gaining strength in our time. Without it, we will come inevitably to a war of all against all.

It is tremendously important to develop a sense of belonging to this wholeness, and of bringing it to consciousness. As I have tried to show, it is this relationship of the whole to the part which is expressed in the art of Waldorf teaching and in the understanding of life which inspires it.

Why is it important to think of education as an ART? and of social forms as social ARTS? What is added by virtue of the word "art"? The root image of art is "to join together." We have seen it in other words like "ratio" and "harmony" and "arithmetic" and "rite." There is a strong movement in the American psyche now for ART — that is, for individuals making connections with physical materials and with each other. Art not only reconnects the person and the physical world, but one subject matter with another. In religion, too, the key image is "to bind together again, to be concerned": person with person, person with universe, person with mineral and plant and animal, outside with inside — that is, connecting through the whole which is in them all. It is an archetypal movement in the human spirit. That is what is meant by saying that certain things are right for our time. What is the unconscious saying? We need to develop ears for the spirit, for we are in continual dialogue with an archetypal world. What, of all the things that it is saying, should we heed?

We should heed the one who contains them all. We should heed the TEACHER who guides us to an understanding of connections between things; the one who is merciful and does not divide; the one who respects all things as original and separate. It is the TEACHER of paradox, of polarity. In order to connect, we may be called to go through the eye of the needle, going through the narrow strait, just big enough for one at a time. In this eye the whole is reflected. The loneliness and alienation of our modern age become transmuted in due course into the vessel of Aquarius. If we study nature and ourselves, we come to perceive how the metamorphosis occurs. And if we entrust ourselves to the form unfolding, we will see how the living waters pour from our hard won separation: from the space between.

Ordinary consciousness is, in a certain sense, the last to know what is happening. The artist in us is aware of this. Our inner artist trusts the darkness of sleep, and knows how to spot the TEACHER in a piece of clay, a flame, a dab of blue, a personal collapse.

I have felt from the beginning of my acquaintance with Waldorf teachers, that there is something in their lives which that first brochure I read in England never talked about. A certain spirit teaches the teachers. It is revealed through reverence for nature, through holistic cognition, through art. It is revealed in a sacramental attitude toward food, toward birth, toward knowledge, toward rites of passage.

The path of the TEACHER is a primal human archetype, reawakening in our time. "Waldorf" and "Camphill" are capacities within life itself. The schools and villages are pilot bodies calling our attention to what is possible and ready in our time. We can open ourselves to re-schooling. We can open ourselves to reconnect-

ing, to observing, and to using all of ourselves in whatever we do. We can receive the TEACHER and make our offering.

The Waldorf schools and the other many works that have arisen out of Steiner's research are frontier efforts in the spirit which stretches across the horizons of our age. They are making sightings, taking soundings. They are bound for earth and its healing. In their living and learning, they seek to receive the TEACHER and be guided toward renewal.

The TEACHER is the wholeness in which we participate. Its lessons are learned in every part of daily life.

Transformation

Rudolf Steiner education asks us to be open to a change in consciousness, a change which is indicated on many fronts. This change is organic to the evolution of consciousness, and it is the task and challenge and fruit of our epoch. As Steiner states in *Spiritual Ground of Education:*

> The pedagogy and didactic of the Waldorf School in Stuttgart was founded in that spiritual life which, I hold, must lead to a renewal of education in conformity with the spirit of our age: a renewal of education along the lines demanded by the spirit of the age, by the tasks and the stage of human development which belong to this epoch.
> The education and curriculum in question is based entirely upon knowledge of man. A knowledge of man which spans man's whole being from his birth to his death. But a knowledge which aims at comprising all the supersensible part of man's being between birth and death, all that bears lasting witness that man belongs to a supersensible world. (p. 8)

The challenge is to move forward without losing the gains we have made, to be able to open our minds to intuitive cognition without sacrificing scientific objectivity and accuracy. It is a matter of widening horizons and of repositioning our thinking-feeling-willing in a way different from the intellectualism we are used to, because intellectualism by itself cannot lead us into the new perceptions which are becoming available. Rudolf Steiner asks us over and over again to avoid one-sidedness and prejudice.

What most of us need are some bridges to get from where we are now in our cultural adaptation over to the kind of imaginative, inspirational, intuitive, cognition which Steiner has identified. There is very little in our culture which equips us for an integration of scientific thinking and artistic creation and religious reverence. We may dream of it. We may fret because we are everywhere made to feel fragmented, divided, confused. At the same time the archetype of wholeness is rising

prophetically in the psyche of contemporary people. As yet we do not have many teachers to help us. We are on the edge of the future. On the edge of the new. On the edge of transformation: feeling the truth and contribution of the cocoon. Without it — no butterfly. Without the modern age of materialism — no free spiritual knowledge. In other words, loyalties are not involved. True and false are not involved. What is involved is hewing to the life-line. What was true is loosening its hold, making way for the new truth. What is becoming true will carry us to the next stage. It is necessary that we attune ourselves to a quality of thinking in which one stage grows out of another, mobile and continuous, the light shining in turn from each stage of our metamorphosis. The important thing is not to obstruct, but to place ourselves into the evolution of humanity with sensitivity to the living fullness of human destiny.

We are not used to hearing about "the living fullness of human destiny" except as a sentimental belief that vaguely affirms the value of life. Rudolf Steiner asks us to take the idea concretely and to begin to ask: What is the human being? What is our place in the universe? He urges us to inquire int[o] the human body and consciousness with an open-r selves transparent, so to speak, so that we do not bl sense, the eye must make itself transparent in orde / In our culture we come to an experience of our what we will find or what to look for. The process school perpetuate and aggravate acquisitiveness, goaded into endlessly *adding*, as if growth were al tive growth is hardly explored. To reduce expectations is rarely a goal. Quantity, consumption, and competition — these are the natural consequences of a philosophy of materialism. If we want to change direction, we must be open to other ratios and other substances. Steiner goes on to say in *Spiritual Ground of Education* that we must see ourselves as not only a bodily entity, but as a body through whom soul and spirit speak, and indeed a body moulded by hidden spiritual powers (p. 10). And we must see ourselves as a being who in seeking birth is already a form: a spiritual being born into life on earth. If we do this, then we will understand more readily how spirit precedes all other experience, and how it works upon all physical things. We will see it as an organic process. And we then will find it not so hard to work free of cultural bias and to reposition ourselves in a new source. We may learn to feel the activity of our inmost being creating the thought, the feeling, the intentional deed. In Steiner's words: "Let us keep in mind that spirit or soul must be sought in profounder depths than mind, or intellect or reason" (p. 24).

180

One bridge that can be made to this adventure is through the depth psychology of C. G. Jung and of James Hillman, who is specifically working toward this repositioning. In Hillman's recent books, *Re-Visioning Psychology* and *The Myth of Analysis,* he speaks of how the health and wholeness of our being requires that we gradually experience our ego, as he calls each person's center of waking consciousness, in "the imaginal." That is to say, we may relieve the one-sidedness of daytime intellectual consciousness and awaken the "I" in the realm of psyche or soul. "The imaginal" is the realm of the archetypes, the Gods, who are a priori to experience — who, in fact, mould it. This is the world of interiority.

In *Re-Visioning Psychology,* Hillman stresses the importance of soul and the imaginal:

> The psyche displays itself throughout all being. Present and past, ideas and things, as well as humans, provide images and shrines of persons. The world is as much the home of soul as is my breast and its emotions. Soul-making becomes more possible as it becomes less singly focused upon the human; as we extend our vision beyond the human we will find soul more widely and richly, and we will rediscover it, too, as the interiority of the emptied, soulless objective world. (p. 181)

> We need an imaginal ego that is at home in the imaginal realm, an ego that can undertake *the major task now confronting psychology*: the differentiation of the imaginal, discovering its laws, its configurations and moods of discourse, its psychological necessities. (p. 37)

Hillman's language is different from Steiner's, but it provides a bridge in that it offers, from contemporary psychological research, an opening into the territory of interiority as an objective world, an opening Steiner found in "spiritual science." Hillman's approach finds an a priori inner activity which models our experience and which ordinary consciousness is only beginning to explore.

Rudolf Steiner education stands outside many of the mainstream assumptions about childhood and about teaching. It challenges, for example, the beliefs that reading should start early or that gifted children should be segregated. At the same time, as Steiner cautions in *Spiritual Ground of Education,* the process works within the society constructively and acknowledges the necessity of adaptation.

> No method of education however ideal it is, must tear a man out of his connections in life. The human being is not an abstract thing to be put through an education and finished with, a human being is the child of particular parents. He has grown up as the product of the social order. And after his education he must enter this social order again. You see, if you wanted to educate a child strictly in accordance with an idea, when he was 14 or 15 he would no doubt be very ideal, but he would not find his place

in modern life, he would be quite at sea. Thus it was not merely a question of carrying out an ideal, nor is it so now in the Waldorf School. The point is so to educate the child that he remains in touch with present day life, with the social order of today. And here there is no sense in saying: the present social order is bad. Whether it be good or bad, we simply have to live in it. And this is the point, we have to live in it and hence we must not simply withdraw the children from it. Thus I was faced with the exceedingly difficult task of carrying out an educational idea on the one hand while on the other hand keeping fully in touch with present-day life. (p. 92)

By itself this quotation would be misleading, however, if we were not to add that education and training were considered by Rudolf Steiner to play important roles in human development toward new social forms. He taught the concept of the threefold social order as a natural consequence of the proper development of the threefold human being. Joan and Siegfried Rudel in *Education towards Freedom* put the matter bluntly: "Whoever wishes to understand Rudolf Steiner education in its full implications will have to come to terms with the ideas of the three-fold social order. Because one of the fundamental goals of his art of education is the endeavour to awaken and to cultivate these social capabilities already in childhood and youth" (p. 15).

One finds the Waldorf methods and the atmosphere of Steiner communities at the same time old-fashioned (or perhaps better "old country") and timeless. The source from which the philosophy comes would appear to be independent of cultural bias — willing to adapt where adaptability is appropriate and necessary, and at the same willing to base itself on intuitive truth, for which there is no blueprint and which can only be proven through experience. It does not stand on ideology, but on forms of being.

Nor does Steiner start from a developmental psychology, though he perceives the growth processes of the human being developmentally. What he starts from is epistemology: that is, the way we know something. How do we know what to do in a classroom? How do we know what the stages of learning are? How do we determine what is best for a child and a teacher? He gives his views on these questions in *Spiritual Ground of Education*:

The spiritual view which we are here representing does not say: Here are limits of human knowledge, of human cognition. It says: We must bring forth from the depths of human nature powers of cognition equal to observing man's complete nature, body, soul and spirit; just as we can observe the arrangement of the human ear in physiology.

If in ordinary life we have not so far got this knowledge owing to our natural scientific education, we must set about building it up. Hence I shall have to speak to you of the development of a knowledge which can guarantee a genuine insight into the inner

texture of child life. And devoted and unprejudiced observation of life itself goes far to bring about such an insight. (p. 11)

Steiner starts, and asks us to start, with the nature of thinking. His *Philosophy of Freedom* purports to find human freedom in the freeing of thought from a reflective, passive mirror-imaging level, body-bound, to a higher level that is body-free. More recently, C. G. Jung in *Psychology and the Occult* corroborates this direction of research:

> The psyche's attachment to the brain can be affirmed with far less certainty today than it could fifty years ago. . . . Under certain conditions it could even break through the barriers of space and time precisely . . . because of its relatively trans-spatial and trans-temporal nature. . . . The hypothetical possibility that the psyche touches on a form of existence outside space and time presents a scientific question-mark that merits serious consideration for a long time to come. (pp. 134–36)

Steiner's theory of knowledge lives in the historical stream that quickened in the manifold labors of Goethe. It is important to note that it is with Goethe, who lived the threefold truth of art-science-practical life, that Steiner found spiritual community.

I put it this way because our contemporary view of history (at least mine) has tended to be external. This happened, that happened; this person lived and died, and so forth. Each fact discrete, added to the next. I never could fathom what real difference it made whether the hordes went East or West; whether the parliament rose or fell. It was all an endless print-out of external facts. Or so it was until I began, with Steiner's help, to develop a sense of inner form — a feeling for the inner life of history — a feeling for the inner face of fact, which opens into a living landscape of ongoing community and human endeavor.

Earlier, the sudden appearance of Rudolf Steiner on the horizon of history had seemed equally gratuitous. This man born on the border of Austro-Hungary in 1861, where did he come from really? How could he be talking about things that few other people were talking about in the early years of the 20th century and be taken seriously? What is the meaning of someone so exceptional?

But in studying the history of ideas and the lives of men and women who bore them into life and expression, we can begin to get a feeling for the ongoing inner scenario — the interiority of history. In this regard, time has no such sharp corners as in daily life or life-time. Inward connections can be felt like a supportive field holding a number of beings — a living atmosphere, an ongoing stream and journey

183

of human souls doing their particular work. And in the ongoing evolution, different work is up front at different times. We see how different one epoch is from another: the time of the building of cathedrals, the time of the spanning of oceans, the time of standing for rights, the time of seeking the power that binds the nucleus of the atom, the time of release and integration. Each epoch has rich variations of culture and subculture.

The quality of Goethe's genius which carried the ball, as it were, from earlier efforts in a similar direction, was the way he found himself able to *see* the idea in a physical form, specifically the archetypal plant. The important step here is the meeting of the inwardness of human perception and the inwardness of nature, as if both human imagination and nature were of the same substance. Later the English poet and philosopher Samuel T. Coleridge (as quoted by Owen Barfield in *What Coleridge Thought*) experienced along these lines as well: "Nature, the prime genial artist, inexhaustible in diverse powers, is equally inexhaustible in forms. Each exterior is the physiognomy of the being within" (p. 79). And further: "In the objects of nature are presented, as in a mirror, all the possible elements, steps, and processes of intellect antecedent to consciousness, and therefore to the full development of the intelligential act; and man's mind is the very focus of all the rays of intellect which are scattered throughout the images of nature." Genius, he said, "presupposes a bond between nature in the highest sense and the soul of man." It is its business to acquire "living and life-producing ideas, which shall contain their own evidence, the certainty that they are one with the germinal causes in nature. . . . For of all we see, hear, feel, and touch the substance is and must be in ourselves" (p. 80).

The main point here is the relation of the human mind to nature, of subject to object. Do these stand external to one another, or do they participate in a common interiority which it is the genius of the spirit to perceive?

Spirit-mind, as Rudolf Steiner knew from experience, is able to see into nature, to see spirit at work in the physical world as in the world of human thinking and feeling and willing, because both mind and nature are the manifestations of a common source. In the Middle Ages, the alchemists proceeded on this basis, finding "spiritual gold" through their transmutations of red earth, lead, and dung. The early Rosicrucians, also, we know through the writings of John Dee and Valentin Andreae in the seventeenth century, experienced the physical world as the language of divinity. They were like occult scientists, priest-physicians, whose task it was to understand God through his presence in creation; to explore and under-

184

stand and revere the physical world; to follow its inner journey as they did their own. Their purposes were to heal the sick, gratis; to bring about universal learning; and to create a nonsectarian religion expressing the universality of Christ. Their work was carried on, as we have seen, by Amos Comenius in education and by Count Zinzendorf in religion, who became pillars of the Camphill movement.

Rudolf Steiner's genius rose within this historical community and stream of endeavor. What he brought to the twentieth century had been ripening in the depths, or heights. And those of us today who feel likewise a significant trust in imagination and intuition; who cherish the physical world and use its materials as manifestations of soul and spirit; who look to education as a natural gift and right; and to religion as a common indwelling within a spirit which may more and more awaken to its universality — we are members together of an ongoing community who today have special work to do: to strengthen these new impulses which society is reaching toward. We will build the new age with our hands. What is built will be humankind. The German original of this image, "Der Bau wird Mensch," is Steiner's interpretation of one of the stained glass windows in the Goetheanum in Dornach, Switzerland: "The temple becomes humanity."

Waldorf education is based on this participatory thinking, which sees into the growing child, which is a path of self-knowledge for the teacher, and which turns outward to the world as an inner way. The teachers strive to develop spirit-mindfulness, spirit-beholding, spirit-remembering, and then to act freely, individually, creatively, following their intuition, spontaneously. Trusting the ground they are on, they do not need directives and syllabuses in the traditional way. They create them. They are in touch with source, ideally. This is what is striven for in a Steiner school. When people don't yet have it, they play follow the leader or work at their own level. But most try to develop it. The education is in the context of the whole of life; and what it seeks, it seeks not for itself but for the healing of persons, nature, society.

One of the problems with American education is a lack of clarity about its real purposes. Ideals are mouthed but they seem unconvincing since they tend to be voiced in situations which do not express any idealism. In Steiner schools and communities, there is evidence of ideals being practiced, not only preached; and of a continual review of policy and procedure in the light of what is possible and what is needed. Naturally the path is lumpy and bumpy, controversy is lively, and goals are only partially achieved. But the spirit is uncynical and presses on with the integrity appropriate to its level of maturity. Sometimes it feels like just a

beginning, or modestly under way; but the life conception is lively in the air, and there is a sense of oneness between the imaginations of the persons and the world they are studying and creating.

In order to understand what is happening in these places, we need to think about things differently than we usually do. The starting point is different, the goal is different, and the methods therefore come from a different source. It is a source available to us all, but it tends to be overlooked in the educational philosphy and pedagogy of our society. In the discussion cited, Steiner writes:

> Now you see there must be something in existence which, when we have the key to it, the so-called solution, calls for further effort on our part, calls upon us to go on and to work on. The riddle of the universe should not be stated as a thing to be solved and done with: the solution of it should give one power to make a new start. And if world problems are rightly understood this comes about. The world presents many problems to us. So many, that we cannot at once even perceive them all. By problems I do not only mean those things for which there are abstract answers, but questions as to what we shall do, as to the behaviour of our will and feelings, as to all the many details of life. When I say the world sets us many problems, I mean such questions as these. What then is the real answer to these many problems? The real answer is none other than man himself. The world is full of riddles and man confronts them. He is a synthesis, a summary, and from man comes to us the answer to the riddle of the universe.
>
> But we do not know man as he should be known. We must begin at the beginning. Man is an answer that takes us back to the beginning. And we must learn to know this answer to our problem Man, this Oedipus. And this drives us to experience anew the mystery of our own selves. Every new man is a fresh problem to be worked at. (p. 131–32)

Transformation is a challenging undertaking. Even to propose it may set up resistance, as if to propose change is somehow to belittle the present, and thereby to arouse defensiveness. But this is not the spirit of transformation. Indeed, it is simply the willingness to yield to the evolution of living forms, actively to cooperate with the changes which are natural to the deepest purposes of things. Mobility for change is another way of speaking about developing a sense for the dynamics of living formative growth. This kind of change grows out of life process itself. The history of consciousness shows many deep changes. And any personal life shows also changes in feeling and direction. Education can help to attune us to the metamorphosis of forms in nature and to transformations in inner development.

These changes are not competitive. It is not better to be a mythically endowed African Bushman than an intellectually endowed Harvard professor, or vice versa. It is not better to be a youth than a sage. There is a need for everything in its own time. The wholeness of growth exists in every part, if we can learn to see it.

In looking at life as the development of form, the unfolding of form, we see within things, persons, experiences, and events, something that changes. What is it? Is it forces of decay? entropy? Is it forces of growth? negative entropy? Is it "the creative purposeful" as C. G. Jung called it, or "entelechy" as Aristotle called it and Paul Tillich echoed? Is it "spiritual being" as Rudolf Steiner called it? Whatever we call it, we experience it in ourselves, expanding and contracting, unfolding and trying to complete ourselves. There is a meditative exercise which Rudolf Steiner suggests. It is to observe regularly a plant which is both growing and dying; that is, which has both new growth green to the eye, and flowers or leaves which are turning brown and falling off. Observe this plant faithfully and you will begin to see a continuous forming/transforming activity, which is itself a kind of circulating integral form, including both the dynamics of what are conventionally thought of as entropy and negative entropy, decay and renewal.

This transformative purposing is not something we are usually conscious of. Ordinary consciousness seems more naturally given to seeking stability, such as mineral and crystalline forms, than the fluid movements of growth. Consciousness seems conservative, useful for focus and maintenance. The purposing we need to awaken in education lies as well in the unconscious. It is what enables us to say, "I don't know what I am doing, and I am doing it." Action, and then recognition. What we wish to encourage is an awakening of spirit in the will. This connects with the Tao of Eastern thought, and with the "it shoots" of Zen and the Art of Archery.

I have learned a lot about transformation from working in clay as a potter. The potter's art has been a great teacher to me, and I would like to refer to it here as a parable to help us understand the principle of transformation and metamorphosis. And to help us see how this experience of transformation is an education, i.e., it is a leading out of what lives within.

Working with clay, we experience a marriage of the opposites. The raw material of pottery is dug out of the earth, formed by hand, and transformed into fired clay, which has an entirely different character and look. The hand, the clay, the fire. The spinning potter's wheel. These all seem to be numinous elements. For what is the human hand? and what is clay? what is fire? and a turning wheel? The clay, millions of years old, itself formed from igneous rock which has been through the fire, feldspathic rock, eroded by wind, washed by rain down into streams and river deltas. The molecules are so ripened that they are enough different from ordinary soil that they can bend and not break, can be heated to high temperatures and not disintegrate, but rather grow stronger. And the human hand — what is that? also

187

millions of years old? the life-line, the heart line, the soul in the hand, intelligence in my fingers more than I know; the uniqueness of the individual handprint, the universal hand. And fire, the divine agency of culture — Prometheus stole fire from the gods, the myth tells us, as a grace to mankind. The outer fire, the inner fire, transforming substances. And the turning wheel — the turning earth, the turning sun, the planets in their orbital rotation, the wheel that by its motion gives balance to form!

And the pot that comes out of the fire, how it rings when we strike it! How changed it is forever by the fire. It has taken form, which cannot be taken away. It cannot be reduced to natural clay again. Now it will hold water, hold heat.

The "great work" of the alchemists took place in clay vessels of certain shapes. The agent which would make the change possible was called "the philosopher's stone." It was known primarily through its paradoxical qualities. It was both hard as a diamond and waxlike and could be melted down. The stone that could be melted down again and again and reconstituted again and again had the greatest value. What an image of stability through transformability! And what a vision: that we shall be both diamond and wax!

Something about a quality that combines the opposites is basic to evolutionary change. Or perhaps better said, the ability to live in the tension of the opposites is what we need in life if we are to avoid one-sidedness — to feel one's life as a sphere and the opposites as poles marking the axis on which it turns. Rudolf Steiner, in one of his lessons in *Guidance in Esoteric Training*, stresses the point that "conflict becomes the very breath of our soul."

The original meaning of sin was to be one-sided, off-balance, not in the bull's eye, not "in the round." Transformation seems often to be in the direction of an inner marriage: of the polarities of freedom and constancy, stability and flexibility, bedrock and wellspring. To know that for every uniqueness there is a common connecting link. To know that for every light there is a shadow, and that in every shadow there is a light that longs to reconnect.

In the school of life we try to create our inner vessel which can contain the opposites.

Such an image, which we find within experience, can guide us. This is what Rudolf Steiner means when he advises us to lift our human thinking to imagination, to think and to hear in living images which are given by life itself. This artistic approach underlies the methodology and curriculum of the years of elementary schooling up to puberty in Steiner classrooms. It becomes the purchase of the mind

upon experience forever after. Thinking, as it develops through adulthood, forever contains the imaginative dimension distributed throughout it.

Rudolf Steiner says, you will remember, that we need not devise educational programs, but rather that we need to perceive how human beings grow and then to surround them with the food they need. In the early years, he said, they need physical milk; in the elementary grades, soul milk; in high school, spirit milk. Thus they are well nourished, and carry this threefoldness strongly throughout life.

Physical, emotional, intellectual — body, soul, spirit — this is the grounding. Further transformations may follow in due course, in personal development as well as collectively in the evolution of human consciousness. Thus education does indeed continue. It is the expression of the transformative human creature. It is our nature to transform our nature. The spiritual history of our species has continually concerned itself with this fact. In the ancient mystery centers of Egypt and Greece, the consciousness of the initiates was transformed in specific rituals. The Western world has developed arts of conversion, of transubstantiation, of altered states of consciousness; the East, of satori and enlightenment.

Education can be thought of as a spiritual discipline and a spiritual practice. We may learn to hew to the line of our destiny as human creatures on this extraordinary planet, Earth. We are slowly learning to be more aware, to know ourselves, to study nature, to live with one another, to understand our history and our future as bearing living inner significance for the universe and ourselves, to make our offering in warmth of purpose which is both personal and more than personal. We can't do it all at once, but we have all the time it takes.

The future lives in us, like a seed force, like the meristem. Aging is a development toward the new, the not yet realized. To grow old is to ripen in discernment and to welcome the as yet unheard of. It is a process of "younging." If we become fixated in youth, we lose the rejuvenating principle of growth. This is important in the education of the young: to teach them that certain resources develop through aging which develop in no other way and to look forward to their own ripening.

So, as we move ahead in time, growing older, and as we experience the ongoing human evolution, we see that we are preparing to take up the childhood of humanity — not as children but, as it were, face to face, in full awakeness. We move ahead in a knowledge which takes in all the data, bravely turning to the living forms as the real forms. To learn to read this living script is the new impulse in education for our time.

Conclusion: Steps Toward a New Culture

The story is told that at the end of his life, Rudolf Steiner said that if he were to begin the Waldorf schooling again, he "would throw the rudder right round to art." He saw that artistic method, rightly understood, is the basis of true learning. Throughout this book we have tried to look at art beyond its usual boundaries, and to chart a new course, whereby meditation and making are the two directions of the one wind, the root and shoot of the same seed, our two hands.

Human beings, like art, are crossing-points of the sensory and meta-sensory. I have used the geometric figure of the lemniscate to illustrate the law by which our outer and inner worlds fuse, one turning into the other without break. The physical is itself meta-physical. Perhaps the most familiar place to see this reality in daily life is the words we speak. Words are sounds and shapes *and* inner meanings. Indeed the world may be looked at in this way, as a living word: a simultaneity of form and inwardness.

Art is a firsthand experience of this world. The things we make bear these dimensions because their makers do and the world does. Disciplines artistically practiced may bring refreshment and renewal because they are quickened from this source. It is no wonder then that art and education must be wed, for what are we learning but to know the world and ourselves in truth and to read with understanding the languages of nature and human kind.

It should be clearer now how art may be a path of initiation, that is, of transforming our consciousness so that we may behold more truly. And it should be clearer why art and myth are so often paired. Myth is the soul's story: it is the expression through narrative of the landscape of the gods, the archetypes made visible through imagery. Art is a way of knowing intuitively the spiritual powers within material existence. It is a way of entering into a phenomenon and sharing its being. This is the artistic method of teaching science in the Steiner schools. Spectatorship

is not the same as this deeper way. The artistic path awakens in the knower a sense of union with the known. The original meaning of "to know" is "to unite with." This conscious gathering-into-one is the healing, the wholeness, the holiness which echo through these pages. The Irish poet Yeats finds inspiration here:

O chestnut tree, great rooted blossomer,
Are you the leaf, the blossom or the bole?
O body swayed to music, O brightening glance,
How can we know the dancer from the dance?

Is there an artistic method which does not depend upon subjective talent? Yes. It is the human capacity for experiencing ourselves as crossing-points, as a union of body, soul, and spirit — and for experiencing physical materials in a similar way. Whenever we touch clay in this light, I see an artistic radiance, no matter what the actual shaping may be. In us all, Rudolf Steiner said, slumber capacities for artistic union; the interiority of matter is a key to our human mystery. It needs a particular kind of schooling to foster these capacities.

Much that calls itself art in our time does not have this wholeness. Much is experimentation with materials; much gives the impression of having been created by a hand without an "I," resulting in a curious thinness of effect, however rich and versatile the means. Artistic method may operate on many levels. The level we are interested in here, makes visible the intimacies of our deeper connections. In *Collages by Irwin Kremen*, the artist says:

A collage comes out of my living, my life. It is not a translation, direct or otherwise, but a distillate of that living. The collage, the distillate, swings free of me, derives its significance from itself alone, is independent, new. Yet its making makes me. I experience its creation and that is my living also. Through it I become and, in this way, spiral outward upon myself like a chambered nautilus. (p. 31)

Earlier we have acknowledged that we cannot see more than we are; therefore self-development and education must go hand in hand. Since imagination is our envisioning power, it is this which must be developed within all other functions. The renewal of society will come when we can imagine it differently and when we are ready, like artists, to take on the actual work of creating new forms. The renewal of art will come when we can experience in our own bones the crystals of a cosmic milk.

It is not only the making that we need to consider, but also the receiving. Appreciation of art enables us to live in ways of seeing and hearing and feeling other

191

than our own. We read poetry to receive what the poem gives to us. We look at a sculpture and feel rise in our own awareness the gesture of spirit that animates physical shape. We look at Redon's painting of the birth of Venus and feel the mountainous seas and the soul-figure of our inner being shift and take on color, his gifts to us. We move into imagination through the door he opens.

This is the artistic ability to be as devoted to another person's perspective as to one's own. It is especially important, imaginatively, to be able to share the thoughts and experience of those with whom we are not in sympathy. This is an artistic, imaginative discipline which is connected with the development of new social attitudes and new social forms. It is also a moral activity. For it is not just a mechanical acknowledgment of another person's reality. It is to be as interested in it as in one's own! This is the warmth that turns artifact into art, and art into moral imagination. This is the "aesthetic of humanness" which Paulus Berensohn introduces in his book *Finding One's Way with Clay.* The artistic impulse is at the same time a social impulse.

Rudolf Steiner, in his lecture on "Truth, Beauty, and Goodness" in *Art in the Light of Mystery Wisdom,* has this to say about "the good man":

And a good man is one who is able to enter with his own soul into the soul of another. Strictly speaking, all morality, all true morality, depends on this ability to enter with one's own soul into the soul of another. Morality is that without which a true social order among men on earth cannot be maintained. (p. 106)

And, in *Illusory Illness and the Feverish Pursuit of Health,* Steiner says: "It would just never be possible for one who continually fathomed the connection of things not to be released from his ego" (p. 16).

As artist-persons, we may receive an imagery which is more prophetic than historic. It is important that we be open to the flow of time from the future as well as from the past. For where is the new impulse to come from if not from the not yet born? We need not mourn forever the absence in our culture of significant gods. Perhaps we have been looking too onesidedly backward. New myths are in the making. New stories of healing are rising out of the genius of our inner ear. What stirs and beckons? What creative guide in us sees the footprint on the water? We must trust our ear for the whole truth and welcome a renewed participation, a waking. Our breath moves us inward and outward. Education, Rudolf Steiner said, is learning how to breathe.

We have heard how, under the guidance of Rudolf Steiner, the House of the

Word was created by artisans from many countries during the first World War. After this first Goetheanum burned, Rudolf Steiner not only began at once to plan a second building, this one to be of cast concrete, but he indicated that the artistic being of the first Goetheanum was transformed through the fire into a spiritual resource for humankind. The first building was designed with two intersecting cupolas, and if one traces the line of their intersection, one sees a figure eight, and at the invisible crossing-point of the columns on which they rest is the form of an open eye. Through this opening, streams the life-line of our learning. Art opens the door of our senses to our soul's ground and fills our spirit with the wholeness of cosmic speech.

Directory of Waldorf Schools, Institutes, and Adult Education Centers

WALDORF SCHOOLS

Acorn Hill Nursery (K)
 9500 Brunett Ave., Silver Spring, Md. 20901

Chicago Waldorf School (K–G)
 333 W. Wisconsin, Chicago, Ill. 60614

Christopher Nursery (K)
 1420 Hill St., Ann Arbor, Mich. 48104

Cincinnati Waldorf School (K)
 320 Resor Ave., Cincinnati, Ohio 45220

Denver Waldorf School (K–G)
 2112 S. Patton Ct., Denver, Colo. 40219

Detroit Waldorf School (K–G–H)
 2555 Burns, Detroit, Mich. 48214

Eugene Waldorf Education Association (K)
 P.O. Box 5119, Eugene, Ore. 97405

Greeley Waldorf School (K–G)
 2418 19th Ave., Greeley, Colo. 80631

Great Barrington Rudolf Steiner School (K–G) (formerly Pumpkin Hollow School)
 R.D. 1, West Plain Rd., Great Barrington, Mass. 01230

Green Meadow School (K–G–H)
 Hungry Hollow Rd., Spring Valley, N.Y. 10977

Haleakala School (K–G)
 P.O. Box 20, Wailuku, Maui, Hawaii 96793

Hawthorne Valley School (K–G–H)
R.D. 2, Ghent, Harlemville, N.Y. 12075

Highland Hall (K–G–H)
17100 Superior St., Northridge, Calif. 91324

High Mowing School (H)
Wilton, N.H. 03086

Honolulu Waldorf School (K–G)
350 Ulua St., Honolulu, Hawaii 98621

Kimberton Farms School (K–G–H)
Seven Stars Rd., Kimberton, Pa. 19442

Lamborn Valley School (K)
Box 461, Paonia, Colo. 81428

Live Oak Waldorf School K–G)
261 Nation Dr., Auburn, Calif. 95603

Marin Waldorf School (K–G)
160 N. San Pedro Rd., San Rafael, Calif. 94901

Mountain Meadow School (K)
12771 Main St., Potter Valley, Calif. 94941

New Morning School (K–G)
245 Ruscombe Lane, Baltimore, Md. 21209

Parsifal School (K–G)
430 Ridge Rd., Nevada City, Calif. 95959

Pine Hill Waldorf School (K–G)
Wilton Center, N.H. 03086

Rochester Waldorf School (K)
40 Laney Road, Rochester, N.Y. 14620

Rudolf Steiner School (K–G–H)
15 East 79th St., New York, N.Y. 10021

Rudolf Steiner Farm School
R.D. 2, Ghent, Harlemville, N.Y. 12075

Sacramento Waldorf School (K–G–H)
3750 Bannister Rd., Fair Oaks, Calif. 95628

San Francisco Waldorf School Assoc. (K)
3456 Jackson St., San Francisco, Calif. 94118

Santa Cruz Waldorf School
 165 Pryce St., Santa Cruz, Calif. 95060

Summerfield School (K–G)
 500 North Main St., Sebastopol, Calif. 95472

Toronto Waldorf School (K–G–H)
 9100 Bathurst St., Thornhill, Ontario, Canada L3T 3N3

Twin Trees Kindergarten
 La Jolla, Calif. 92014

Vancouver Waldorf School (K–G)
 2725 St. Christopher Road, North Vancouver, B.C., Canada V7K 2B7

The Waldorf School (K–G)
 380 Concord Avenue, Belmont, Mass. 02178

The Waldorf Kindergarten (K)
 300 N.W. 35th St., Boca Raton, Fla. 33432

Waldorf Kinder House (K)
 16945 W. 14 Mile Road, Birmingham, Mich. 48009

Waldorf School of Adelphi (K–G–H)
 Garden City, N.Y. 11530

Washington Waldorf School (K–G)
 Hearst Hall, Wisconsin Avenue, Washington D.C. 20016

TEACHER TRAINING INSTITUTES

Highland Hall, 17100 Superior St., Northridge, Calif. 01324
Los Angeles Center for Art and Science in Anthroposophy, 18219 Napa St., Northridge, Calif. 01324
Rudolf Steiner School, 15 E. 79th St., New York, N.Y. 10021
Rudolf Steiner College, 9200 Fair Oaks Blvd., Fair Oaks, Calif. 95628
Threefold Center for Adult Education, 262 Hungry Hollow Rd., Spring Valley, N.Y. 10977
Waldorf Institute of Mercy College, 23399 Evergreen Road, Southfield, Mich. 48075

OTHER ADULT EDUCATION CENTERS

Camphill Seminar, Beaver Run #1, Glenmoore, Pa. 19343
Eurythmy School, Threefold Center, Hungry Hollow Rd., Spring Valley, N.Y. 10977

197

Rudolf Steiner Summer Institute, Box 199, R.D. 2, Phoenixville, Pa. 19460
Anthroposophical Library, 211 Madison Avenue, New York, N.Y. 10016
Arts in the Image of Man, Summer Workshops, 3911 Bannister Rd., Fair Oaks,
 Calif. 95628

A Brief Chronology
of Rudolf Steiner's Life and Works

1861 Born 27 February at Kraljevic on the Murr Island in Hungary, now Yugoslavia. Father worked for the railway.

1868–1878 Youth in Neudörfl on the River Leitha in the Burgenland.

1879 Study at Technical College in Vienna. Fundamental study of Goethe's works.

1882–1886 During study, private tutor of Specht sons, one a hydrocephalic boy. First experience in curative education. Very successful.

1883 Selected to edit Goethe's scientific writings for Kuerschner's *National Literature*.

1886 Wrote *Theory of Knowledge Implicit in Goethe's World Conception*.

1890 Permanent member of Goethe-and-Schiller-Archive in Weimar. Editor of Goethe's scientific writings for the Sophia edition.

1891 Ph.D. Rostock University.

1892 *Truth and Knowledge* published.

1894 *The Philosophy of Freedom* (alternative title: *The Philosophy of Spiritual Activity*) published. Visit to Nietzsche.

1895 *Friedrich Nietzsche, Fighter for Freedom* published. *Goethe's World Conception* published.

1897 Editor of literary review, critic, writer, in Berlin.

1899 Marriage to Anna Eunicke. Personal experience of the "Mystery of Golgotha."

1899–1904	Teacher at the Worker's College in Berlin. Start of lecturing activity.
1900	Lectures at Theosophical Library, later published as *Mysticism at the Dawn of the Modern Age.*
1901	Lectures: From Buddha to Christ. Christianity as Mystical Fact.
1902	Founding of the German Section of the Theosophical Society with Rudolf Steiner as General Secretary. First lecture on Anthroposophy.
1903	*Reincarnation and Karma* published.
1904	*Theosophy: An Introduction to the Supersensible Knowledge of the World and the Destination of Man* and *Knowledge of the Higher Worlds* published.
1907	Munich Congress of the Theosophical Society. "Occult Seals and Columns" presented. Publication of the lecture "The Education of the Child in the Light of Anthroposophy." Lecture tours in Germany, Czechoslovakia, Switzerland.
1908	Lecture cycles: The Gospel of Saint John. The Apocalypse.
1909	*Occult Science: An Outline* published. Lecture cycles: The Spiritual Hierarchies. The Christ Impulse and the Development of Ego Consciousness. Gospel of Saint Luke. Withdrew from Theosophical Society.
1910	Lecture cycle: Gospel of Saint Matthew.
1910–1913	Writing and production of Four Mystery Dramas: "The Portal of Initiation," "The Soul's Probation," "The Guardian of the Threshold," "The Soul's Awakening."
1911	Lecture cycles: Occult Physiology. World of Senses and World of Spirit. Anna Steiner died.
1912	Lecture cycles: Gospel of Saint Mark. The Mission of Christian Rosenkreutz. The Bhagavad Gita and the Epistles of Saint Paul. Beginnings of the art of eurythmy.

1913	Dornach, Switzerland, became center for Anthroposophical Society. Laying of the corner stone for first Goetheanum building.
1914	Lecture cycles: Life between Death and Rebirth. Ways to a New Style of Architecture. Married Marie von Sivers.
1915 on	Work with artisans from many nations on the Goetheanum.
1916	Lectures on the history of art. *The Riddles of Man* published.
1917	*Riddles of the Soul* published, with first statement of the threefold division of the human organism.
1918	Threefold Social Order Movement.
1919	Publication of *Threefold Commonwealth*. Founding of the Free Waldorf Schools for Boys and Girls in Stuttgart. Pedagogical courses and seminars. First course for scientists.
1920	First course for doctors and medical students. Courses: Color for Painters. Recitation and Declamation. Thomas Aquinas.
1921	Courses: Curative Eurythmy. Astronomy. Course for Theologians.
1922	Lectures in Holland and England on new ideals in education. Course on world economy. Assisted the founding of the Christian Community for religious renewal.
1922–1923	New Year's Eve: First Goetheanum burned to the ground.
1923	Foundation of the General Anthroposophical Society and the Free School of Spiritual Science in Dornach, Switzerland. Course at Ilkley in England: Education and Modern Spiritual Life (published also as *A Modern Art of Education*). Course on world history in the light of Anthroposophy.
1924	Agriculture course and beginning of biodynamic agricultural movement. Courses given in medicine, eurythmy, karmic relationships, speech and drama, apocalypse for theologians.

Course on curative education. Foundation of the first institute for therapy and education for children in need of special soul care at Lauenstein near Jena.

Autobiography, *The Course of My Life*, begun.

Lectures on education in Torquay, England, "True and False Paths of Spiritual Investigation," published under title *The Kingdom of Childhood*.

1925 *Fundamentals of Therapy* written in cooperation with Ita Wegman, M.D.

Died 30 March.

Bibliography

George Adams. *Physical and Ethereal Spaces*. London: Rudolf Steiner Press, 1965.

George Adams and Olive Whicher. *The Plant between Sun and Earth*. Stourbridge, Worcestershire, England: Goethean Science Foundation, 1952.

Paul Allen and Carlo Pietzner, eds. *Christian Rosenkreuz Anthology*. Blauvelt, N.Y.: Rudolf Steiner Publications, 1968.

Antonin Artaud. *The Theater and Its Double*. Translated by Mary Caroline Richards. New York: Grove Press, 1958.

Owen Barfield. *History in English Words*. London: Faber and Faber, 1962.

————. *Poetic Diction*. Middletown, Conn.: Wesleyan University Press, 1973.

————. *Romanticism Comes of Age*. Middletown, Conn.: Wesleyan University Press, 1967.

————. *Saving the Appearances*. London: Faber and Faber, 1957.

————. *Speaker's Meaning*. London: Rudolf Steiner Press, 1967.

————. *What Coleridge Thought*. Middletown, Conn.: Wesleyan University Press, 1971.

————. *Worlds Apart*. Middletown, Conn.: Wesleyan University Press, 1964.

————. *Unancestral Voice*. Middletown, Conn.: Wesleyan University Press, 1965.

Paulus Berensohn. *Finding One's Way with Clay*. New York: Simon and Schuster, 1972.

Bio-Dynamics. A magazine published by Bio-Dynamic Farming and Gardening Association, Inc., 308 East Adams St., Springfield, Ill. 62701.

R. H. Blyth. *Zen in English Literature*. Tokyo: Hokuseido Press, 1942.

Doug Boyd. *Rolling Thunder*. New York: Dell Publishing Co., 1974.

Fritjof Capra. *The Tao of Physics*. Berkeley: Shambhala, 1975.

Edward S. Casey. "Toward an Archetypal Imagination." *Spring: A Journal of Archetypal Psychology*. Zürich, 1974.

Henry Corbin. *Avicenna and the Visionary Recital*. Bollingen Series, vol. 66. Princeton: Princeton University Press, 1960.

————. *Creative Imagination in the Sufism of Ibn Arabi*. Princeton: Princeton University Press, 1969.

————. "Mundus Imaginalis or the Imaginary and the Imaginal." *Spring: A Journal of Archetypal Psychology and Jungian Thought*. Zürich, 1972.

John Davy, ed. *Work Arising from the Life of Rudolf Steiner*. London: Rudolf Steiner Press, 1975.

Martin Duberman. *Black Mountain: Experiment in Community*. New York: Random House, 1970.

Edward F. Edinger. "Depth Psychology as the New Dispensation." *Quadrant: Journal of the C. G. Jung Foundation for Analytical Psychology*. Winter 1979. Vol. 12, no. 2, pp. 4 ff.

Karl Ege. *An Evident Need of our Times: Goals of Education at the Close of the Century*. Hillsdale, N.Y.: Adonis Press, 1979.

Mircea Eliade. *Images and Symbols*. New York: Sheed and Ward, 1961.

————. *Patterns in Comparative Religion*. New York: World Publishing Co., 1967.

————. *The Sacred and the Profane*. New York: Harcourt, Brace & World, 1959.

Francis Edmunds. *Rudolf Steiner's Gift to Education*. London: Rudolf Steiner Press, 1975.

Education As an Art. A magazine published by the Association of Waldorf Schools of North America, Green Meadow School, Hungry Hollow Road, Spring Valley, N.Y. 10977.

Marilyn Ferguson. Editorial. *Brain/Mind Bulletin, Frontiers of Research, Theory and Practice*. 8 July 1978.

John Gardner. *The Experience of Knowledge*. Garden City, N.Y.: Waldorf Press, Aldelphi University, 1975.

Johann Wolfgang von Goethe. *Metamorphosis of the Plant*. Springfield, Ill.: Bio-Dynamic Farming and Gardening Assoc., 1974.

————. *Theory of Color*. Ed. Rupprecht Matthaei. New York: Van Nostrand Reinhold Co., 1971.

A. C. Harwood. *Recovery of Man in Childhood*. London: Hodder and Stoughton, 1958.

————. *The Way of a Child*. London: Rudolf Steiner Press, 1967.

Johannes Hemleben. *Rudolf Steiner: A Documentary Biography*. East Grinstead, England: Henry Goulden, 1975.

High Mowing School. "Annual Report, 1978." Wilton, N.H.

James Hillman. *Re-Visioning Psychology*. New York: Harper and Row, 1975.

————. *The Myth of Analysis*. Evanston: Northwestern University Press, 1972.

James Joyce. *Finnegans Wake*. New York: Viking Press, 1939.

C. G. Jung. *Aion: Researches into the Phenomenology of the Self*. Bollingen Series,

vol. 9, no. 2. New York: Pantheon Books, 1959. See especially ch. 5, "Christ, a Symbol of the Self."

————. *Memories, Dreams, Reflections.* New York: Pantheon Books, 1963. See especially ch. 6, "Confrontation with the Unconscious."

————. *Psychology and Alchemy.* Bollingen Series, vol. 12. New York: Pantheon Books, 1953.

————. *Psychology and the Occult.* Princeton: Princeton University Press, Bollingen paperbacks, 1977. See "The Soul and Death," paragraphs 812–14.

Karl König. "The Camphill Movement." *The Cresset: Journal of the Camphill Movement.* Aberdeen, 1960.

————. "The Human Soul," "Some Fundamental Aspects of Diagnosis and Therapy in Curative Education," and other articles. *Aspects of Curative Education.* Ed. Carlo Pietzner. Aberdeen: Aberdeen University Press, 1966.

————. *Three Lectures on Community Building.* Grange Village and Glencraig Printery.

————. "The Meaning and Value of Curative Education and Curative Working." Mimeographed translation of *Camphill Brief,* 1965.

Irwin Kremen. *Collages by Irwin Kremen.* Washington, D.C.: Smithsonian Institution, 1978.

Ernst Lehrs. *Man or Matter.* New York: Harper and Row, 1958.

————. *Rosicrucian Foundations of the Age of Natural Science.* Spring Valley, N.Y.: St. George Publications, 1976.

Oliver Mathews. "Religious Renewal." *Work Arising from the Life of Rudolf Steiner.* Ed. John Davy. London: Rudolf Steiner Press, 1975.

Sylvester Morey, ed. *Can the Red Man Help the White Man?: A Denver Conference with the Indian Elders.* New York: Gilbert Church Publisher, 1970.

Erich Neumann. *Art and the Creative Unconscious.* Bollingen Series, vol. 61. Princeton: Princeton University Press, 1971.

————. *Depth Psychology and a New Ethic.* New York: G. P. Putnam & Sons, 1969.

————. *Amor and Psyche.* Princeton: Princeton University Press, 1971.

————. *The Great Mother.* Bollingen Series, vol. 47. New York: Pantheon Books, 1963.

————. *Origins and History of Consciousness.* Bollingen Series, vol. 42. New York: Pantheon Books, 1954.

Ekkehard Piening and Nick Lyons, eds. *Educating as an Art: The Rudolf Steiner Method.* New York: The Rudolf Steiner School, 1979.

Carlo Pietzner, ed. *Aspects of Curative Education,* Aberdeen: Aberdeen University Press, 1966.

————. "Ceremony of the World-Order." *The Cresset: Journal of the Camphill Movement.* Aberdeen, 1969.

————. "Thoughts on Rudolf Steiner's Birthday." A lecture given 27 February 1971 in Camphill Village, Copake, New York. Mimeographed.

Mary Caroline Richards. *Centering: In Pottery, Poetry, and the Person.* Middletown, Conn.: Wesleyan University Press, 1964.

————. *The Crossing Point: Selected Talks and Writings.* Middletown, Conn.: Wesleyan University Press, 1973.

Walthier Roggenkamp and Bernhard Fischer, eds. *Healing Education Based on Anthroposophy's Image of Man: Living-Learning-Working with Children and Adults in Need of Special Soul Care.* 1974. Distributed by Ausgabe für den Buchhandel, Verlag Freies Geistesleben GmbH, Stuttgart.

Joan and Siegfried Rudel, eds. *Education towards Freedom.* East Grinstead, England: Lanthorn Press, 1976.

Theodor Schwenk. *Sensitive Chaos.* London: Rudolf Steiner Press, 1965.

————. "The Spirit in Water and the Spirit in Man." *Journal for Anthroposophy,* Autumn 1977.

A. P. Shepherd. *A Scientist of the Invisible.* London: Hodder and Stoughton, 1969.

Rudolf Steiner. *Anthroposophy and the Social Question.* New York: Anthroposophic Press, 1958.

————. *Art in the Light of Mystery Wisdom.* London: Rudolf Steiner Press, 1970. Eight lectures given in 1914, 1920, and 1923.

————. *Christianity as Mystical Fact.* New York: Anthroposophic Press, 1947.

————. *The Christ Mystery in Relation to the Secret of Pentecost.* Goetheanum Series, no. 3. London: Anthroposophical Publishing Co., 1927. Lecture, given 17 May 1923.

————. *The Cycle of the Year.* London: Anthroposophical Publishing Co., 1956. Five lectures given 31 March–8 April 1923.

————. *Curative Education.* London: Rudolf Steiner Press, 1972. Given 25 June– 7 July, 1924.

————. *Discussions with Teachers.* London: Rudolf Steiner Press, 1967. Fifteen discussions, 1919.

————. *The East in the Light of the West.* London: The Rudolf Steiner Publishing Company, New York: Anthroposophic Press, 1940. Second edition.

————. *Education of the Child in the Light of Anthroposophy.* Trans. George and Mary Adams. London: Rudolf Steiner Press, 1975. Lecture, given 1909.

————. *Education As a Social Problem.* New York: Anthroposophic Press, 1969. Six lectures, given 9–17 July 1919.

————. *Essentials of Education.* London: Anthroposophical Publishing Co., 1948. Five lectures, given 8–12 April 1924.

————. *From Jesus to Christ.* London: Rudolf Steiner Press, 1973. Ten lectures, given 5–14 October 1911.

————. *The Four Seasons and the Archangels*. London: Rudolf Steiner Press, 1968. Five lectures, given 5–13 October 1923.

————. *The Four Temperaments*. New York: Anthroposophic Press, 1976. Three lectures, given 9 January, 19 January, 4 March 1909.

————. *From Buddha to Christ*. Spring Valley, N.Y.: Anthroposophic Press, Inc., 1978.

————. *Goethe the Scientist*. New York: Anthroposophic Press, 1950.

————. *A Theory of Knowledge Based on Goethe's World Conception*. New York: Anthroposophic Press, 1968.

————. *The Gospel of St. John*. New York: Anthroposophic Press, 1962. Twelve lectures, given 18–21 May 1908.

————. *Guidance in Esoteric Training*. London: Rudolf Steiner Press, 1972.

————. *Human Values in Education*. London: Rudolf Steiner Press, 1971. Ten lectures, given 17–24 July 1924.

————. *Illusory Illness and the Feverish Pursuit of Health*. New York: Anthroposophic Press, 1969. Lecture, given 1907.

————. "Individual Spiritual Beings and Uniform Ground of the World." Dornach, 19 November 1917. Quoted from a lecture by Carlo Pietzner, "Thoughts on Rudolf Steiner's Birthday." 27 February 1971 in Copake, N.Y. Mimeographed.

————. *Karma of Human Vocation*. New York: Anthroposophic Press, 1944. Ten lectures, given 9–27 November 1916.

————. *The Kingdom of Childhood*. London: Rudolf Steiner Press, 1974. Seven lectures, given in Torquay, England, 12–20 August 1924.

————. *Knowledge of the Higher Worlds and Its Attainment*. 3rd ed. New York: Anthroposophic Press, 1947.

————. *Lectures to Teachers*. Reported by Albert Steffen. Ten lectures, given 23 December 1921–2 January 1922. Anthroposophical Publishing Co., 1948.

————. *Man As Symphony of the Creative Word*. London: Rudolf Steiner Press, 1970. Twelve lectures, given 19 October–11 November 1923.

————. *Michaelmas*. Vol. 4. *The Festivals and Their Meanings*. London: Anthroposophical Publishing Co., 1957. Seven lectures, given 1913–24.

————. *The Mission of the Archangel Michael*. New York: Anthroposophic Press, 1961. Eight lectures, given 1918–19.

————. *Modern Art of Education*. London: Rudolf Steiner Press, 1972. Fourteen lectures, given in Ilkley, Yorkshire, 5–17 August 1923.

————. *Practical Advice for Teachers*. London: Rudolf Steiner Press, 1976. Fourteen lectures, given 21 August–5 September 1919.

————. *Rudolf Steiner: An Autobiography*. Ed. Paul Allen. Blauvelt, N.Y.: Rudolf Steiner Publications, 1977.

————. *The Roots of Education.* London: Rudolf Steiner Press, 1968. Five lectures, given 13–17 April 1924.

————. *The Social Future.* Spring Valley, N.Y.: Anthroposophic Press, Inc., 1972. Six lectures, given 24–30 October, 1919.

————. *Spiritual Ground of Education.* London: Anthroposophical Publishing Co., 1947. Nine lectures, given at Oxford, 16–25 August 1922.

————. *Study of Man.* London: Rudolf Steiner Press, 1966. Fourteen lectures, given 21 August–5 September 1919.

————. *Study of Man Gained through Meditation.* Four lectures. Stuttgart, 1920. Mimeographed.

————. *Supplementary Course — The Upper School.* Forest Row, England: Michael Hall, 1965. Eight lectures, given June 1921.

————. *The Tension between East and West.* London: Hodder and Stoughton, 1963. Ten lectures, given at Vienna, 1922.

————. *Theosophy.* London: Rudolf Steiner Press, 1965.

————. *Toward Social Renewal.* London: Rudolf Steiner Press, 1977. (Formerly published as *Threefold Social Order.*)

————. *Ways to a New Style in Architecture.* London: Anthroposophical Publishing Co., 1927. Five lectures, given 11–26 July 1914.

————. *The Younger Generation. Educational and Spiritual Impulses for Life in the Twentieth Century.* New York: Anthroposophic Press, 1967. Thirteen lectures, given 3–15 October 1922.

———— et al. *Education as an Art.* Blauvelt, N.Y.: Rudolf Steiner Publications, 1970. Two lectures, given 2 November and 27 February 1921; also essays by P. Allen, C. Heydebrand, and N. Baditz.

E. A. Karl Stockmeyer. *Rudolf Steiner's Curriculum for Waldorf Schools.* London: Rudolf Steiner Press, 1969.

William Irwin Thompson, "Spiralling into the Future: A Conversation with William Irwin Thompson" *Parabola.* Fall 1976. Vol. 1, no. 4, pp. 82 ff.

Thomas Weihs. *Children in Need of Special Care.* London: Souvenir Press, 1971.

————. First Annual Stanley Segal Lectures, Trinity and All Saints Colleges, England, 1977.

Frances Yates. *The Art of Memory.* Chicago: University of Chicago Press, 1966.

————. *Theatre of the World.* Chicago: University of Chicago Press, 1969.

————. *The Rosicrucian Enlightenment.* London: Routledge and Kegan Paul, 1972.

The editions of Rudolf Steiner's books cited above are those used by the author. Steiner's books have appeared in many editions.

Many other works related to Waldorf Education are distributed by St. George Books and by the Anthroposophic Press, both in Spring Valley, N.Y. Selected titles are listed below.

Hermann von Baravalle
 Astronomy: An Introduction
 Geometric Drawing and the Waldorf School Plan
 Introduction to Physics in the Waldorf Schools
 Perspective Drawing
 The Teaching of Arithmetic and the Waldorf School Plan
Fritz von Bothmer
 Gymnastic Education
Mariana Brühl
 Songs
 Child and Man extracts
 Articles originally published in the magazine *Child and Man* by practicing
 teachers in Rudolf Steiner schools
Lois Cusick
 Waldorf Parenting Handbook
Margaret Fröhlich and H. R. Niederhauser
 Form Drawing
Hildegard Gerbert
 Education through Art
E. Geuter
 For the Parents of a Mongoloid Child
Werner Glas
 Speech Education in the Primary Grades of Waldorf Schools
E. M. Grunelius
 Early Childhood Education
Ursula Grahl
 The Exceptional Child: A Way of Life for Mentally Handicapped Children
 *How to Help Your Growing Child through an Understanding of the Four Temper-
 aments*
 The Wisdom in Fairy Tales
Gerbert Grohmann
 The Plant
A. C. Harwood
 Christmas Plays from Oberufer
Hedwig Hauck
 Handwork and Handcrafts
Karl König
 Brothers and Sisters: A Study in Child Psychology
 The First Three Years of the Child
 The Human Soul

Eugen Kolisko
 Chemistry for Children
Elizabeth Lebret
 Pentatonic Songs
 Shepherd's Songbook for Grades 1, 2, and 3 of Waldorf Schools
A. E. McAllen
 The Extra Lesson: Exercises in Movement, Drawing and Painting for Helping Children in Difficulties with Writing, Reading and Arithmetic
 Teaching Children To Write
George Metaxa
 Music for Children's Eurythmy and Dance
Lisa D. Monges
 Eurythmy Exercises
Paul Nordoff and Clive Robbins
 Music Therapy in Special Education
Marjorie Spock
 The Lively Art of Teaching
Caroline von Heydebrand
 Curriculum of the First Waldorf School
Olive Whicher
 Projective Geometry: Creative Polarities in Space and Time
Roy Wilkinson (booklets)
 Commonsense Schooling
 The Curriculum of the Rudolf Steiner School
 The Development of Language
 Learning To Write and Read
 Miscellany — Play and Poems
 Plant Study — Geology
 Social Aspects
 Studies in Practical Activities
 Teaching Geography
 Teaching History I
 Teaching History II
 Teaching History III
 Teaching History IV
 The Temperaments
 Man and Animal

Please remember that this is a library book,
and that it belongs only temporarily to each
person who uses it. Be considerate. Do
not write in this, or any, library book.

DATE DUE

AP 19 '91	2-0-96	ILL	
AP 19 '91	OCT 10 '97	7568734	
JE 13 '91	ILL	9/7/04	
AG 13 '91	826353	OC 26 '08	
OC 26 '91	11/27/97	AP 30 '08	
NO 11 '91	MAR 13 1998		
DE '91		ILL	
JA 27 '92	SEP 05 1999	12/24/09	
MR 30 '92	APR 30 2000		
NO 25 '92	MR 11 '01		
FE 25 '93	AG 24 '01		
april 22	AP 10 '03		
NO 7 '93	JE 22 '03		
JE 29 '94	OC 31 '03		
DEC 22 '94	AG 31 '08		
OCT 25 '95			
MAR 9 '97			

Demco, Inc. 38-293